The Great Impressionists

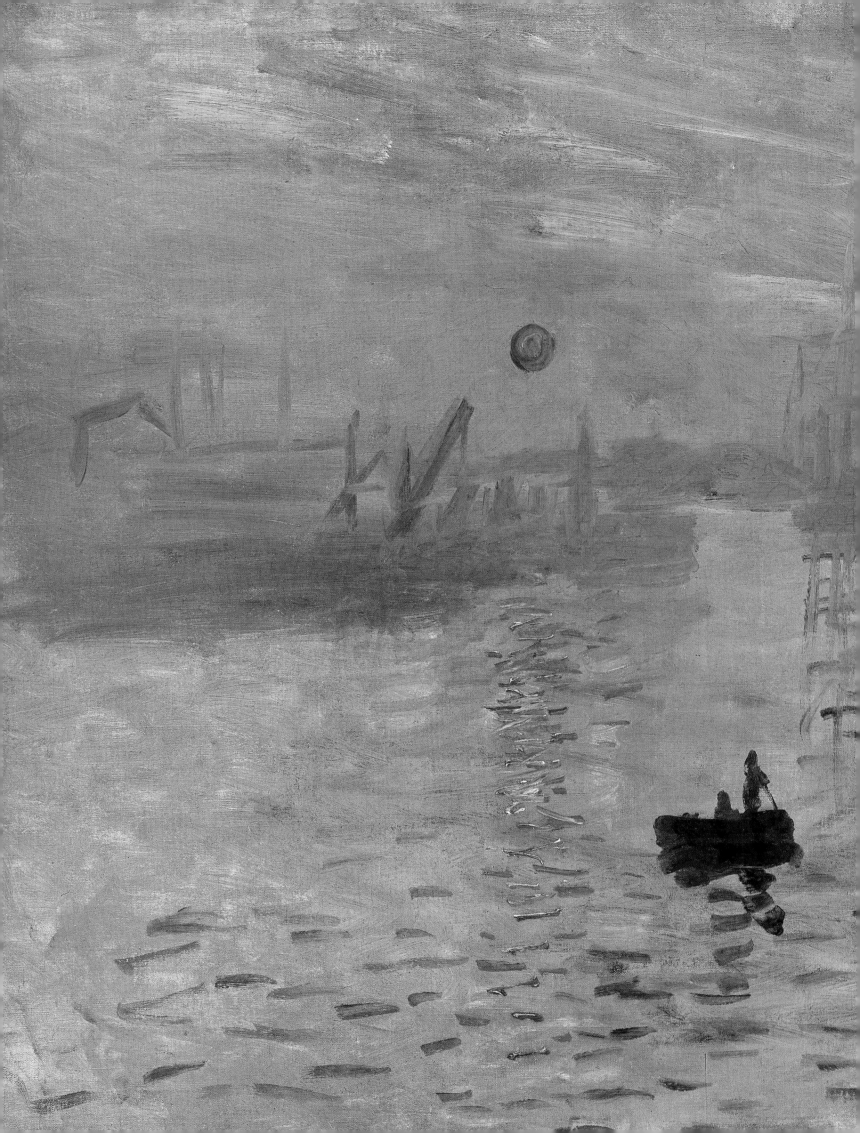

Fritz Novotny

The Great Impressionists

With an introduction by Artur Rosenauer

Prestel Munich · New York

Front cover: Pierre-Auguste Renoir, *Bal à Bougival*, 1883,
 Museum of Fine Arts, Boston

Frontispiece: Claude Monet, *Impression, soleil levant*, 1972,
 (detail) Musée Marmottan, Paris

Translated from the German by Elizabeth Clegg
Copyedited by Mike Green

© 1995 by Prestel-Verlag, Munich and New York
© of illustrated works by Pierre Bonnard, Albert Marquet,
Henri Matisse, and Paul Signac by VG Bild-Kunst, Bonn, 1995

Photograph credits on p. 152

Prestel books are available worldwide. Please contact your
nearest bookseller or write to either of the following addresses
for information concerning your local distributor.

Prestel-Verlag
Mandlstrasse 26, D-80802 Munich, Germany
Tel. (89) 38 17 09-0; Fax (89) 38 17 09-35
and 16 West 22nd Street, New York, NY 10010, USA
Tel. (212) 627-8199; Fax: (212) 627-9866

Layout and Typeset by Wigelprint, Munich
Lithography by ReproLine, Munich
Printed by Pera Druck Matthias GmbH, Gräfelfing near Munich
bound by MIB Conzella, Pfarrkirchen
Typeface: ITC Garamond and Helvetica

Printed in Germany

ISBN 3-7913-1450-5 (English edition)
ISBN 3-7913-1440-8 (German edition)

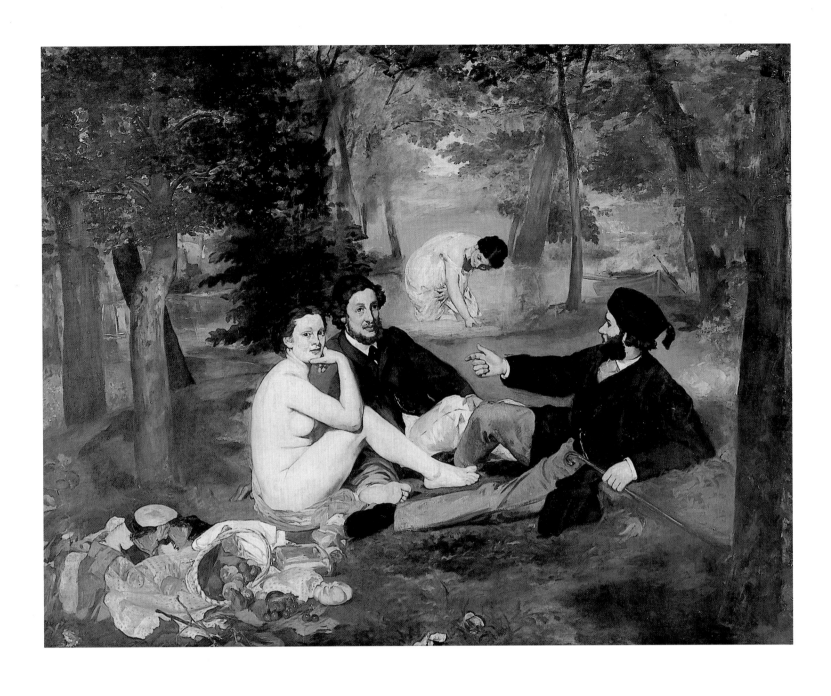

Edouard Manet, *Le Déjeuner sur l'herbe*, 1863, oil on canvas,
208 x 264 cm, Musée d'Orsay, Paris

Artur Rosenauer

Introduction

The principal essay in this volume was first published in 1952 in a sumptuous album-format edition with plates individually mounted. John Rewald, in the annotated bibliography of his *History of Impressionism*, praised Novotny's text as an excellent introduction to its subject and drew attention to the interesting selection of plates, some of them illustrating little-known works. This was, in fact, a virtue that Novotny had made of necessity. In the early 1950s he did not have access to the abundance of illustrations that we enjoy today. With his thorough knowledge of the subject, however, it was not difficult for him to make the unusual and yet apt selection on which he settled. In the present volume this selection has to some extent been altered, but also supplemented.

The approach adopted in Novotny's essay is "phenomenological": he is concerned not so much with the preconditions for the emergence of Impressionism or with its evolution, but rather with its essential qualities and its defining structural characteristics. In what must now be recognized as one of the most concentrated and best introductions to the aesthetic questions raised by Impressionist painting, Novotny describes its essential qualities and shows how these complement and condition one another. Comparisons with examples of Post-Impressionist painting, on which Novotny writes almost as thoroughly as he does on Impressionism, provide an alternative perspective on the principle subject.

The important second part of the original, as of the present, volume consisted of plates and commentaries on them. In opening the sequence with Delacroix and concluding it with Matisse, Novotny is able to illustrate his argument by reference to the whole chronological range of his subject – from its precursors to its successors. The plate commentaries themselves also complement the main text.

The following introductory remarks touch on aspects of Impressionism that Novotny does not himself discuss in his essay but that may be of interest to the reader.

On 25 April 1874 the critic Louis Leroy published a review in the satirical magazine *Charivari* of an exhibition mounted by the "Société anonyme des artistes" at the studio of the photographer Nadar in the Boulevard des Capucines. In his text he used the term "Impressionists," prompted to do so by the title of one of the exhibited pictures – *Impression, soleil levant.* The term "Impression" was not itself particularly new. Corot and Daubigny had already used it of pictures of a sketchy character, in which they attempted to capture certain atmospheric effects. As has so often been the case in the history of art, a word used by chance became a term describing an entire approach to painting.

The exhibition held at Nadar's studio was to be the first of eight – the last taking place in 1886 – that are now recognized as milestones in the history of Impressionism. All the artists that interest us in the present context (with the exception of Manet) took part in some or all of these exhibitions.

By the time of the first exhibition in 1874 Impressionism had already attained its full flowering. By the time of the last exhibition in 1886 new artistic developments were already competing with it.

It is not possible to point to the exact moment at which Impressionism came into being. The decisive circumstance was that a group of young artists, from different social classes but with similar aims, met in Paris in the late 1850s and early 1860s. Manet came from the upper middle class, Degas was an aristocrat; Monet and Renoir, on the other hand, were so poor that the first had to earn his living as a caricaturist, and the second by working as a painter of china.

Shortly after Manet arrived in Paris in 1859, he met Pissarro at the Académie Suisse, a place of training for young artists. Monet met Renoir in 1862 at the studio of Gleyre, where they came to know Sisley. At the Académie Suisse a few years later Pissarro met Cézanne, the two remaining close in the following years. A further meeting place for this group of artists was the Café Guerbois; there Manet played an important role, despite the certain distance at which he held himself from the others. Manet had met Degas (the great outsider of the group) at the Louvre in 1862. Manet first met Monet in 1866.

The fact that, as late as the summer of 1869, Monet often had to abandon his work on a picture because he had run out of paint and could not afford to buy any more shows in what straitened circumstances many of the Impressionists were living, even though they would help each other out as best they could with their meager resources. The first support and the first glimmer of hope for the Impressionists was provided by the art dealer Paul Durand-Ruel, who had met Monet and Pissarro in London in 1870 and who subsequently bought a great many of Monet's pictures. In 1872 Durand-Ruel mounted the first exhibition of the work of some of the painters later to be known as the Impressionists: Manet, Pissarro, Renoir, Monet, and Degas took part in this show. It was anything but a success. In 1874 the auction of paintings held after the exhibition at Nadar's studio was a disaster. The first Impressionist exhibition that Durel-Ruel mounted

in New York, in 1886, was in itself no great success, but it is significant in that it created a new public interest in Impressionism that was to prove of importance in the future. The gradual acclaim for Impressionist painting in America had an influence, in turn, on public opinion in France, leading to an increase in the sale prices that Impressionist paintings might fetch. One of the most important champions of Impressionism in America was Mary Cassatt, who had painted and exhibited with the Impressionists. Not only did she collect their work, she also encouraged her rich American friends to do so.

In France, however, Impressionism had still received very little recognition even by the end of the nineteenth century, as reactions to the Caillebotte Bequest reveal. Gustave Caillebotte, himself an Impressionist painter and a collector of Impressionist work, died in 1894 and bequeathed his collection of Impressionist paintings to the French state so that these would secure a place in the state museums. This gesture,

however, placed the authorities in an awkward position. Only after long and tedious negotiations did they agree to accept thirty-eight of the total of sixty-seven pictures they had been offered.

The speed with which Impressionism blossomed and became established is explained by the close contacts between the various artists, which enabled them to learn from each other. In view of this mutual give and take, any account of Impressionism should, if possible, consider the subject from every angle – from the enthusiasm for particular kinds of subject matter to the adoption of certain stylistic and technical devices. In the following comments I shall touch on a number of telling episodes in this interplay of talents and discoveries.

Monet had reacted to Manet's work long before the two artists met. When Manet showed the picture we now know as *Le Déjeuner sur l'herbe* (illus. p. 6) at the Salon des Refusés in 1863, where it was exhibited as *Le Bain* (The Bathe), Monet

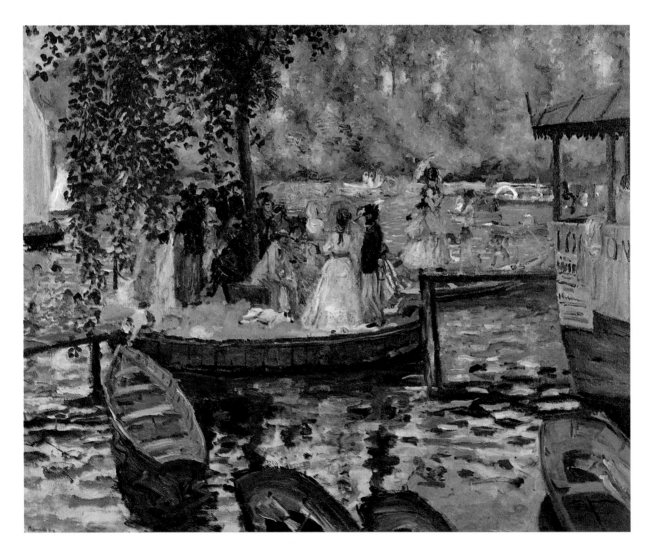

Claude Monet, "*La Grenouillière*", 1969, oil on canvas, 74.6 x 99.7 cm, The Metropolitan Museum of Art, New York

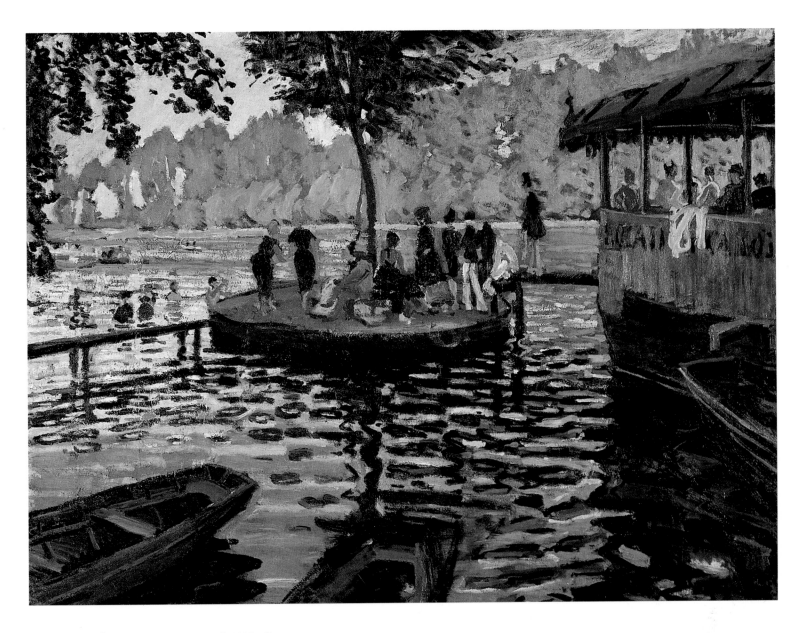

Pierre-Auguste Renoir, "*La Grenouillère*", 1869, oil on canvas,
66 x 81 cm, Nationalmuseum, Stockholm

responded with his own *Déjeuner sur l'herbe* – a much larger painting that met the requirement of showing a scene of modern life in a quite different way than had Manet's more tradition-bound composition. Manet's recognition of this challenge to his own work is demonstrated by the fact that in 1867 he renamed his own picture *Le Déjeuner sur l'herbe*. His intention is obvious: he was anxious to emphasize his own position as the leading painter of modern life.

Monet was the first to evolve what we would now recognize as a distinctively Impressionist technique, and he did so in the context of landscape painting. A few years later Sisley and Pissarro followed him in painting landscapes of an Impressionist character. By 1869-70, under the influence of

Monet's work, both had achieved a freer application of paint and had begun to employ a much lighter palette.

Monet and Renior had met in 1862, drawn together by a shared dissatisfaction with their teacher, Gleyre. During the 1860s Renoir had still been strongly influenced in his portraits and female nudes by the work of Courbet; but in 1869 he went to paint with Monet at "La Grenouillière," an island in the Seine that was a popular spot for picnics and bathing. This experience made Renoir an Impressionist. While the pictures produced by Sisley and Pissarro in the early 1870s could easily be taken for work by Monet, Renoir's Impressionism is quite distinct in character. In the case of his treatment of the motif of "La Grenouillère" itself (illus. p. 9), Renoir's quite

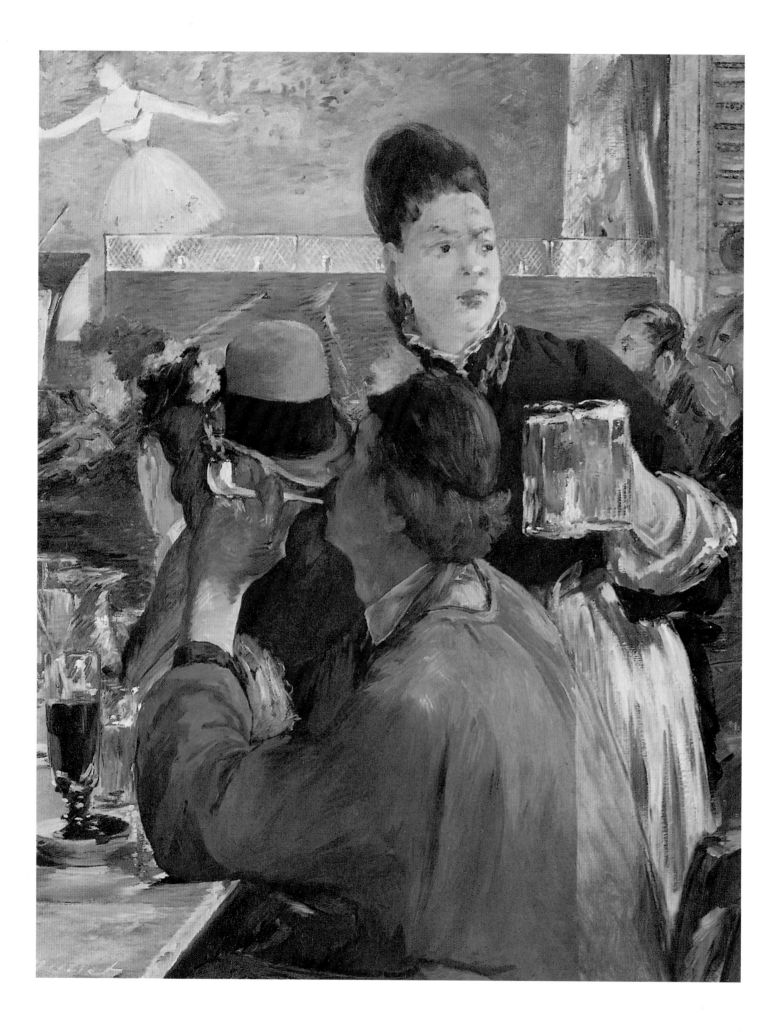

distinct approach to the rendering of visible reality provides an instructive contrast with that of Monet. In his own work, Monet (illus. p. 8) focuses unambiguously on color. He is not concerned with rendering the surfaces of the depicted reality in terms of their sensuous appeal. Rather, each of his brushstrokes and spots of color retains its own, chromatic value. In complete contrast, Renoir imbues everything he paints with a soft sensuousness. Here, as in all his pictures, whether landscapes, female nudes, or portraits, we find the gleam of mother-of-pearl, an atmosphere that softens and reconciles the individual colors.

Manet, who provided such a stimulus to the Impressionists, retained throughout the 1860s and 1870s a cool, dark coloring and employed black in a way that recalls the work of Velázquez and other Spanish artists. It was through the immediate influence of Monet, with whom Manet spent several weeks at Argenteuil during the summer of 1874, that Manet turned to real *plein air* painting and adopted a lighter and richer palette. The most striking testament to this period of collaboration is the picture that Manet painted of Monet in the boat that Monet used as a floating studio: here, the new Impressionist use of color is seen in all its brilliance.

In the 1870s Pissarro and Cézanne were very close, and painted together in Auvers and Pontoise. Of all the Impressionists, Pissarro was the only one to have faith in Cézanne. "Our Cézanne shows great promise. I saw a picture by him that had remarkable energy and power. If he stays in Auvers for a while he will astonish all the artists who were so quick to dismiss him."[1] This far-sighted assessment was informed by a certain artistic affinity. There can be no doubt that Pissarro, whom Monet had only recently converted to Impressionism, was the artist whose aims were closest to those of Cézanne. It was in response to Pissarro that Cézanne adopted a brighter tonality and he later described this older mentor as "humble et colossal." We can also detect Cézanne's influence on Pissarro during this period of collaboration, in the emphasis on volume in the latter's treatment of landscape.

Of all the Impressionists, Degas was the most pronounced outsider. He remained throughout his life a great admirer of Ingres, and in his own work line is more important than color. One could well ask whether he would even be regarded as one of the Impressionists had he not so persistently exhibited with them. Degas was close to Manet not only on account of their related artistic aims, but also because they both came from the upper classes. Their friendship was, however, not without a certain element of friction. Manet liked to recall that at a time when he was already producing scenes of modern life, Degas was still executing history paintings. Degas, for his part, was proud that he had discovered the racetrack as a subject long before Manet had done so. The ambivalence in this friendship is especially evident in two comments made by Degas after Manet's death, comments that could hardly be more contradictory: "He was far greater than any of us realized"[2] and "he was the worst possible painter, he couldn't paint a stroke without thinking of the Old Masters."[3]

It appears that Manet and Degas drew on each other's achievements only relatively late in their friendship. One of Manet's pastels showing the back view of a woman bathing is without doubt related to the work of Degas, in whose monotypes this motif occurs from the 1870s onward. It was only after Degas had come to know Manet's work in pastel, however, that he himself embarked on the large-scale pastels now so widely acclaimed.[4]

A composition such as Manet's *Beer Waitress* of 1879 (illus. p. 10) is cropped in a way that distinctly recalls devices employed by Degas. Large, forceful figures occupy the picture's foreground, while the stage with the dancer is shown as a strip along the picture's upper edge. This arrangement is very close to that found in pictures by Degas such as *Musicians in the Orchestra* of 1870-71 (illus. p. 12). While it is true that Manet is more restrained, and less daring in his use of cropping than Degas, the connection between the two is clear.

One of the defining characteristics of Impressionism – whether one regards it as an achievement or a loss depends on one's point of view – was the disregard for the conventional categories of genre, a disregard that was often the prelude to the entire disappearance of such categorization. As an example we may cite a portrait by Degas, though we would not at first be inclined to classify it as a portrait. Strictly speaking, it is not possible to say whether the picture is more appropriately titled *Place de la Concorde* or *Vicomte Lepic*. Every element of "representation" that one might well expect in a portrait is absent here. The spectator encounters this *flâneur* as if in a snapshot, just as he is passing out of the field of view – it is a momentary impression, the sense of the transitory and the incidental being achieved through the calculated irregular disposition of the figures across the picture plane and through the daring use of cropping. Degas's interest in the depicted person as such is clearly diminished, but the setting, the Place de la Concorde, takes on a new role: as the social and cultural environment of this person, it contributes to our impression of his character.

Edouard Manet, *The Beer Waitress*, 1879, oil on canvas, 98 x 79 cm, National Gallery, London

There are, of course, much earlier instances of reciprocal influence between the traditional categories of painting. Rembrandt opened up new possibilities for the portrait in drawing on his own experience as a painter of genre scenes and Old Testament subjects. Until Degas painted the Vicomte Lepic in The Place de la Concorde, however, the notion of a portrait that left the spectator uncertain as to whether it was not, rather, the depiction of a city square would have been unthinkable. There is no better proof of how out of date the strictly defined categories of the various genres of painting had come to seem. Artists had ceased to think in terms of such categories. It no longer mattered whether a picture was to be defined as a portrait, a still life, or a landscape. Now the important thing was that the painter should capture a piece of reality exactly as it appeared to him, however seemingly arbitrary the result.

The work of Monet provides the best evidence of how closely this diminished importance, this waning of the conventional genres was connected with the Impressionist manner of painting. Whatever the object represented, the relation between it and the brushstrokes and spots of color on the canvas was much looser – looser, too, in terms of emotion and content. The focus of attention had shifted from the "solid" object in its own right to its appearance in a particular light and in particular atmospheric conditions. Even more significant is the shift of emphasis from reality itself to the individual – be this the painter or the spectator – who registers this reality. The optical sensations given off by an object in certain lighting were to be captured by the painter in exactly the way that they struck the retina of someone looking at such an object in reality. The determining element was not the object itself, but rather the impression it made on the retina, an impression made up of a variety of colors. The painter, anxious to suppress his prior knowledge of the subject and its associations, would thus eschew any form of commentary or interpretation or any sort of emotional involvement. In setting free the colored appearance of things, he reduced himself to nothing more than an eye registering the result.

In 1879 Monet painted his first wife, Camille, on her deathbed (illus. p. 14). The face of the dead woman emerges through a veil of color – if the circumstances had not been so securely documented one would be inclined to assume that she was asleep. In this work Monet was able to depict for the last time an individual with whom he had lived for decades, and whom he loved; but he did so with an almost bewildering neutrality, an apparent lack of emotion. The picture is not a declaration of love for a person; it is a profession of faith in painting itself. It is difficult to resist the impression of a somewhat tasteless excess here. Monet himself must have felt a certain unease, because many years later he confided with striking frankness to his friend Clemenceau: "Color is my daily passion, my joy and my torment. And to such an extent that I once caught myself standing by the deathbed of a woman who was, and still is, very close to me, and, even as my eyes focused on this tragic sight, I was observing the sequence of tonal gradations that death called up upon her motionless face. Blue, yellow, gray tones, and a host of others. That's how obsessed I was! Nothing is more natural than the need to capture the last impression of a person who is departing this life. But before I was struck by the idea of trying to record the features that meant so much to me, my whole being had already started to react to the colors themselves. And, inspite of everything, I found myself caught up in an unconscious process, and I fell back into my daily routine."[5]

This statement is both a testament to relentless self-observation and the record of the "reduction" of an individual to nothing but an eye. To be an eye-witness means not to be involved in the object or event observed. And, as in this case, being an eye-witness can approach the bounds of inhumanity. Novotny refers to Manet's *Execution of the Emperor Maximilian* (illus.p. 31) as a work of "such a markedly Impressionist spirit that nothing of the horror of the event ... finds expression." It would, however, appear that no true painter can act otherwise: between his emotional experience and the act of registering the visible world there is a sharp dividing line.

The most successful and most compelling achievements of Impressionist painting came about where capturing the visible was all that was required. The indifference of the Impressionist painters to subject matter is nowhere more evident than in their enthusiasm for landscape. Their landscape paintings are remarkable for the absence of spectacular elements of any kind; they are as far as possible from the convention of the *veduta*. They are segments of reality that, considered from an objective point of view, must be regarded as inconspicuous. In selecting his motif, the artist acts without prejudice and without reference to convention, making his choice purely on account of appearance in terms of color; and, in doing so, he puts himself at the mercy of the arbitrary nature of his viewing position and of the atmosphere and the lighting, or at least he purports to do so.

Paradoxically, this decline in the significance of the motif is at its most evident in Monet's famous series of pictures of Rouen Cathedral (illus. p. 36-37). When he rented a house opposite the façade of the cathedral in 1892, he was not

Edgar Degas, *Musicians in the Orchestra*, 1870/71, oil on canvas, 69 x 49 cm, Städtische Galerie im Städelschen Kunstinstitut, Frankfurt

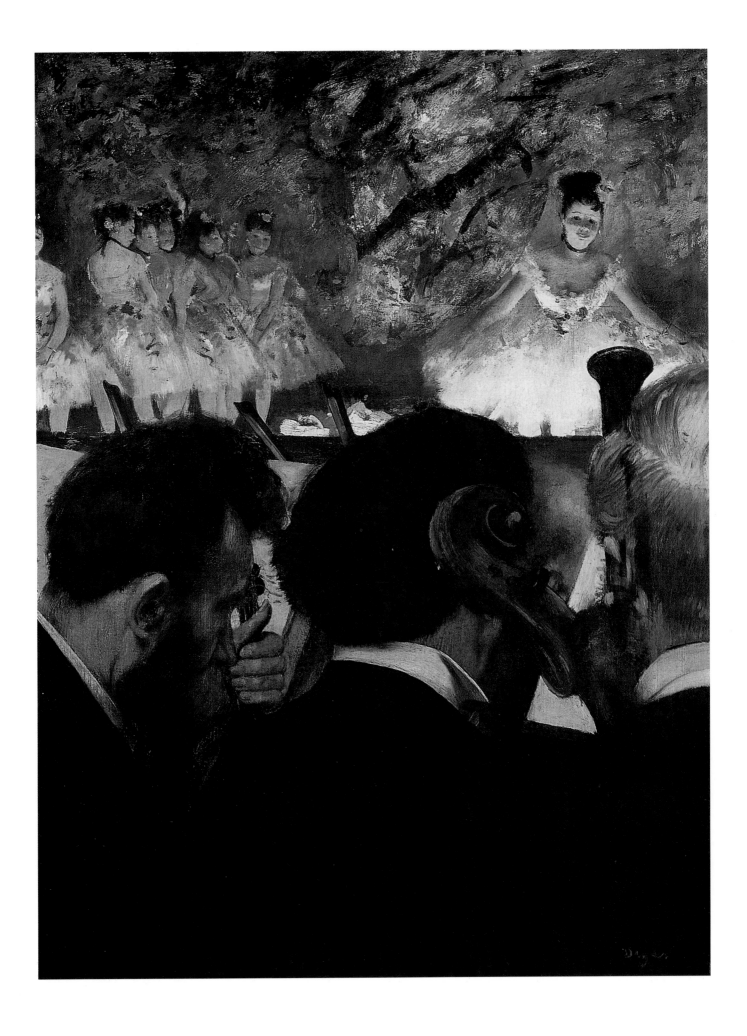

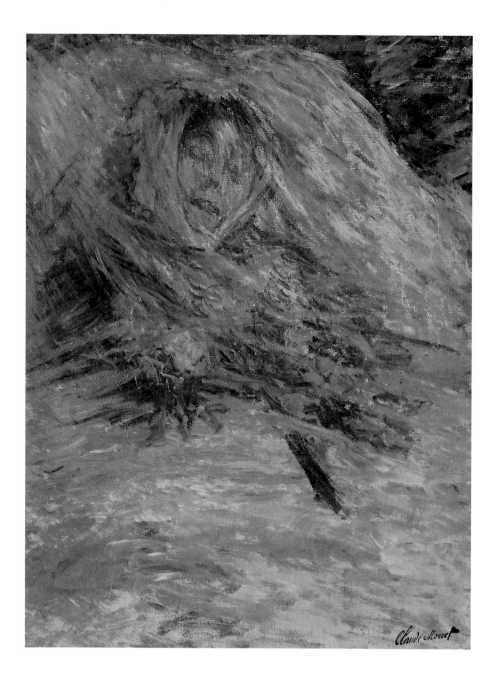

interested in this façade for its own sake, but rather in the ever varying effects of the light playing over its rugged surface: it is literally this that Monet sought to capture moment by moment. And it is precisely through the fact that there are many images instead of one, through the serial character of the image, that the façade of Rouen Cathedral is here deprived of its more conventional significance. It becomes a neutral entity, a blank screen onto which is projected the painter's real subject – light itself as a fluctuating apparition.

We may assume that Monet's understanding of Impressionism allowed him to progress smoothly and consequentially, and without a sense of conflict, toward the dissolution of the boundaries that had so far marked out the conventional genres of painting. The early work of Manet, on the contrary,

offers very clear evidence of the incompatibility of the qualities associated with the traditional genres and those associated with the new painting – an incompatibility that was sensed not only by the public, but also by the painter himself.

When Manet showed his *Dead Christ with Angels* (illus. p. 17) at the Salon in 1864 he reaped a harvest of negative criticism. We know hardly anything about the circumstances of the composition of this picture or of the artist's aims in painting it; but the early work of Manet prompts us to conclude that in this work, as in his other pictures of the 1860s, he wanted to demonstrate his ability to address the great themes of the "noble" categories of painting: religious subjects, the nude, and history painting. The subject, a *pietà* with angels, a compositional type devised around 1400 and adopted

countless times over the following centuries, is as hallowed by tradition as it is freighted with emotion. And this burden of tradition, which even the late twentieth-century viewer can hardly ignore, would have been sensed even more keenly by Manet's contemporaries. When Manet was inspired by the figure of one of the philosophers painted by Velázquez to depict a Parisian tramp, this connection with tradition was not especially problematic in that it was possible to regard a beggar as not so very different from a philosopher. But the way in which Manet treats his religious theme must really have offended and shocked the spectators of the 1860s. It is evident that the cultural associations of the divinity of Christ and those of the representation of the nude in the studio could not be reconciled. Only a few, Degas among them, were able mentally to abstract technique from subject and appreciate the painting as painting. Even most of these sympathizers, however, sensed the discrepancy.

The great difficulty of reconciling religious painting with an accommodation of "reatlity" had first become apparent when painters began to pay serious attention to this "reality." Masaccio had encountered difficulties in attempting to base on empirical evidence his treatment of God the Father in his Trinity fresco. This problem became especially acute in the art of the nineteenth century, and attains a vexing urgency in relation to Manet's *Dead Christ with Angels*.

In other such cases we are now unable to share the shock felt by Manet's contemporaries because we have lost any sense of the expectations once aroused by certain genres. At the Salon of 1865 Manet showed his *Olympia* (illus. p. 41) a work painted two years earlier. As the image of a reclining nude, the picture takes its place in an honorable tradition originating in Giorgione's Dresden *Venus* and still very much alive in the nineteenth century. Goya's *Naked Maya* or the sumptuous female nudes painted by Ingres (himself not a very distant predecessor of Manet), not to mention the many nudes exhibited at the Salon, may all be understood as part of the same tradition. In *Olympia*, Manet clearly draws on the model of Titian's *Venus of Urbino*, a picture that he had copied during his stay in Florence. This is an indication of the context in which Manet intended *Olympia* to be seen, and indeed the context in which it *was* seen. The outcry provoked by this picture was apparently caused by the discrepancy between what contemporaries regarded as an artist's duty to tradition and the character of the image that Manet had in fact painted. The ideal beauty of Titian's figure, who offers us her divine nudity in a mood of serene composure, stands in sharp contrast to the "banal" reality of the model Manet presents. This barely mature young woman, posed in a rather tense manner with a certain "honest" awkwardness and stiffness, is still wearing slippers, a neckband and a bracelet. She is thus

not shown nude in the Classical manner, giving rather the impression of being simply unclothed. The poetry of Titian's picture is here transformed into the prose of everyday reality – and this is what so angered the public. Reactions ranged from angry condemnation to the bewilderment and helplessness of friends. The furore was such that the organizers of the exhibition felt themselves obliged to hang Manet's picture higher in order to remove it from the center of attention and, above all, to protect it from the hands of the public.

Like *Olympia*, Manet's *Le Déjeuner sur l'herbe* also provoked a fierce controversy. It was rejected by the Salon jury in 1863 and exhibited at the Salon des Refusés, where it left the critics puzzled as to what Manet had been aiming at. Antonin Proust, Manet's friend and biographer, reports that the artist's aim was to paint a modern version of Titian's *Fête champêtre*. This would not, of course, have been the only Classical model to which Manet looked on this occasion. The poses of the three main figures correspond exactly to those of three nymphs in an engraving by Marc Antonio Raimondi after a lost Judgment of Paris by Raphael. In this case it was precisely the tension between the associations with tradition that aroused such indignation. Manet's picture has been seen as a parody of a High Renaissance model, through its transformation into a contemporary scene that is both provocative and banal. It is this, together with the unusual poster-like manner of painting, that appears to have caused such an uproar.

It would seem that two souls dwelt in Manet's breast. One accepted tradition and rose to its challange, the other followed the dictates of its own talents, taking great pride in being "of its time." Manet attempted to unite these two tendencies in his painting, the consequent friction invariably resulting in a scandal. It is impossible to say with any certainty whether Manet deliberately set out to parody tradition, as some scholars have argued, or alternatively, attempted to revive tradition by infusing it with the atmosphere of his own age and the sense of his own reality. In any case, the result of his efforts was such that it was certainly possible to perceive his work as parody. For the late twentieth-century viewer it is precisely in this conflict between the intention and the result, in this heroic failure, that some of the appeal of Manet's early work is to be found. The attempt to breathe new life into the old genres ultimately caused them to shatter. Perhaps it would be more correct to say that they simply broke in Manet's hands.

Impressionism may also be defined in terms of what was lost with the advent of this sort of painting. Harald Keller, in the chapter on iconography in his book on Impressionism,[6] interestingly devotes more attention to the waning genres – religious subjects, history painting, and allegory (all, insofar as they were forms of "intellectual" painting, entirely alien to

Impressionism) – than he does to subject matter that was new in the later nineteenth century. Nonetheless, despite the decreasing importance of genres defined by their elevated content, it would be wrong to suppose that there was no such thing as Impressionist iconography or a range of characteristically Impressionist genres. Certain genres, such as landscape and still life, remained. Landscape painting, indeed, experienced one of its heydays. The genuinely new subjects were those taken from modern life: a dance at a suburban tavern, bathers, crowded Parisian, boulevards, and so on. Novotny speaks of the "experience of the visible" as the "inexhaustible source for the painter"; and one could well think in terms of an iconography of the act of witnessing. As the deathbed portrait of Camille Monet so graphically demonstrates, such an act might require the virtual suppression of empathy.

Some of the great Impressionists – Renoir (died 1919), Degas (died 1917), and Monet (died 1926) – lived some way into our century. In his monumental late paintings Monet took Impressionism close to Abstraction. A number of leading painters in the twentieth century – Pierre Bonnard, Lovis Corinth, or Oskar Kokoschka – have seized on certain possibilities offered by Impressionism and pursued these in their work. This notable endurance allows us all too easily to forget that Impressionism constituted the avant-garde of European painting for no more than fifteen years. From 1880 on new tendencies were apparent.

To our eyes, Impressionism is a firmly established episode in the history of Western art, a high-point of painterly freedom, signaling an unproblematic and hedonistic relationship to reality. The fact that the Impressionists started out as seekers, doubters, and darers is all too easy to overlook today, after the triumphal success that their work has achieved in the interim. But, in fact, it is precisely the achievement that we now reckon as among the great contributions of the Impressionists – everything that freed them from the burden and the demands of tradition – that appears to have provoked in these painters themselves a sense of unease and a feeling of doubt as to the seriousness of their venture.

Such doubts began to find clear expression around 1880. Emil Zola, one of the leading champions of the new direction in painting, appears to have remained at heart deeply uncertain about it. His observation on his portrait by Manet is itself surprising: "Yes, the picture is not bad, especially when you consider that Manet was not a great painter." Even more surprising is his verdict on Impressionism in 1880: "The real misfortune is that none of the artists of this group has been able to formulate powerfully and definitively the new means of expression that is to be found throughout their work. –

They are all precursors. No genius has emerged. We can see their points of view and agree with these, yet we still seek in vain the new masterpiece, the foundation stone of the new . . . This is why the battle fought by the Impressionists has not achieved its victory; they have been defeated in their project, they stammer, unable to find the words they wish to utter."[7] Cézanne, too, was troubled by the element of the ephemeral in Impressionism, as is apparent in his claim: "Out of Impressionism I wanted to make something as solid and lasting as the art in museums."[8]

Some of the Impressionists were themselves not sure of what they really wanted to achieve. Around 1880 there developed something of a crisis, which is most clearly to be seen in relation to the work of Renoir. In his pictures of the 1870s one notes that both his figures and their settings are rendered with regard to the effect of light falling on them, light thus uniting them. Around 1880, however, it appears that Renoir began to have doubts about the approach he had been pursuing; he turned to the example of Ingres and Raphael – artists whose work was as distinct from Impressionism as one could possibly imagine . In 1881-82 he went to Italy in order to study the paintings and frescoes of Raphael and the murals at Pompeii. In Renoir's subsequent work there is a notable strengthening of forms and an emphasis on outline. This development reached its high-point in the *Large Bathers*, painted between 1884 and 1887 and now in the Philidelphia Museum of Art (illus. p. 18). The incisive contours that set off the figures from their setting and the emphasis on the beauty of line itself recall the work of Ingres. The numerous preparatory studies that Renoir made for this work – in itself a procedure quite opposed to the (alleged) spontaneity of Impressionism – are evidence of the high ideals he had set himself in painting this picture. While Renoir's work of the 1870s was dominated by figures or scenes from contemporary life in Paris – one thinks of the *Moulin de la Galette* – he now sought to treat a timeless theme, taking as his starting point a relief by François Giradon (1628-1715). Nude female figures, so central to the tradition of Western art, evidently have a very different claim to universal validity! In his later years Renoir remained faithful to this "timeless" iconography, even though returning to the painterly qualities attainable by means of the Impressionist technique.

Edouard Manet, *The Dead Christ with Angels*, 1864,
oil on canvas, 179 x 150 cm, The Metropolitan Museum of Art, New York,
Bequest of Mrs. H. O. Havemeyer

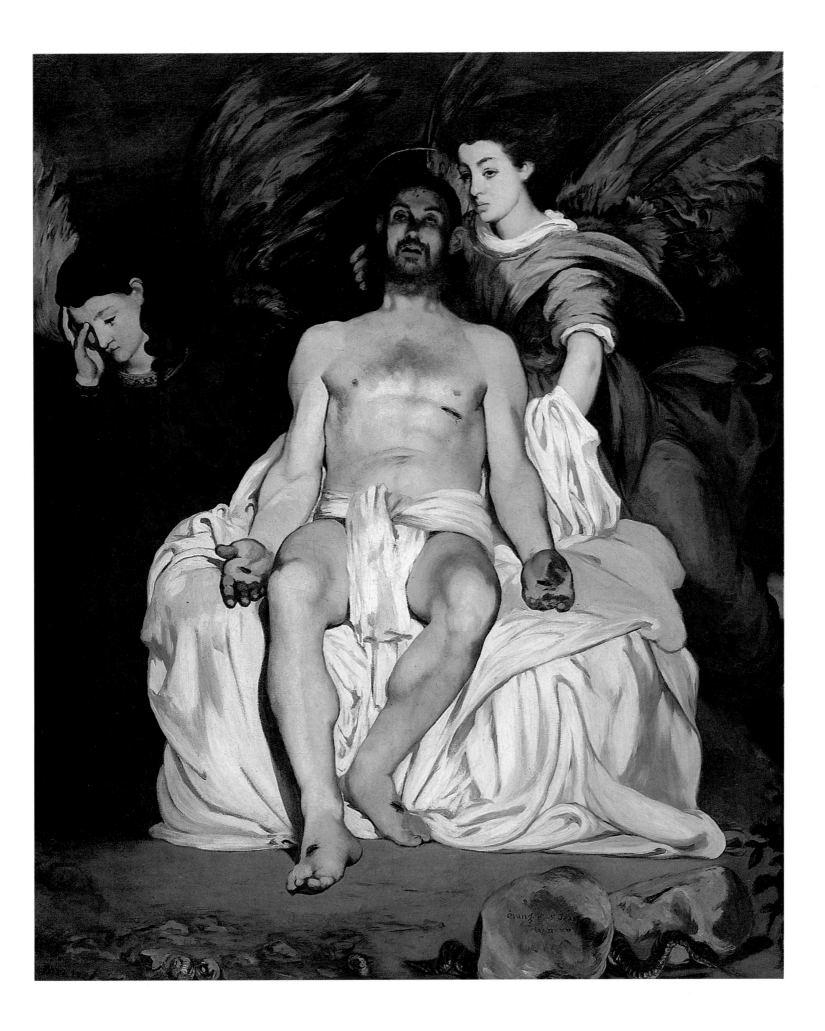

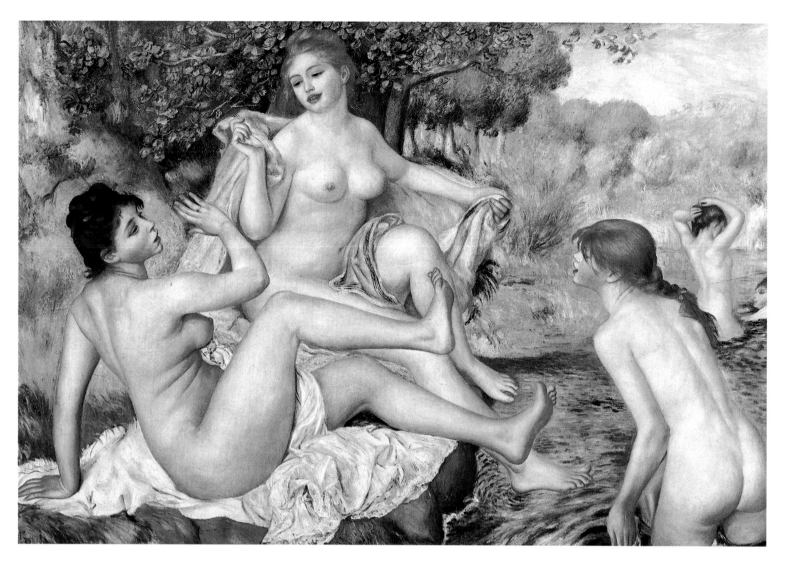

Pierre-Auguste Renoir, *The Large Bathers*, 1884-87, oil on canvas,
115 x 170 cm, Philadelphia Museum of Art, Carol S. Tyson Collection

In Pissarro's work, too, we can detect distinct changes at the start of the 1880s. Figures now begin to play a greater part in the compositions, and the spots of color become more regular. In short: Pissarro's method approaches that of Pointillism. From 1885 he came for a time so much under the influence of Seurat that Renoir is said to have greeted him one day with the words "Bonjour, Seurat." After his period of working with Cézanne, Pissarro apparently saw in Pointillism a means of accommodating his preference for plasticity that went far beyond what was possible in the context of Impressionim.

It is significant that both Renoir and Pissarro first came to Impressionism under the influence of Monet. Perhaps neither of them was a really convinced Impressionist. It is often to be observed that an artist, during the course of his development, returns to his starting point; perhaps one could say that he finds himself again. There is no doubt that the encounter with

Impressionism was beneficial for both Renoir and Pissarro. Nonetheless, as the crisis of the 1880s emerged, both of these artists sought to adopt positions in which it is possible to detect connections with the strivings of their early years.

Even those who had been Impressionists from the start and out of their own conviction were concerned, after 1880, to impose on their compositions a strict formal arrangement. In Manet's *Bar at the "Folies-Bergères"* the horizontal form of the counter and the upright figure of the girl directly facing the spectator combine to create an orthogonal framework for the image. The reflections in the mirror of the line of the balcony, the lamps, and the bottles vary and repeat the principle horizontal and vertical, the picture's appeal lying very much in the tension between strict form and painterly freedom.

Monet, too, increasingly tended to give his compositions a simpler, more lapidary form. In the case of the images of

the Normandy coast, high cliffs constitute the principal motif in the foreground, and from these the view stretches into the distance: Monet is working here, that is to say, with monumental elements of landscape. In the 1890s Monet painted poplars that, as in the picture now in New York (illus. p. 19), are presented as a regular alignment of vertical forms. No compositional device could be simpler or clearer.

The response of the Post-Impressionists was much more radical. Novotny describes their achievements, referring in particular to the fundamental alterations in the treatment of pictoral space, the negation of the rendering of light, and the emergence of "pure" form as a perceptible entity. Seurat, Gauguin, and Van Gogh belonged to the generation following that of the great Impressionists and had not themselves taken part in creating the formal language of Impressionism; rather, they encountered this language in its mature state and, for this reason, were all the more prepared to rework it. Only

Cézanne was a contemporary of the Impressionists and had to some degree shared in their struggle. From the start, however, he felt out of sympathy with Impressionism, a feeling that became very evident, in spite of everything, in an "ability to paint in a non-Impressionist manner." It was thus only natural that Cézanne's work was at first not understood by the Impressionists. The formal consistency and the inner logic of his paintings, on which Novotny writes in exemplary fashion in his essay, was not fully apparent until the 1880s, but it was then ever more obvious.

Seurat received a traditional training at the Ecole des Beaux-Arts under a pupil of Ingres, from whose collection of casts from Classical sculptures he drew. He also made copies of works by Holbein, Raphael, and Poussin. In 1879 he experienced a "choc inattendu et profund" (a deep and unexpected shock) at the fourth Impressionist exhibition and, as a result, was drawn away from the smooth style of painting he had

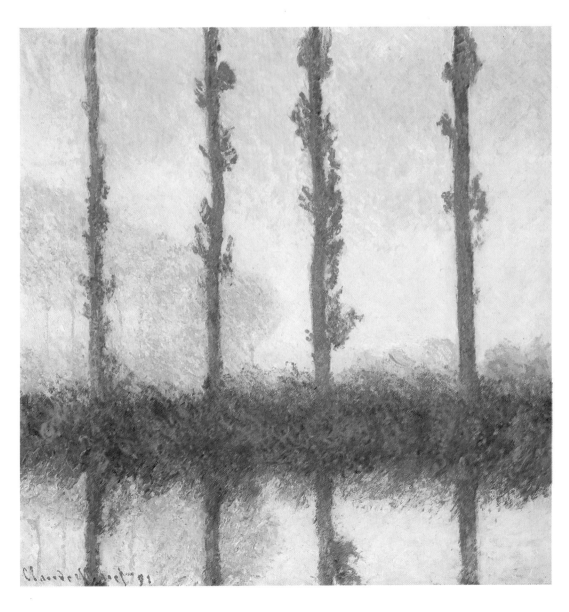

Claude Monet, *Poplars*, 1891,
oil on canvas, 81.9 x 81.6 cm,
The Metropolitan Museum of Art, New York,
Bequest of H. O. Havemeyer

derived indirectly from Ingres. Seurat subsequently adopted an Impressionist technique, without himself becoming an Impressionist. In 1978-79 he painted his *Vase of Flowers* (illus. p. 21), a picture in which the firm cylindrical form of the vase is the principal focus of interest. The flowers themselves are reduced to a single sponge-like mass that recalls the spherical shapes into which the foliage of trees was simplified in the painting of the *Trecento*. A glance at Manet's *Carnations and Clematis in a Crystal Vase* (illus. p. 74), painted only a little later, shows that at this period, he, too, was employing simpler forms. The difference is that, while in Manet's picture we find all the brightness of the life of nature, in Seurat's painting we discover the most rigorous formal reduction to geometric simplicity, a cancellation of every element of life.

Between 1884 and 1886 Seurat painted *A Sunday Afternoon on the Island of La Grande Jatte* (illus. p. 38). There is as little here of the spontaneity of the Impressionist approach to creation as there is of the sense of the transitory in an Impressionist composition. On an island in the Seine forty members of the Parisian bourgeoisie are enjoying their Sunday afternoon in the manner that the artist prescribes. In spite of the ephemeral nature of such a subject in itself, everything in Seurat's record of it conveys a sense of the definitive. The subject is taken from modern life, entirely in the Impressionist spirit, but its presentation has the hieratic quality that one would expect of an Ancient Egyptian depiction of a court ceremony. The visitors to Seurat's island are viewed frontally or from behind or in strict profile – it is as if they were petrified into lifelessness, just as the trees are reduced to the simplest forms. The result is monumentality and rigidity carried to an extreme through the suppression or exclusion of every form of life. Here, time does not flow; it appears, rather, to have been frozen in its tracks.

Van Gogh embarked on his career as an amateur painter in the 1880s, producing scenes with the heavy, awkward figures of peasants and paupers, dominated by dark brown tones. His first direct encounter with Impressionist painting occurred during his stay in Paris from 1886 to 1888. While it might at first appear that this encounter had distracted Van Gogh from the path on which he had embarked, in reality it opened up new possibilities for him. Through Impressionism, he found his own way and was able to evolve his unique style. The crucial lesson that Van Gogh was able to draw from Impressionism was that of the autonomy of color, its freedom from objects. In the pictures painted during the last years of his life, light no longer has its effect on color by falling on it from outside; rather, it appears to emerge from within color. The dominant character of Van Gogh's pictures is established by their expressive outlines and their dynamic brushwork.

One brushstroke takes up the sense of movement set up by another and carries this on to the next, with the result that the compositions appear to be made up of magnetic lines of force. The movement is already exaggerated, imposed by the artist on the objects he observes, these (freed from the logic of the laws of nature) being grasped directly in terms of such movement and all that it expresses.

So far I have attempted to explain the various responses to the possibilities offered by Impressionism in terms of the particular talents of a number of individual artists. It should, however, be borne in mind that these responses were virtually simultaneous. One is therefore moved to ask if this was really sheer coincidence, or if one would be justified in assuming that it implies the inevitability of a logical sequence of events, such as one might assume if one believed that the work of the Post-Impressionists was to some degree an answer to questions posed by the Impressionists. Any careful reading of Novotny's text will reveal passages that suggest the notion of a logical development (which can also embrace a transformation) from Impressionism to Post-Impressionism. In the history of Western art we do in fact know of cases in which an "Impressionistic" stance has ceded to "Expressionistic" exaggeration. In Carolingian manuscript illumination the shift from the "Impressionistic" Vienna Treasury Gospel to the "Expressionistic" Ebo Gospel, with its dynamic use of line, is in some respects comparable to the shift from the work of Monet to that of Van Gogh. Guido von Kaschnitz Weinberg has remarked on the apparent analogy with Late Antiquity: "It is remarkable how many moments one can find in the developments of the late third century that have equivalents in those of the late nineteenth century."[9]

As mentioned earlier, Novotny touches on this problem in his essay. He also returned to it in a lecture, which was later published. "We should not, of course, think here in terms of a 'blind' law [of artistic evolution], and we should be careful not to say: it had to be so, because – this being after all a question of events in the sphere of intellectual history – it could certainly have been otherwise. Nonetheless, as it did turn out in this way, we must recognize that it is a process of some consistency that is here revealed to us."[10]

The problems that we have discussed in the context of Post-Impressionism also arise, of course, in that of Impressionism. In retrospect, Impressionism has become such a fixed point, and also high-point, in the history of Western painting that it is hard to resist the temptation to see its emergence as a sort of historical necessity. It would not be difficult to devise an art historical narrative suggesting a necessary pattern of evolution in painting from the beginnings of the representation of reality in the fifteenth century to the Impressionism of the nineteenth. But we should take care here. Such narrative,

Georges Seurat, *Vase of Flowers*, 1978-79, oil on canvas, 46 x 38 cm, The Fogg Museum of Art, Harvard University, Cambridge, Mass., Maurice Wertheim Collection

it is true, would certainly draw attention to important preconditions for the emergence of Impressionism, but the necessity of its emergence would not thereby be proven. Werner Hofmann's observation – that, although there were preconditions for the evolution of a sort of Impressionism in the work of Constable and Turner in England, these artists were in fact followed by the Pre-Raphaelites – should alert us to the danger of an over-deterministic way of thinking.[11]

In recent decades scholars have paid more attention to the complex interaction of the Impressionists with their own era. It is no longer acceptable to leave out of account the work of the Salon painters – of Bouguereau or Tissot. There is now more interest in the influence exerted by dealers and collectors and in the organization and reception of exhibitions. Nonetheless, from whatever point of view one considers Impressionism, and however much one's conception of it may be modified, it will not be possible to doubt or to dispute the assertion that no other artistic development of the nineteenth century was of such crucial importance for the emergence of modern art.

Fritz Novotny

The Great Impressionists

The Dawning of Modernism

What does Impressionist painting mean to us today in 1952? In the mid-twentieth century, it cannot but appear a past era of painting long removed from scholarly discussion, and easy to grasp in terms of its origins, its development and its decline. From our current perspective, we can perceive it as the *last* historically distinct era in the history of painting; and it is distinct in a more radical way than that in which the manifold tendencies in painting that followed are distinct from each other. A concensus is in fact in the process of emerging: an acknowledgment that we have to locate the deepest caesura, and fundamental turning point, in the painting of the last hundred years, precisely in that distinction between Impressionism and everything that can be embraced in the terms "Post-Impressionism" and "modern painting." It is for this reason that these two categories, however meaningless in themselves, may be seen to serve a useful purpose.

The current retrospective appraisal of Impressionism is by no means one on which agreement has long been reached. Quite contrary interpretations of it emerge. On the one hand, Impressionism is admired as the final consequence of a tradition of painting that had endured for centuries and as its classical, closing phase. It is viewed as the fortunate coincidence of the achievements of a number of great painters who, together, appear to constitute a "school" in the old sense of that term, to which we look back longingly. It is regarded as the last triumph of European landscape painting, as the sovereign, artistic expression of a pantheistic view of the world, free from all ties to intellectual content, and its greatness is seen to lie precisely in the fact that only its high regard for visually perceptible phenomena could foster such an abundance of creativity.

Those who hold the opposite view do not recognize such a deliberate limitation as an admirable focusing of concentration. They regret the lack of precisely that which an Impressionist picture of reality will not, and cannot, provide. They view the pantheistic expression of natural phenomena as too

materialistic because it is limited to rendering what is sensorially perceptible, to the rendering of light and atmosphere. They thereby detect in Impressionism a certain lack of depth. Those who are keenly engaged in defending modern painting see its own beginnings in the passionate gravity of Vincent Van Gogh and the inscrutability of Paul Cézanne. Measured against the image of nature informed by these qualities, nature as represented by the Impressionists appears to them a little like landscape observed from the windows of a dining car. They remain sceptical about a kind of painting that, however successful it may be in its own terms, is still ultimately devoted to achieving a naturalistic result. These opposed appraisals of Impressionism are determined by the various attitudes to Post-Impressionist art, revealing how closely linked Impressionism is to the painting of our own century. By directly opposing these two extreme points of view regarding Impressionist painting we can easily discern how one-sided each is.

Of all the definitions of Impressionism, the most comprehensive is probably that which describes it as the painterly rendering of optical experience. Cézanne's very apposite pronouncement on the art of Claude Monet – "Monet, ce n'est qu'un œil – mais, bon Dieu, quel œil!" (Monet is nothing but an eye – but, good Lord, what an eye!) – embraces the restriction implied in the formula "art for the eye" but also its excuse. That is to say: if visual experience and its realization in a painting – and for Cézanne this meant above all its realization in terms of color – is precise enough, then it requires no further justification. If, however, Impressionism is thought to signify more than the mere recording and reproduction of optical sensations – if, in other words, it is to be regarded as *art* – then we must above all be concerned with what is not yet accommodated in the optical projection of the merely visible.

Exponents of nineteenth-century Impressionism programmatically opposed the idealizing construction and composition of a painting as sanctioned by other tendencies, be they academic-classicist or Romantic. The new watchword was "artistic truth," expressed in the image of an extract from reality, produced with the least possible intervention into the optics of the pure act of seeing. This was the "ethics" of Impressionism, a "moral code" of which its practitioners and followers were more or less aware and in which they bluntly opposed the principles of idealization and the recognized norms of non-naturalistic painting. In reality there had merely been a shift in the notion of what sort of intervention into the image of reality was acceptable for the sake of pictorial structure and composition. In fact, an analysis of Impressionist painting, like that of any other creative method, uncovers all manner of modification to phenomena such as space, plasticity, color and outline.

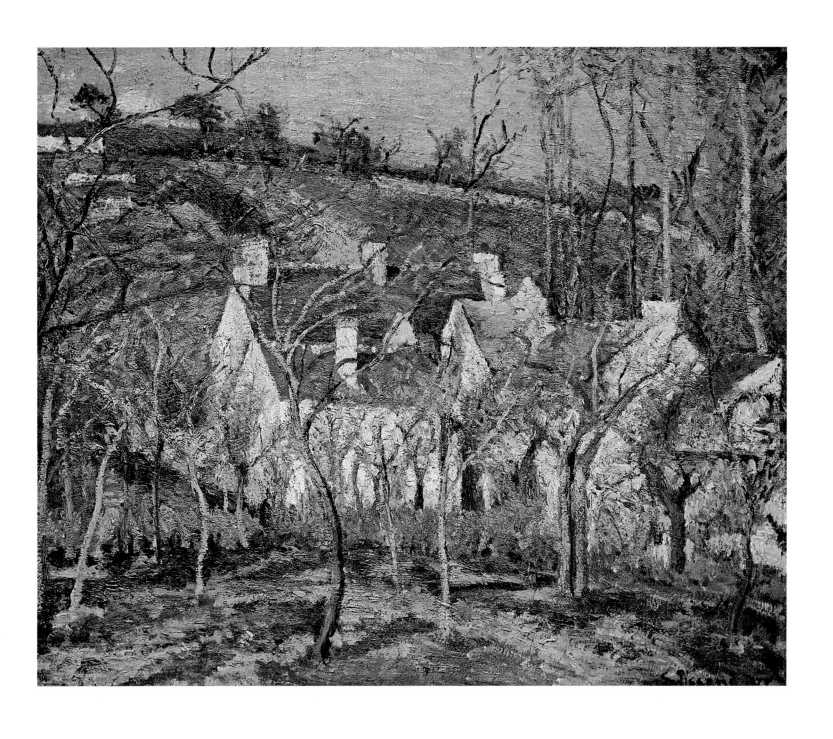

Camille Pissarro, *Red Roofs*, 1877,
oil on canvas, 54.5 x 65.6 cm, Musée d'Orsay, Paris

Perspectival Space

In their insistence that the natural optical impression be retained, Impressionist painters committed themselves to the realm of linear perspective. No aspect of the Impressionist manner of representation is subject to so few compositional alterations. Conversely, no other painterly means of depiction and expression has been so decisively influenced by the illustrative correctness and the precision of linear perspectival construction. In the landscapes of Monet, Alfred Sisley and Camille Pissarro, for all the daring freedom in the use of color and the loosest imaginable structure, the supporting framework of linear perspective retained a demonstrable correctness. This peculiarity is nowhere so clear as in the works of these painters, and in the type of Impressionism that they represent, while it cannot unreservedly be associated with the painting of Edouard Manet or Edgar Degas. This raises the question as to whether we ought to regard these latter as Impressionists of a less pronounced type, or if we should, rather, view the adherence to exact linear perspective as itself characteristic of only one sort of Impressionist painting.

The situation as it appears to us today may be described as follows: Impressionism, in the strict sense of this term, occupied only a short period in the history of artistic development, and we are probably justified in seeing the commitment to precise linear perspective as its purest expression, and in treating this as a yardstick for the concept of Impressionism as a whole. This must be acknowledged as our most important criterion if we are to grasp what distinguished the Impressionism of the later nineteenth century from the Impressionism of earlier periods, and above all from Impressionism in painting of the Baroque era – the work of Frans Hals or of Diego Velázquez. Impressionist painting of the later nineteenth century is still the most naturalistic perspectival space that

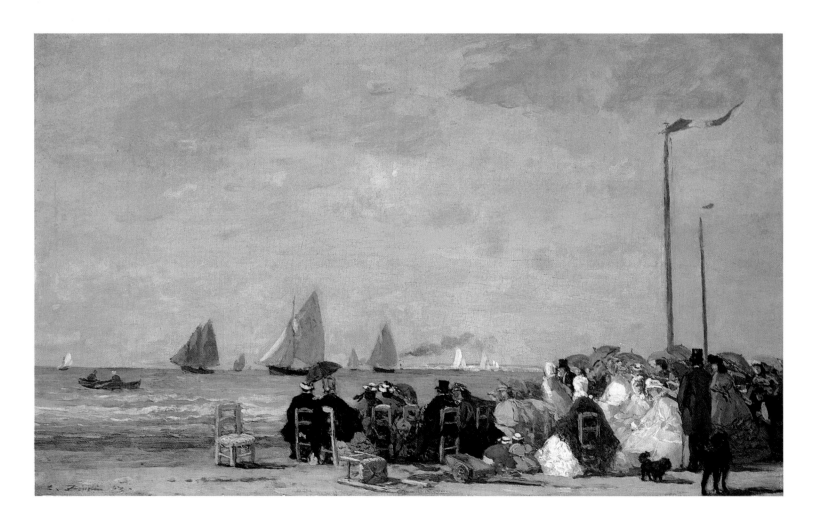

Eugène Boudin, *The Beach at Trouville*, 1863, oil on panel, 34.9 x 57.8 cm, National Gallery of Art, Washington, D.C., Collection of Mr. and Mrs. Paul Mellon

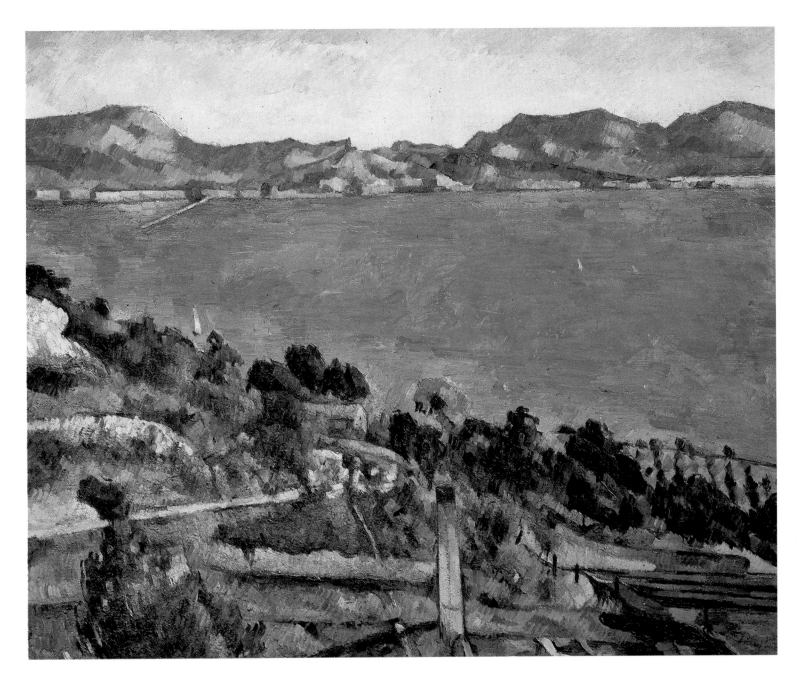

Paul Cézanne, *The Sea at L'Estaque*, ca. 1878-79,
oil on canvas, 60 x 73 cm, Musée d'Orsay, Paris

there has ever been in the history of painting. At least in this respect, it is apposite to classify Impressionism as an extremely naturalistic form of art.

Just as important as the illustrative correctness of linear perspective is the way it was employed in Impressionist painting as a matter of course. In certain individual cases we can detect how perspective effects have been altered, intensified or moderated, but the impact of such changes tends to be insignificant. The Impressionist painter never calls into question the laws of perspectival optics, of the construction of space according to the everyday experience of scientific perspective; nor, however, does he raise these to the rank of a problem. The image of space that obeys these laws constitutes the calm foundation for everything that comes into play within the picture – the manifold tensions and movements, the range of tones and colors, the interaction of light and shade.

Since the period of Impressionism a great deal has occurred as far as the creation of pictorial space is concerned. Accordingly, the question as to what the pictorial space really signifies in artistic terms has come to seem increasingly

important. With regard to new means of experiencing and creating free space and three-dimensional structure, the painting of our own century has come up with an exciting and often precipitate succession of discoveries. These have been daring and often bizarre, sometimes profound and sometimes merely playful. In comparison with all the diversity that came on the scene with the most radical of all these – Cubism – the naturalistic, illusionistic perspectival space of Impressionist painting cannot help but appear esthetically impoverished, and its stricter manifestations altogether dubious in terms of their artistic content. It should not be forgotten, however, that the illusionistic perspectival space found in Impressionist pictures was itself a new discovery, and that, in its one-sidedness, it was as dangerous as it was enticing. While this would not have sufficed on its own as the content of the Impressionist image understood in purely artistic terms, it was evidently very suited to serve as a vehicle for a novel approach to the way paint was applied to the canvas – that is to say, in small dabs of color.

The peculiarity and the power of exact linear perspective in Impressionist painting, and the position of this phenomenon in the history of art, is thrown more sharply into relief if we consider what is to be found in the work of those painters who succeeded in making the radical break with Impressionism: Van Gogh, Cézanne and Georges Seurat. However distinct from one another as personalities – and in many respects they are so different as to embody completely opposed approaches to artistic creation – these three are united in their sense of debt to the basic principles of empirical perspective in their representation of space. This is the more remarkable in that each of these three consistently and radicaly negated the spirit of painterly perspectival space as the Impressionists understood it – a break with an established system that was just as fundamental, and in essence of no less importance, than that occurring with the advent of Cubism. Of the three artists, it is Van Gogh who remained the most closely linked to the Impressionist experience of space. What he removed from the perspectival image of space as found in Impressionism was the automatic way in which it had been employed, and also its qualities of balance and calm. His own intervention lay in accentuating perspectival effects and working these up into dramatic exaggerations. Perspective, formerly nothing more than the only conceivable means by which space and three-dimensionality could be rendered visible and measurable, became, in Van Gogh's paintings, something that the viewer could feel he was experiencing directly. Of something that was in essence passive and subservient to the mystery of space and the presence of corporeal structure, Van Gogh made something active in the extreme, something that took on the independent character of an object in its own right.

This is rather more than a merely metaphorical description of the intensity of Van Gogh's use of perspective; there is indeed something special about the unbridled turbulence of his use of foreshortening and the sense of sharp recession in his pictures. In certain cases, such features have the effect of imbuing the representation of natural things with a strong sense of animation, even though this result is hardly ever intended. In essence, the turbulence in Van Gogh's work is the expression of subjective experience, restless in the extreme, but with an objective aspect to be found in the realm of linear perspective. Space, comprehended in terms of perspective, becomes a dynamic experience, and this dynamism, limited in Impressionist painting to the intensity of empirical vision, was greatly intensified by Van Gogh in a manner that recalls certain phenomena in painting of the Baroque era.

One would not be justified in classifying this sort of intensification as a radical breakdown of the principles of linear perspective. Nevertheless, the excessive turbulence also brings with it certain types of deformation, that is to say fundamental alterations in the perspective image: we discover enlarged angles and forms that are atrophied or fractured. By this means, Van Gogh's use of perspective departs so defiantly from that of Impressionism that even his pictorial space becomes the space of another, entirely new world. For this reason, a view of plowed and planted fields by Van Gogh is at least as deeply distinct from an Impressionist picture with a related subject as this, in turn, from the image of space in pre-Impressionist landscape painting – the academic construction of space in a landscape by Jean François Millet, for example, or the space arranged in strata that is to be found in the work of Gustave Courbet.

The diametric difference of personality between Van Gogh and Cézanne is probably nowhere more apparent than in the way each artist uses linear perspective as a tool of pictorial organization. One encounters the new ordering principle in Cézanne's painting most readily in the parallel arrangement across the picture plane of the smaller blocks of form within the image, and one inevitably overlooks how often Cézanne also incorporates receding diagonals and sharp foreshortenings, that is to say the formal devices fundamental to Impressionist cropping. Cézanne's own transformation of perspective occurs

Claude Monet, *Garden in Vétheuil*, 1881, oil on canvas, 150.5 x 120.3 cm, National Gallery of Art, Washington, D.C.

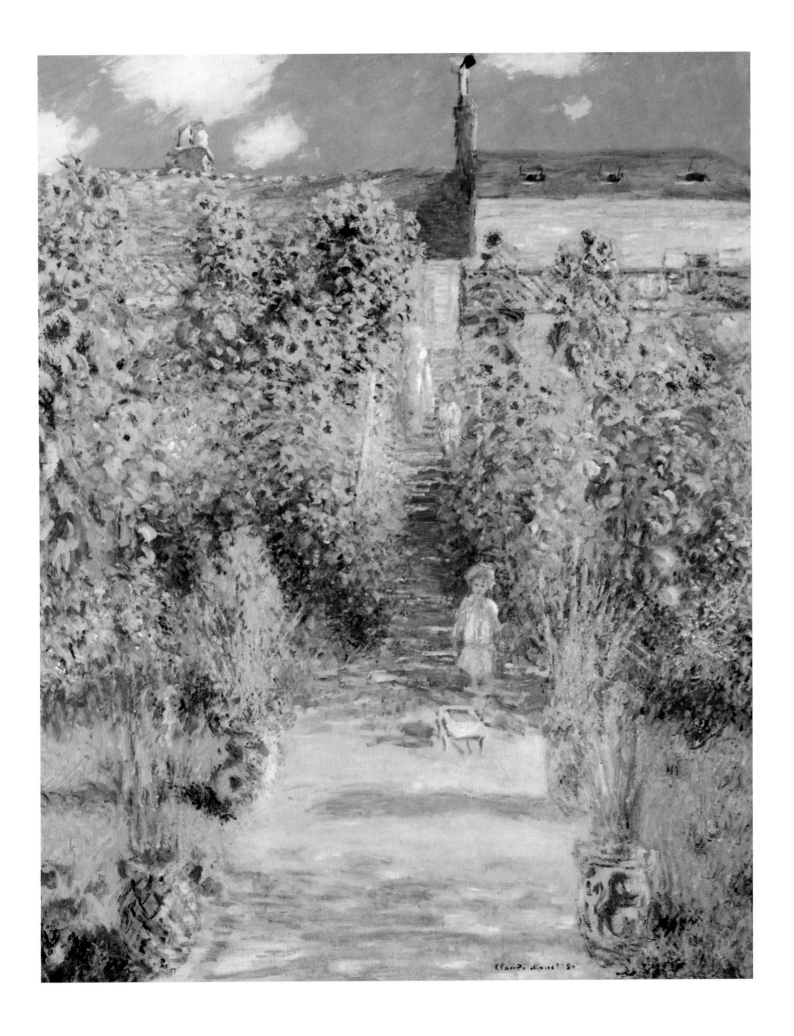

in another more complex and more concealed manner. In every case it results in a weakening of perspectival intensity, a slowing of movement and a lessening of tension in comparison with the overall effect of Impressionist perspective. Although not appearing so on the surface, this is no less a break with what came before than is the quite distinct type of transformation of perspective in the work of Van Gogh – it is, indeed, more far-reaching in that it signifies a devaluation of perspective.

In the pictorial space found in the work of Seurat, at least in his landscapes, perspective assumes a similar role in so far as here too the underlying framework of the linear perspectival construction is retained, while perspective itself is, on the whole, deprived of any vitality. In the work of Cézanne this transformation occurs through a reduction in the natural tensions and movements, through a *weakening* of perspectival sensation; but in the case of Seurat it occurs through a process of *stiffening*. In all three cases one could say that exact, empirical linear perspective is only present in order to be overcome. The character of perspective in pure landscape Impressionism thus becomes much clearer in comparison with what followed, be it the exaggerated, over-heated liveliness and the animated perspective of Van Gogh's work, or the cooling and stiffening of perspective in the paintings of Cézanne and Seurat. At the same time, these forms of variation and rejection reveal their own historical function.

Measured against such examples of Post-Impressionist painting, the true-to-nature linear perspectival conception of space in Impressionism appears prosaic and lacking in any intriguing uncertainty. Impressionism fulfilled only to a relatively modest degree the task of heightening the sense of artistic transposition, fascination and mystery, in so far as these were already contained within the experience of real perspective; and so there is little to be said about the overall perspectival arrangement of Impressionist pictorial space. All that emerges as remarkable in this respect is the choice of surprising forms of cropping, the sharp view down on to some subjects and comparable perspectival effects of the sort that entered European painting through the innovations of those Impressionist painters working under the influence of Japanese art.

It should here once again be emphasized that, in less strict forms of Impressionism, above all those of the early and the late phases, departures from the principle of a "neutral" linear perspective of an extremely naturalistic stamp are encountered often enough. Manet, for example, for reasons of pictorial composition in his history painting *The Execution of the Emperor Maximilian* (illus. p. 31), did not shrink from a blunt contravention of perspectival correctness: the direction of the rifle barrels in this picture is such that the soldiers could not possibly hit their target. (And this in a work of such a markedly Impressionist spirit that nothing of the horror of the event – which was, indeed, ineffable in the language of Impressionism – finds expression.) Elsewhere, even in "pure" landscape Impressionism, the strict neutrality of scientific linear perspective is often not observed, succumbing to the greater strength of the demands of pictorial construction or the manifestations of a perspective determined by emotion. On the whole, however, such infringements may be regarded as exceptions that prove the rule.

In its historical function, the perspective of Impressionism is located between the reasonable, traditional laws of composition of the subordinate space construction found in Realism after the 1850s and the types of transformation that have just been described, with which, in the 1880s, some of the founders of modern painting opened the way for new discoveries. The innovations of this period had various qualities in common with forms of pictorial space both from the era immediately before the advent of Impressionism and from more distant eras. There is, for example, the similarity between Van Gogh's vehement form of perspective and the effects of space in the painting of the Baroque era, or that between pictorial space in the work of Cézanne and that of the Classical Baroque. As a whole, however, we can say that it was at this time that the foundations were laid for every sort of artistic daring, much of it quite unprecedented. The fact that scientific perspective is not denied even in the work of the pioneers of the new art (where it is, rather, outwardly retained) attests, in turn, to its power and its historical significance in Impressionist painting.

Out of the carefree, essentially unproblematic naturalism of Impressionist perspective, these innovators derived a means of opening up the mysteries of space. These mysteries were also found to offer possibilities for new spiritual expression, as in the art of Edvard Munch or Henri de Toulouse-Lautrec. In some of the later work of Degas, who may in general be regarded as an adherent of Impressionism, the coolly precise form of Impressionist perspective already appears to us to be interspersed with something excitingly novel. Van Gogh, on the other hand, when he had long ceased to be an Impressionist, and increasingly towards the end of his life, employed forms typical of Impressionism, such as close cropping. This same feature of unexpected and foreshortened focus has an effect that varies according to the context established by the other means of representation and expression that an artist may employ. In the work of Degas, it offers us an instance of Impressionism on the point of being transformed out of all recognition by means of extreme forms of exaggeration; in that of Van Gogh it is encountered as the last clear echo of the Impressionist treatment of space.

Light

In Impressionist painting there is a second element – the representation of light – that, in no less a measure than linear perspective, constitutes an aspect of precise naturalism. The two are not, of course, to be understood as belonging to the same conceptual category: while perspective is a means of representation, light is a goal, one aspect of the content of representation. This element of imprecision in our method is perhaps allowable, if only because it helps to draw attention to the principal means of rendering space with a minimum of artistic transformation of the subject as observed – the linear perspectival arrangement of the picture as a whole. The same thing cannot be established, to the same degree, of Impressionist pictorial space, while in the case of light the situation could be described as the reverse. In this case, the desired result – the strongest illusion of reality – is achieved with means that generally reproduce the actual appearance to an extreme degree, namely the micro-structure of the picture – the way in which brush and color are employed. This is a crucial point in the definition of Impressionist painting and a fundamental principle of Impressionism, one that also has other possibilities of articulation.

It would be very simple indeed to emphasize the degree of reality in the representation of light in Impressionism by means of a comparison with what is to be found in later painting. The negation of the rendering of light in Post-Impressionist painting is even more striking than is the negation of scientific perspective. One could say that the rendering of light is almost entirely limited. While, for the Impressionists, light was paramount – one could almost call it the central subject of Impressionist painting, at least the most important *conscious* subject – in the painting that followed Impressionism light was no longer deliberately represented.

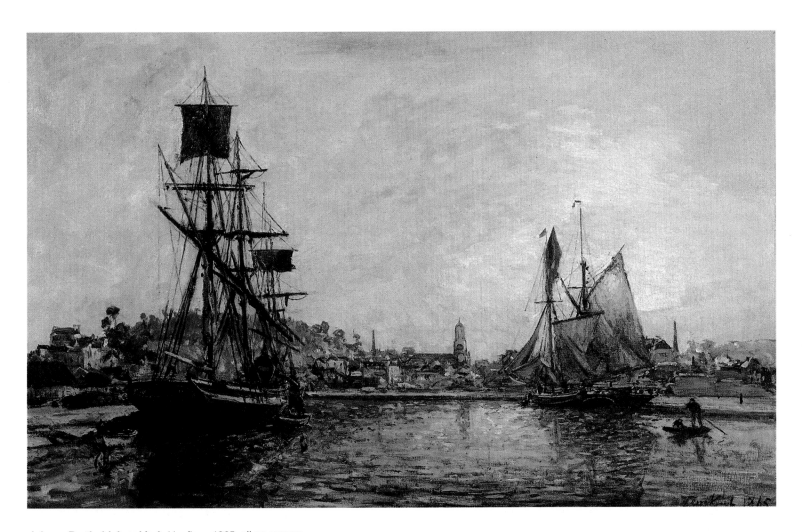

Johann Barthold Jongkind, *Honfleur*, 1865, oil on canvas,
52.6 x 82 cm, The Metropolitan Museum of Art, New York

This does not, of course, mean that light as a phenomenon and as an experience played no part in the work of the great vanquishers of Impressionism. Van Gogh, who so frequently showed the sun in his pictures, spoke often enough of the rendering of light. If, however, one turns to those pictures that Van Gogh had in mind on such occasions, one is confronted with a discrepancy reminiscent of that between the painting of Giotto and the "new Realism" that his contemporaries discovered and celebrated in the artist's work. This is to say that, in the process of spiritualization that may be said to take place in Van Gogh's work, an illusionism reliant on light effects – and above all modeling and cast shadow – is either extremely limited or is altogether absent. Light is present only in the form of an all-embracing colored brightness. In a picture by Van Gogh such as the grandiose late landscape of *The Plain at Auvers-sur-Oise* (illus. p. 110), we can still trace the connection with Impressionism in terms of perspective, but in the magical, curiously rigid brightness of this landscape, we detect hardly anything of the character of light that fills Impressionist landscape paintings. The situation is not very different with regard to the illusionistic capacity of light in the painting of Cézanne. Where there is something in his pictures approaching a representation of light, where there appears to be light and shadow, these are really only a sort of memory; they are phenomena with an outer resemblance to what is past and what is familiar but with a wholly new meaning which is never in doubt.

Alongside this radical rejection of the representation of light, there were also less striking departures from the sort of naturalistic illusion found in Impressionism. These can be seen in Pointillism, in the late phase of the work of both Edgar Degas and Auguste Renoir as well as in Pierre Bonnard's fantastical employment of light.

In Impressionism, exact spatial perspective and the precise rendering of light correspond to each other; they belong together like two sides of the same coin. As with perspective, exactitude in the observation and painterly rendering of light was an extreme development in the history of painting. The parallel with perspective here also extends to the fact that in the work of the leading painters of French Impressionism the greatest naturalistic illusion of light was a characteristic of mature and late phases of relatively short duration. This can be traced as clearly in the development of the work of Manet as in that of Monet, Degas, Sisley and Pissarro. With regard to the general illusionistic effect, there is hardly more to say on the extreme rendering of light in these painters' pictures than there is to be said on their use of perspectival illusion. In contrast to the naturalistic perspective in Impressionism, however, the Impressionist rendering of light represents a real historical terminus.

The scientific perspective of Impressionism may be defined as unnaturalistic when considered in terms of its position in art history: it was preceded by approaches to the construction of pictorial space that are restrained, realistic, academic or Romantic and followed by the wide range of possibilities to be found within Post-Impressionism. It has, moreover, to be recognized as itself only one possibility among very many. In contrast, the subject of light, notwithstanding its long antecedents in painting, found but a temporary terminus in Impressionism. This was, none the less, a glorious terminus, with a sense of fulfillment and apotheosis. Yet before we inquire into the painterly approach that turns this fulfillment into an *artistic* phenomenon, we should note several salient factors about the treatment of light in which the spirit and philosophy of Impressionism become manifest.

The fact that light was the principal subject, effectively the subject, of Impressionist painting not only reduced to insignificance the importance of plasticity, the presence achieved by three-dimensional masses and bodies. In essence, and as a final consequence that Impressionist painting soon realized, it reduced the importance of the individual entities themselves, of the totality of individual structures making up the world of visible reality. As a result of this development, in the second half of the last century a dilemma crucial to all artistic representation assumed a new guise. Over the course of history the artistic preoccupation with the individual being and the individual thing has been repeatedly subordinated to the struggle to make visible some overriding entity. In certain periods it has been possible to define this superior form as the transcendental content of a religious idea. In the art of the West the subordination of the individual being within the universal harmony of the spirit was never more evident than during the centuries of the Early and High Middle Ages; and the contrast with an art focused on the individual object was never sharper than at the dawn of this medieval spiritual world, at the end of Antiquity.

It was only recently that these first signs of the no-longer-Classical came to be appreciated as something positive rather than merely as phenomena associated with the decline of the artistic sensibility of Antiquity. As art historians at the start of our century first approached a genuinely historical understanding of these revolutionary forms of artistic expression, there occurred a comparable intellectual upheaval in contemporary society. Strictly speaking, this had come about slightly earlier, when the foundations of a new art were established (albeit as yet unacknowledged and without any obvious impact) through the achievements, during the last blossoming of Impressionist painting, of Van Gogh, Cézanne Seurat, Munch, and Paul Gauguin. Just as the heightened illusionism of Impressionist painting served as the immediate precursor of a new

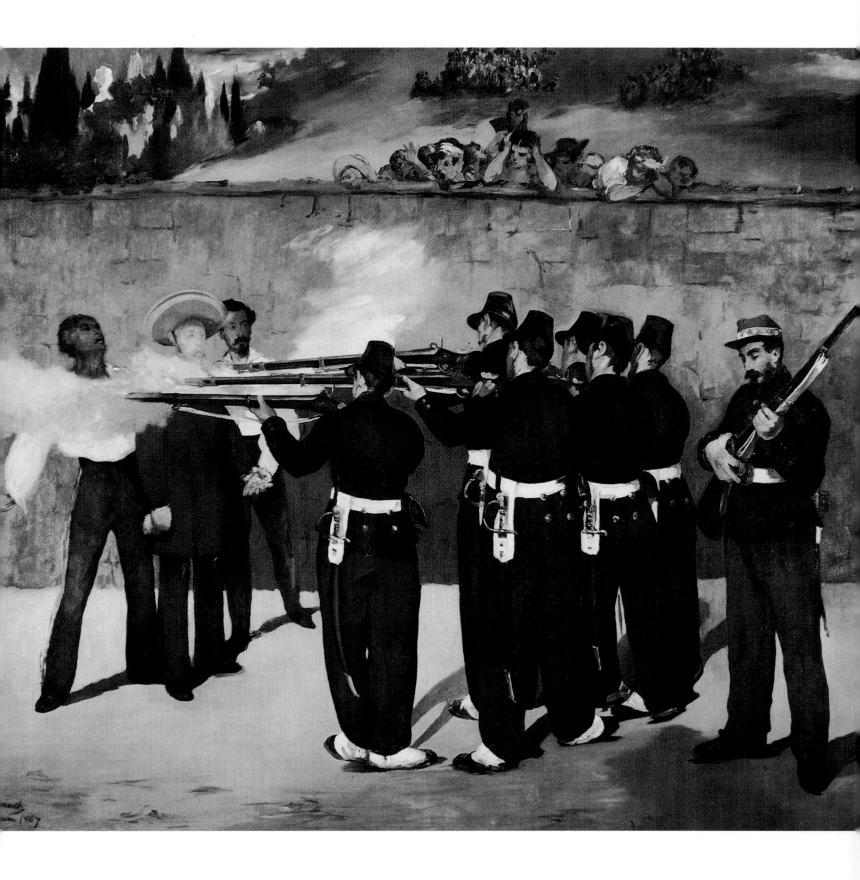

Edouard Manet, *The Execution of the Emperor Maximilian*, 1868/69,
oil on canvas, 252 x 302 cm, Städtische Kunsthalle, Mannheim

form of art, so the phase of Late Antique illusionism may be seen to have intervened between Classical Antiquity and its blunt opposite – early Christian medieval art.

When the peculiarity of the illusionism of Late Antiquity was rediscovered around 1900, little attention was at first paid to the striking evidence of innovative alien forms already appearing in it. Thus, the first art historian to analyze the illusionism of Late Antiquity, Franz Wickhoff, illustrated his argument by reference to the miniatures of the "Vienna Genesis," without attending to any of the features that were wholly alien within this work from the Early Middle Ages. This was, None the less, something other than a mere oversight or the excited over-estimation of an item only recently discovered. Wickhoff's argument also expressed an intuitive recognition of those qualities that, in spite of everything, could be seen to link two exceedingly different approaches to art. Much the same could be said to occur when the work of Cézanne and Van Gogh is included in text books and other art historical accounts of Impressionism. This is a "mistake" that masks the underlying recognition of a fundamental characteristic that is common to both Impressionism and to a considerable amount of Post-Impressionist painting: the repression of the value of individuality as a result of an emphasis on something superior.

It is much harder to define what this superior entity in painting since Impressionism is than, in the case of the art of the Middle Ages, even though its impact on the form of the individual entity is now so often much more radical than it was in medieval art. Here we are concerned with Impressionism and what it was in Impressionism that prepared the ground for every subsequent threat to an impartial, secure world of appearances with its individual phenomena. This element of the supra-individual in Impressionism seems at first to require no interpretation: light and atmosphere are, after all, elements of reality that can be depicted, they are indeed material entities. Long before Impressionism, however, these had both been employed by painters in such a way that neither corpo-reality nor the individual independence of things was compromised. When this begins to occur in Impressionist painting both depiction and illusion begin to loose their significance. Simultaneously, it becomes evident that the arbitrary individual characteristics of light are of much less importance than its role as a universal value, and also that the artistic character specific to Impressionism is to be found in the expression of this value.

The idea with which we are here concerned – though it certainly cannot be called by a single name – arises, above all, in connection with the Impressionist conviction that painting had to limit itself to rendering the visible. As a result of this limitation, much more was excluded than would at first appear. This was not only an exclusion of every sort of intellectual content with regard to what was represented. What was being excluded, at least in principle, was every experience and every understanding of reality that had its starting point in the individual being and the individual thing. Not only were these no longer objects of interest, through which an experience of the world might be conveyed to the viewer, they were no longer even understood as the smallest unit in the construction of the world of visual phenomena. This world now evinced a sort of molecular structure. It is for this reason that Impressionist painting has so often been defined as a form of painterly symbol for the molecular or atomic structure of the world. As such, it would of course only be a metaphor for the knowledge and the belief in such a structure, for it has no relation to what can be empirically experienced, and in particular, visually experienced. It stands, indeed, in the sharpest possible contradiction to every sort of naturalism.

Of course, only a seemingly slight step was required, as was to occur in the progress to Neo-Impressionism or to the strictness of the Pointillist system, for the metaphor to give way to the image of invisible realities. This state of affairs, this lightning change from the illustration of sensory phenomena to the stellar coldness of a non-sensual world of the imagination, has a logic characteristic of Impressionist painting. Impressionism, however, through its concentration on the effects of light and atmosphere, discovered the possibility of taking a curious middle path. The solid individual structure might become a complex of colored spots, the human face, and with it the whole human image, be reduced to a mere colored blob, the intrinsic value of the individual entity be accordingly reduced, and its significance altered. As long as these very telling alterations to each of the details contributed as a whole to the rendering of light and atmosphere, the overall naturalistic effect could remain entirely intact. In the final phase of pure Impressionism, this was ultimately to provide a path back to observed reality.

As long as the "veil" of brushmarks was constituted in such a way that it functioned as a projection of the phenomenon of light, a great deal of painterly transformation of reality might take place in the details. In the end, according to the more or less explicit theory of Impressionist vision, everything was a function of light. So firmly is the whole power of illusion based on this all-embracing element – and on the correct application of linear perspective in its restrained sobriety – that the sacrifice of the content of reality that this implies is not immediately noticeable. Such a sacrifice, a really drastic departure from the normal impressions of vision, is to be found in the aerial perspective of Impressionist painting. In its immediate foreground, the Impressionist picture is treated with the same device of a dissolved, vibrating structure of brush marks as is to be found in the furthest distance. This represents a

Berthe Morrisot, *The Port of Lorient*, 1869, oil on canvas, 43.5 x 73 cm,
National Gallery of Art, Washington, D.C., Ailsa Mellon-Bruce Collection

substantial intervention into the illustrative correctness of the
picture space. If this intervention cannot impair the overall
illusion, it is because of the power implicit in the vibrating
liveliness of the whole picture surface. This is the expression
of the life of the light and atmosphere; and, where Impres-
sionist painting attained its true greatness, the illusion of this
vitality was sufficiently strong to function as the expression
of the omnipresent, ever-flowing life of nature as such.

This shimmering light in Impressionist painting is "sym-
bolic form," and the dynamism of the small formal structure is
its true source of life and movement. It is this that is the real
triumph of Impressionist art – a triumph much more crucial
and much more telling than the virtuosity in the representa-
tion of the movement of living bodies that is also associated
with Impressionism. It is true that the Impressionists achieved
something unprecedented in the rendering of the transient,
but this signifies only an intensification in the degree of na-
turalism, just as Impressionist linear perspective observed an
extreme degree of precision. The movement of the human or
animal body, as a movement of the individual being, is not

as specific to Impressionism as is the movement of light and
atmosphere.

With this we come to the root of the artistic articulation
of Impressionism, to the means employed to construct the
Impressionist image out of a number of small parts. It is not
always easy to perceive the full significance of the role or the
intensity of this method on account of its use to illusionistic
ends. Here too, it helps to look forward, to the first signs of
a turning away from a naturalistic intention in the art that
followed. Such signs are nowhere so clear as in instances of
the reduction in the rendering of light. We have already con-
sidered a complete contrast to Impressionism – one of the
late landscapes of Van Gogh. As we have seen, the decon-
struction of the Impressionist manner of rendering light also
took on a more gradual form, as in the work of Seurat and
that of Cézanne.

In essence, even the least departure from the illusion of
light signified a fundamental turning point. If light as a subject,
the illusion of light, as a naturalistic anchoring, was omitted,
what would then remain if the molecular picture construction,

Edouard Manet, *The Rue Mosnier*, 1878,
oil on canvas, 64 x 80 cm, private collection

which destroyed the individual value of entities, were retained? One result might be the reintroduction of new, large-scale elements of construction, and in the case of both painters, this did, to some degree, happen. These new elements – Seurat's use of a new pictorial framework and Cézanne's provision of summary outlines and volumes for his figures – only apparently secured a new value for the individual entity within the picture as a whole. There could be no real return to the object. The step out of a world of objects and into a world of elemental phenomena, the step taken by Impressionism, was

not only a step that its immediate successors – Cézanne and Seurat – failed to retrace, but one that, in the painting of both masters, was further developed.

At first, it is true, we seem to be confronted with an absolute contrast between Impressionism and Post-Impressionism in this respect. The Impressionists, sought to retain the illustrative aspect in their representation of individual entities, even in the face of the destructive power of the small-scale construction of their pictures. Thus, the smudge of color, resistant to interpretation in itself, becomes, in the context of the overall

image, a figure defined with disconcerting exactitude, or a house standing in landscape at a precisely determined distance. Astonishing effects of this sort, this constant to and fro of the cancellation and simultaneous creation of individual entities, may indeed be said to constitute a defining characteristic of the Impressionist method.

Cézanne's pictures, on the other hand are full of peculiar visual phenomena which cause individual entities – largely clear, recognizable, and separable from each other – to lose their illustrative clarity within the context of the overall composition. Everywhere there are deformations and obscurities. In Seurat's painting the restriction of the illustrative value of the individual forms is of an entirely different kind: it does not at all appear as an obfuscation. Yet his geometrizing simplification of the represented structure leads to a comparable result: neither living nor inanimate things retain their full validity as individual entities, nor do they have the weight and the corporeality that is often attained by their counterparts in the painting of our century.

At first, the renunciation of the illusion of light was necessarily perceived as a process of draining, cooling down after the vibrating life of the Impressionist pictorial universe. There was now no means of returning to the sense of an overriding, ever-present, real medium. With all the connection and subordination of its parts, in the Post-Impressionist picture the illusion of real space and natural light could be no more than an unavoidable side-effect. The system of the subordination and interrelation of the parts now functioned as a "symbolic form" – no longer for something tangible, the light-filled atmosphere, but rather for the spiritual reality of the underlying powers that give order to nature.

It is certainly open to debate how far this reduction in the illusionistic character of painting was a loss and how far it was a gain. Without doubt, however, one may define it as a process of *spiritualization*, relative and simply logical, though this is not to make any value judgment – in contrast to the "unspiritual" character often associated with Impressionist painting. With certain reservations, Impressionism is indeed unspiritual, both in terms of its own principles and in comparison with other approaches to painting. None the less, we cannot, without further ado, term an Impressionist work such as a flower painting by Manet more "materialist" than one by Cézanne, for its element of naturalistic illusion also incorporates something spiritual. The difference between the two lies, rather, in the fact that Manet's picture hovers somewhere between pictorial illusion and construction, on a tack that the mainstream declined to follow.

There was a constant danger in the preponderance of illusion in Impressionist painting. Yet it is fundamental to Impressionist illusion that the image is less material than at first meets the eye. This is less easy to detect in the rendering of light (it being hard to assess) than in that of texture (where the artist's fidelity to visual and tactile experience is easier to gage). Nevertheless, a more thorough consideration of this aspect of Impressionism reveals a surprising unevenness of attention and inconsistency of technique in the characterization of material and its surface, even though these are rarely apparent in the overall effect. In this matter too, the repression of the individual entity as a result of the predominance of light had a crucial impact. If everything is understood as a structure created by light, only *one* material requires precise characterization – the air itself. It is instructive to consider the Impressionist representation of the surface of water, concentrating on its lively glitter, and to ask how much of the essence and how much of the material quality of water is conveyed by this means. Invariably one will find a good deal of the former but very little of the latter, certainly less than is readily to be found in the realistic painting of the period *before* Impressionism. Similarly, if we compare an Impressionist flower piece with one produced earlier, starting with the Netherlands in the seventeenth century, we find that the Impressionist painter not only applies an entirely different system of representational optics in achieving a comparable feeling of the material nature of his subject, but also that his attention is much less evenly spread within his virtuoso shorthand technique. Far more, for example, is expressed of the structure of the petals than of the appeal of their surfaces.

This high degree of perfection attained by the selective application of illusionistic abbreviation is a crucial element in the naturalism of Impressionist painting. This particular form of shorthand consisted not only in bestowing conviction on effects of natural phenomena without going to the trouble of representing these in any detail or clarity, but also in contriving to make other effects disappear entirely without anyone noticing. By this means Impressionist painting may be said to have embarked on a "secret" process of reduction that was of great significance for the painting that followed, and which was only reversed much later, and then only in Surrealism and *Neue Sachlichkeit* (New Sobriety).

The Means of Pure Form
Impressionist Micro-Structure – Color – Line

The highly ingenious artistic system of illusion in Impressionist painting ultimately depends on two types of purely formal structure: the structure of marks created by the visible pattern of brushstrokes and the structure established by color relations. The "purity" of such formal structures is of a special kind, considering that their value for Impressionism lies in their contribution to illusionism. Impressionist painters aimed to evolve a system that combined the highest degree of illusion with a new awareness of the picture plane, for the painted image

had also to be effective there. In this respect, these painters, however innovative, may be seen to have adopted and adapted elements from a long artistic tradition, most readily associated with painting of the Baroque era beginning in the sixteenth century. The most striking outer aspect of this type of painting, with its clearly visible structure of brushmarks and its particular use of color, is the increasing elimination of modeling. In the art of the Baroque era, as is well known, there are numerous examples of painting in which modeling was negated and the image functioned on the picture plane. The Impressionists were therefore able to take their cue from some very important predecessors, from Titian to the artists of the late eighteenth century.

In general, Impressionist painters pushed such emphasis on the picture plane to an extreme, this tendency finding its ultimate embodiment in Pointillism, which went so far as to sacrifice illusion altogether. At the beginning of Impressionism, however, in the early works of Manet and Monet, one finds two approaches to emphasizing the picture plane: alongside

Claude Monet, *The Cathedral of Rouen at Midday,*
1894, oil on canvas, 100.4 x 66 cm, National Gallery of Art,
Washington, D.C., Chester Dale Collection

Claude Monet, *The Cathedral of Rouen at Midday,*
1894, oil on canvas, 100.2 x 66 cm, National Gallery of Art,
Washington, D.C., Chester Dale Collection

works characterized by the negation of modeling and the dominant presence of the small-scale pattern left by the brushstrokes, there are others in which one encounters large, homogeneous silhouettes. While the aim of both approaches was the same, in the generally later style involving the microstructure, it was sheer technical bravura that played as much of a role as any intellectual ambition.

Nowhere is the peculiar complexity of Impressionist painting more evident than when we consider what the picture plane signifies in the terms of spiritual expression. During the actual process of painting the important role of the picture plane may well have been less consciously borne in mind by the Impressionist painter than it was by painters used to working in terms of any other system of pictorial organization. Each brushmark remaining visible added great density and intensity to the planar structure. The eternal dual nature of the picture plane in all forms of representational painting – which is simultaneously the screen on to which an illusory space is projected and the vehicle for the construction of an image

functioning in two dimensions – is charged with a new sort of tension; and this came within a hair's breadth of giving the picture plane an altogether new meaning and value.

This was already happening in the work of Cézanne in the late 1870s. Here, the traditional balance between pictorial space and the picture plane underwent an uncontrollable, yet subtle shift in favor of the latter, which thus acquired a new "weight." Such a change is another aspect of the process of spiritualization, of which we have already spoken. Whenever greater significance is accorded to the picture plane this points to the predominance of formal structure and of formal relations. A picture by Cézanne cannot be experienced as one experiences an Impressionist work, that is to say only in terms of illusory space; it no longer contains this illusory space even where it continues to rely on the Impressionist system of projection. While it only required a small step to progress to this state of "enchantment," this was a step that signified a complete upsetting of the pictorial universe of Impressionism. In taking this step, Impressionist painting came closest to the

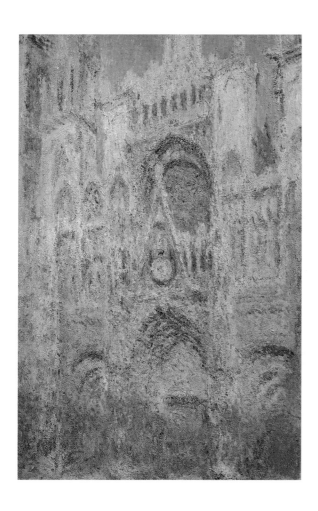

Claude Monet, *The Cathedral of Rouen in the Evening*, 1894, oil on canvas, 100 x 65 cm, Pushkin Museum of Fine Arts, Moscow

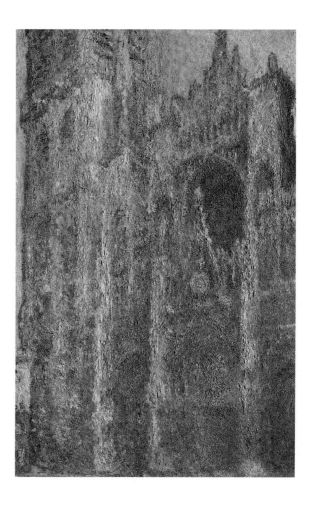

Claude Monet, *The Cathedral of Rouen at Midday*, 1894, oil on canvas, 100.1 x 65 cm, Pushkin Museum of Fine Arts, Moscow

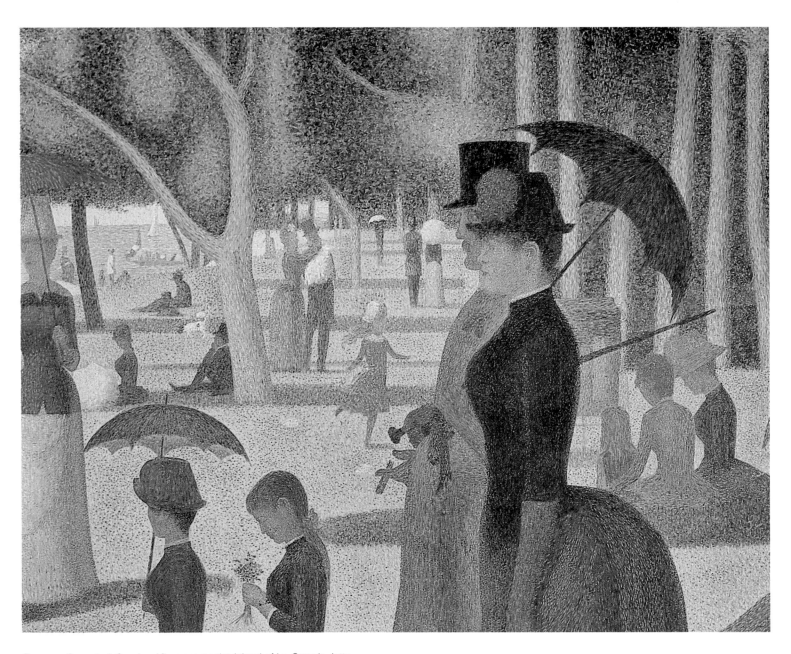

Georges Seurat, *A Sunday Afternoon on the Island of La Grande Jatte*,
1884-86, oil on canvas, 207 x 308 cm, The Art Institute of Chicago,
Hellen Birch Bartlett Memorial Collection

new way of seeing and forms of pictorial construction of the
"modern" painting that followed it. In painting after Impres-
sionism, the retention of the system of perspective is an echo
of the past while the renunciation of the representation of
light is a break with the past, and the limitation of illusion is
an intellectual turning point in the overall conception of picto-
rial content. The increasing visibility of "pure" forms and their
growing power in Post-Impressionist painting are entirely logi-
cal consequences of changes initiated within Impressionism.

The Impressionist use of color, and its approach to con-
structing the image out of the visible marks left by the brush-
strokes cannot be separated. Even if one were to attempt to
distinguish these two elements of the formal language of Im-
pressionism, it would be impossible to decide which of the
two played a dominant and which a subservient role. In being
a structure made out of brushmarks, the Impressionist image
was a structure made out of *colored* marks. In as far as Im-
pressionist brushmarks responded to the dictates of the illu-
sionistic rendering of light, color had also, by implication, to
be naturalistic. Here, there emerged a tension, typical of Im-
pressionism, between the true-to-nature illusion of the overall
effect and the often highly unnaturalistic character of the

means used to achieve this. Unlike the other sorts of tension we have already noted in Impressionist painting, this was one that Impressionist painters consciously employed, it became a basic principle that they claimed as their particular achievement and is recognized as their most striking discovery: the principle of the division of color.

In employing the division of color, the Impressionists drew on discoveries and theories in the realm of physics and optics, and this encouraged contemporaries to characterize their work dismissively as scientific and rationalistic. Although justified, this claim had little significance; as an apologia of no more value than the many comparable empty criticisms in the course of the history of art. In itself, of course, the division of color was not an artistic principle. The way in which it was employed, above all in French Impressionism, is a shining example of the artistic exploitation of rational insight.

It is not easy to say how far the fundamental principles of the division of color had already been applied in earlier painting or, accordingly, to distinguish which aspects were most characteristic of the Impressionism of the nineteenth century. It is, however, easy enough to point to one fundamental characteristic of the coloring of Impressionist pictures: its overall brightness and, in direct relation to this, the pronounced brightness of the tones used for shadow. It should at this point be added that the elevation of coloring itself into a principle is a thoroughly artistic process, and not one that follows at all naturaly from optical experience.

The situation is not very different with another salient characteristic of Impressionist color theory – the denial of local color. It is surely a demonstrable fact that the color of every object alters with changes in the light, so that, strictly speaking, no such color remains constant. From the point of view of ordinary experience, a type of painting that recognizes only atmospheric colors, instead of local colors – so treating objects as no more than the projection of the energy of light – clearly accommodates aspects of the fantastical and the unreal, however strong and precise the illusion may be as a whole. Ultimately, Impressionist color theory is informed by artistic rather than scientific discoveries.

At whatever point in one's analysis of Impressionism one seeks to get to the essence of the defining peculiarity of the Impressionist use of color, one discovers the crucial role of considerations of pictorial construction. In this context color is seen to embody two distinct functions. The first is purely formal and is derived from the role of color in the composition as a whole, whereby color as an element of pictorial composition is clearly comparable with musical composition – the illustrational value of individual colors being completely irrelevant. The only important thing, here, is the overall color effect – a criterion of value in all genuine painting. The

second is the illustrational, with color functioning as a crucial aspect of the pictorial reproduction of observed reality.

Between these two extremes, there is a third function of color, its use deriving from the acknowledgment that certain experienced visual effects can only be conveyed within a picture by means of an intensification of the element of color, by means of exaggerated brightness. The most celebrated and most striking practical application of this insight is the principle of the division of color, of "Divisionism." This method emerged in Neo-Impressionist painting, where the concern was to attain the greatest possible intensity in the representation of light, a goal that could not be achieved in any other way, however bright the colors employed. This process was the most radical instance of a more general development: the resort to unnaturalistic color prompted by the desire for an ever more naturalistic result.

Similarly, an exaggeration of color is often the only means by which to establish the desired relation, in terms of both space and movement, between the individual parts within a composition without undue sacrifice of either realism or intensity. The blue of the sky, exactly copied by the painter, is not sufficient in every context to achieve the intended naturalistic effect, and the precisely rendered modelling of an apple lying on a table does not guarantee the full impact of its solidity. In such cases a painter may alter, and above all differentiate and exaggerate, the colors of his subject as a means of ensuring that the desired intensity is not lost as experienced phenomena are transformed into pictorial phenomena.

The type of color to which painters resort to this end is not one they have observed in nature, nor is it an invented color, a color incorporated into the picture purely for the sake of expression or of compositional harmony. Its role may be seen to stand mid-way between the formal and the representational. To some degree, as painters themselves have so often emphasized, the colors of this "middle" type are derived from the scientific analysis of visual experience, above all experience of the complementary colors at the tonal extremities and of their impact on our perception of space. Colors employed in such a way are often very far from those directly encountered in the real world. The painted green outline that throws a red apple into relief against a neutral background stands at some distance from an observable natural phenomenon. It is a color that derives from the painter's experience that the optics of actual vision must undergo a transformation in becoming the optics of the picture.

One might call this fundamental aspect of the painter's use of color "color as necessity," a category distinct from both "color as pure form" and "color as illustration." Only this last type is related, under any conditions, to the individual object as found in the real world. "Color as pure form" may retain

some such relation, but this would be incidental to its principal purpose. "Color as necessity," however, could be described as serving to convey the relation between individual entities rather than as a characteristic of any single one of them. As a result of this relative independence from the individual object, this form of color can also very easily function as a formal value within a composition, in the service of chromatic harmony. Its position mid-way between the two other functions of color means that it can effectively mediate between the spiritual and the material aspects of the role of color in a composition.

To some extent, these observations on color might be regarded as relevant to all types of painting. It is true that some element of the conscious intensification of color is to be detected in all painting that belongs to the tradition initiated by the Venetians of the sixteenth century – a tradition to which Impressionism itself belongs. Such intensification of color is even to be found in some entirely unnatural forms of representation, as in certain types of art from the Early Middle Ages and in Byzantine mosaics. The principle of intensification is not, however, universally valid, nor is it even valid for every type of "painterly" painting. Wherever line, chiaroscuro and plastic modeling are especially important in pictorial construction – as in the painting of the fifteenth century – there is little scope for that form-creating function of intensified color.

The Impressionists were not, however, the first to draw attention, clearly and programatically, to the significance of this function of color. When Paul Signac, in his essay of 1899, "D'Eugène Delacroix au Néo-Impressionnisme," theoretically expounded and justified the basic principles of Neo-Impressionist Divisionism, he took as his starting point a selection of Delacroix's observations on color. In these he saw a model and a formulation of almost all of his own theory. Anyone seeking to study the application of the theory of the division of color, and the use of contrasting and complementary colors by reference to the paintings produced by Delacroix, by the Impressionists and by the Neo-Impressionists, will soon learn that such laws are only the doctrinaire simplification of much more complex processes.

Common features here are the brightness and colorfulness of shadow, the elimination of modeling in dark tones of relative colorlessness, and the increasing brightness generally, althoughl what is new in the relations between colors themselves can only partly be defined in terms of the system of a division into contrasting and complementary colors. One also has to take into account the impact of broken and mixed colors, for the Impressionists and the "Divisionists" by no means definitively excluded these from their palettes. Ultimately we come up against questions that are much less readily accessible to a scientific approach; we touch on the crucial element of mystery in color. The "laws" governing any formal structure of the relationships affecting color and its overall effect are no less puzzling than those operating between the mathematically tangible laws of music and the intangibles of musical expression.

To return to the central problem of the Impressionist use of color – its intensification in the service of the illusion of light. There is probably no more striking example of the necessary divergence between color as observed in nature and color as employed by the painter than the late Impressionist representation of radiant light. It was precisely with this that the abolition of illusion began. Color took on a new form of freedom and independence.

In the last of the eight Impressionist exhibitions held in Paris in the 1870s and 1880s, that of 1886, Seurat's large painting *A Sunday Afternoon on the Island of La Grande Jatte* (illus. p. 38) was shown. What is striking in this most monumental of Neo-Impressionist works, alongside the stiffening and cooling in the image of the human figure, is the analogous change in the rendering of light. The picture contains the image of a water surface in sunlight and there are bright passages of light, as well as dark, cool, shaded areas on the grass of the river bank, but this is not sunshine as the Impressionists loved it and represented it. It is, rather, a strangely, altered, subdued illumination. Here, the strict system of the division of color, evolved in the pursuit of an unheard of glorification of natural light never previously possible, no longer serves such an end. Seurat had turned away from the illusionism of light.

This was not the case with Signac and the painters of his group. Their form of "Chromo-luminarism" allowed for illusionism, even though the tension arising between this and the relative independence of the spots of primanry color threatened to interrupt any clear sense of individual forms within a composition. This led Signac to insist, in his essay mentioned earlier, on the necessity for an ordered structure of molecular color particles that was distinct from the freer methods of the Impressionists. Signac found his own solution in the decorative arrangement of masses and colors. This was, of course, only one possible response to the need to liberate form. Another, very radical approach to the same problem was adopted by Gauguin, who at the same time – the late 1880s – abandoned altogether the use of a micro-structure of visible brushmarks in favor of constructing the picture by means of large masses and color planes. With this move, there was virtually nothing left of Impressionism.

Nor was there a great deal left of it in the approach eventually adopted by Van Gogh, however clear the traces connecting his work to what had gone before. Until the very end of his life, and in contrast to Seurat and Gauguin, Van Gogh

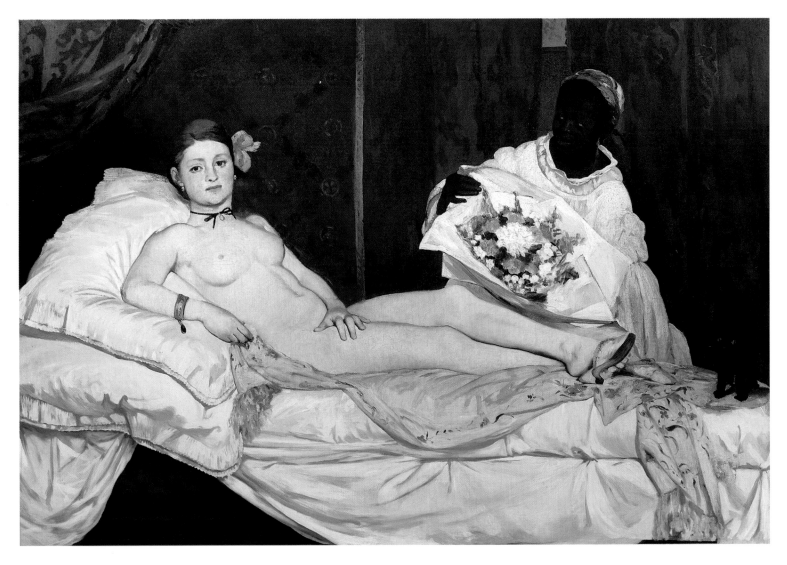

Edouard Manet, *Olympia*, 1863,
oil on canvas, 130.5 x 190 cm, Musée d'Orsay, Paris

took his subjects directly from observed reality, making the necessary changes to color to recreate this reality in pictorial terms. That function of color that we have defined as "color as necessity" is not clearly detectable in his painting (though certainly employed there) because the viewer's attention is invariably captured by the entrancing power of the almost symbolic color of individual objects.

Extreme examples of such a use of color are to be found in the work of Cézanne. Here, color in its own right – what we have called "color as necessity" – has much greater significance. Now, in fact, we sense the artist's compulsion to exaggerate color tones, these being freed from their role as part of the illusion of light. Especially notable is Cézanne's bold use of chromatic juxtaposition so as to generate the greatest possible sense of the coherence of compositional depth and picture plane. This sort of color is far removed from the color

of the Impressionists, yet we can sense that the two are linked within the same art historical development. One could certainly claim that Cézanne's color, for all its new tasks and its new significance, would be unthinkable without its predecessor in the atmospheric color of the Impressionists.

Conversely, Cézanne's use of color appears as if it were an entirely new means of achieving the coloristic aims of the Impressionists. This was an achievement that owed much to what Cézanne had learned from the discoveries of the great painters of the past; but it also relied upon the discoveries of the Impressionists themselves. It is important to recognize in this context that Cézanne, in his insistence on continuing to refer to the observed reality of natural forms, remained closer to the Impressionists than did the Neo-Impressionists. Unlike the latter, Cézanne did not acknowledge any justification for resorting to decorative form. In fact, the only aspect of

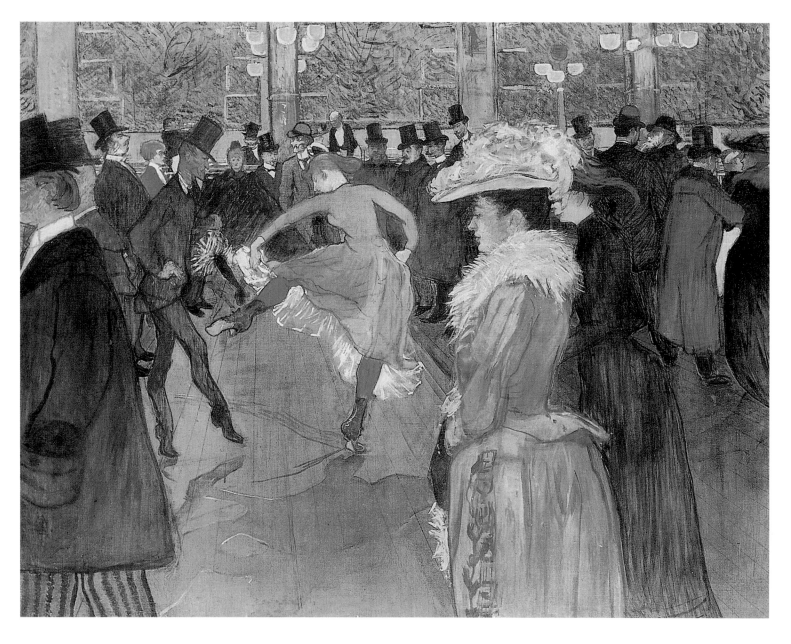

Henri de Toulouse-Lautrec, *The Moulin Rouge*, 1889/90,
oil on canvas, 115.5 x 150 cm, Philadelphia Museum of Art, Philadelphia

Cézanne's work that prevented the Impressionists from recognizing his œuvre as the true continuation and fulfillment of their own strivings was his indifference to the illusion of light. So vital was this to the Impressionist conception of the rendering of visible reality that its absence resulted in images of a world that felt entirely alien to them.

Even from their own very different points of view, the Impressionist painters must have appreciated the formally perfect synthesis achieved in Cézanne's work: the connection between picture plane and pictorial space that he accomplished essentialy by means of his use of color. This is a telling point of contact in the context of French Impressionism, where we find that color is invariably so strong in its own right that it constantly challenges the illustrative role imposed upon it, while simultaneously proving so effective a tool of illusionism as to compromise the impact of its use as a purely formal device. This is a characteristic of the work of every single one of the great Impressionists in France.

The drama of color resplendent in its own right, and in spite of the requirements of its context, first appeared in the early work of Manet. In *Olympia* we encounter both the female body and the white drapery of the bed as bold blocks of color silhouetted against a neutral background. The tradition ends with the drizzle and swirl of fiery tones in the last

pastels of Degas, in which there is hardly any element of darkness to be found. There is a counter-example in the work of the greatest German Impressionist, Max Liebermann, who (except in his boldly colored late works) answered the French insistence on the coloring of the seemingly colorless with the discovery of the painterly values of the almost monochrome image of nature, favoring delicate grays and diffused light.

Freedom in the use of color and the scope for departing from the colors observed in nature were the most important and the most obvious of the advantages that Impressionism offered its exponents. There was, none the less, more scope for personal expression than is readily assumed, in the freedom it offered with regard to painterly structure, both in terms of the crucial role of the brushstroke and in the use of line. It is true that there would appear to have been no place in Impressionism for the graphic, for line: the Impressionist artist was concerned, after all, with the *painterly* language of expression in the most extreme sense, that is to say with the opposite of the use of line. Impressionism was indeed criticized by contemporaries for this very characteristic.

It would also seem to be significant that not many of the leading Impressionists were great draftsmen. It is for this reason that Toulouse-Lautrec, who *was* one, appears to us not to be a true Impressionist, and Degas to be an exception. The work of Degas does show us that Impressionist painting, even though it might imply a subordination of line, did not necessarily lead to the destruction of graphic form. The Impressionist method of painterly projection in fact merely served to veil the presence of line in its function as outer contour, and, as a matter of principle, made minimal use of its expressive possibilities. Impressionism may, then, be defined as adopting a passive position in its relationship to line (the reverse, in fact, of its relationship to color). Its commitment to the painterly, meanwhile, might be seen as an artistic accommodation of the experienced fact that in Nature line is nothing but the limit of a particular color, so that any emphatic resort to the use of line constitutes an unwarranted departure from the purely optical realization of the subject.

As a whole, the Impressionists' attitude to line could be said to correspond to their attitude to linear perspective: in their pictures there are hardly any interventions into the form derived from the observation of nature. Line, accordingly, is present only in so far as it is already implicit in everyday experience and perception. In painting of this sort, drawing is not a language of formal expression; the problems associated with it do not therefore arise as they were to do, for example, in the work of Cézanne.

There are, of course, certain important exceptions to this rule. One need only think of Degas, in whose paintings and drawings the treatment of light never impinges in the least degree on a use of line that is of a classical clarity and consistency. Admittedly, Degas adhered to a relatively narrow range of subjects, almost always centered on the figure, and he favored interior over landscape settings; in his late work, moreover, the arbitrary quality of the color compromises any attempt at the exact rendering of light. These qualifications are useful in helping us to assess the degree to which bold and effective use of line might be reconciled with bold and effective use of color in the work of an artist who was an idiosyncratic but none the less a "true" Impressionist.

Closest to Degas in this respect was Renoir, in whose figure paintings we find a spirit of serene vitality derived both from the flowing curves of modeling outlines and from the play of light and color set off by the intermittent brushstroke characteristic of Impressionism. In fact, even the strictest forms of Impressionism offered opportunities for specifically graphic expression. Even in the "loosest" Impressionist landscapes, an exciting graphic energy may be found to vibrate in the network of brushmarks which will, in turn, give way here and there to a bold expressive curve. Such scope for graphic expression, however discreet, hardly points to the passionless objectivity that we might have been led to expect of Impressionist painting.

In as far as one's concept of Impressionism can accommodate work in which the use of line is of some importance, neither Degas nor Renoir need be classified as exceptions who contradict Impressionist principles. Such a contradiction only really occurs where line ceases to be an expression of the corporeal (which it still is in the work of Degas and Renoir) and stands for more abstract entities, and where it ceases to be the expression of a subjective temperament (which it still is with Degas and Renoir) and becomes more objective in function. This distinction helps us further define the essential difference between color and line in Impressionism: the fact that line had to operate within much narrower bounds than were imposed on color. Within the framework of the overall structure, the exuberant life of color, exaggerated into fantastical contrasts, could still remain Impressionist. The drama of line, however, has no place in Impressionism beyond its presence within the brushmark pattern of the micro-structure.

It is, of course, true that the expressive line in the grand style might successfully combine with a markedly painterly form, as in the case of Théodore Gericault, Delacroix or Honoré Daumier. This does not, however, call into question our observation on the drawn and the painterly as irreconcilably distinct. It is telling in this respect that Daumier remained entirely untouched by Impressionism. It is equally significant that, while many of the coloristic discoveries of Delacroix were absorbed by the Impressionists, the latter inherited nothing of the Romantic drama of his use of line in composition.

However obvious this opposition may seem, one should continue to bear it in mind, above all because it is one of the characteristics (the other being the regard for exact linear perspective) that distinguish "real" Impressionism – that of the nineteenth century – from the Impressionism of the Baroque era, the latter proving perfectly able to accommodate the effects of expressive line. In the course of the history of painting, the impressionistic in the broader sense has, of course, been a feature of a wide range of styles. A celebrated example is provided by the use of broken lines in some of the drawings of Pieter Bruegel the Elder, above all in his studies of village scenes.

Within the painterly approach of Impressionism, the pictorial composition in general is likewise connected with all these peculiarities in the role of line. Here our central concern is whether a composition that has a framework which seems to shine through a veil is still a "composition" in the old sense, or whether the web of brushmarks has a fundamental influence on the essence of the composition in its picture plane and depth. In so far as painterly structure is never really anything more than such a veil, the intervention in the traditional role of composition was not very significant. This was in fact the case throughout the era of Impressionism, with very few exceptions. It was only in the final forms of Impressionist painting that the micro-structure itself began to have a much more telling impact on the pictorial arrangement as a whole. This is often a characteristic of the late landscapes of Monet – in many of the mist-filled views of London and in some of the last water-lily pictures, the "Nymphéas." Here the shimmer of light and color effectively breaks down the "composition" in the usual sense of this term, without itself serving as the vehicle for a new compositional form. In such pictures, for the first time, the hidden compositional stability is sacrificed.

The point here is not that the painterly principle of these pictures should be condemned as a form of dissolution, but simply that it should be compared with the painterly methods of other artists whose overall compositional arrangement is, on the contrary, built up out of the micro-structure. This happened, above all, in Neo-Impressionism, where it resulted in the ordering of the picture plane into decorative silhouettes. In these, the Pointillists saw something corresponding to the more or less strict uniformity of the individual brushmarks. By this means, the pictorial structure was composed out of optical units of two different orders of magnitude. This is a consequence that may be derived, at least logically speaking, out of the freer form of Impressionism. As a reaction, however, against Impressionist casualness, there appears the controlled, decorative work of Gauguin and, in a certain sense, also the more complex interconnectedness of a structure combining large and small forms in Cézanne's approach to composition.

The spirit of Impressionist pictorial organization may be found to have passed, above all, into the painting of Bonnard. The Impressionists' ambition and ability to make do without line and none the less to preserve a structural framework is also found, in an intensified form, in this body of work. None of the great French painters active around 1900 so spiritualized the substance of Impressionism as Bonnard did in transforming images of reality into visions of a cheerful serenity, without thereby departing from the content derived from experience.

Pierre Bonnard, *Skaters*, 1896-98, oil on cardboard, stuck to panel, 100 x 75 cm, private collection

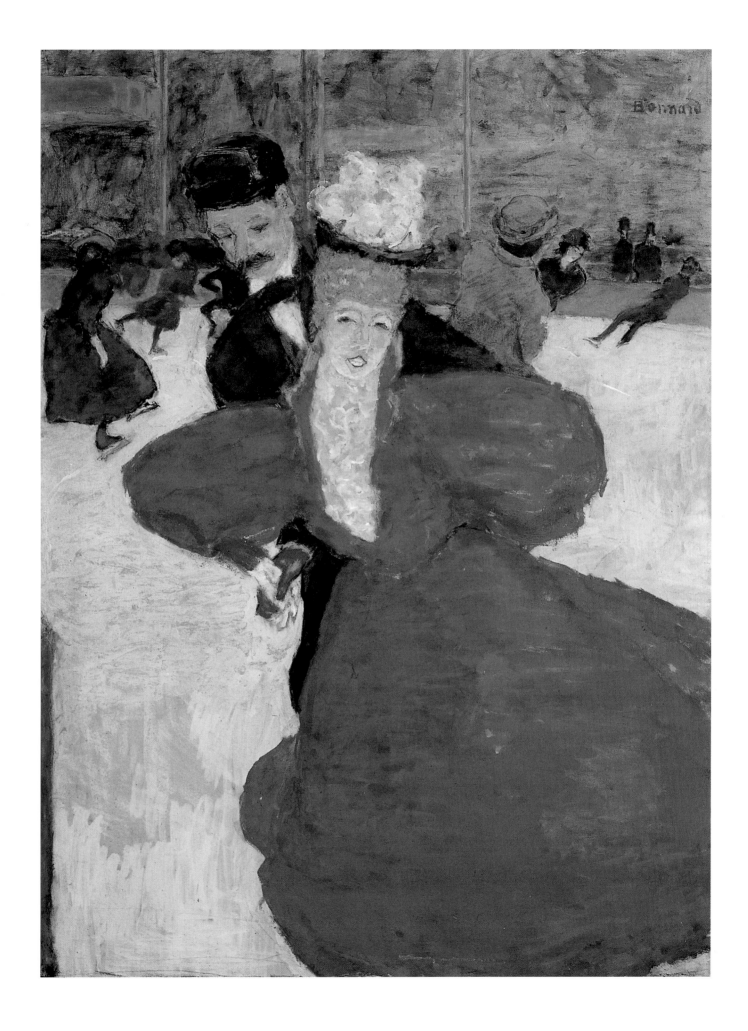

45

Form and Content

We are concerned here with a particular instance of tension between the illusion of reality and the means used to construct the form of the picture. A tension that belongs to the essence of all painting that wishes to record aspects of reality and, at the same time, to qualify as art. Viewed historically, the presence of this tension may be understood to signal the fact that the Impressionist painting of the later nineteenth century strove for the greatest degree of illusion and yet eventually established the foundations for a type of painting that renounced the illusion of external reality with an unprecedented determination.

We must also ask how Impressionism appears if one considers it freed from its historical connections, in terms of its essence. What was the painting of Impressionism able to offer of the endless multiplicity of reality? In terms of subject matter, it would appear that the Impressionist painters were committed to the depiction of observed reality in all its aspects. This was, of course, a quality they shared with the representation of reality in the art of other eras, except for the much more limited range of their own subject matter. Impressionist painting alone culminated in landscape painting, although one might point to seventeenth-century Dutch art (the first triumph of landscape painting in Europe) which is most closely related to Impressionism in spirit, even though this embraced a fair

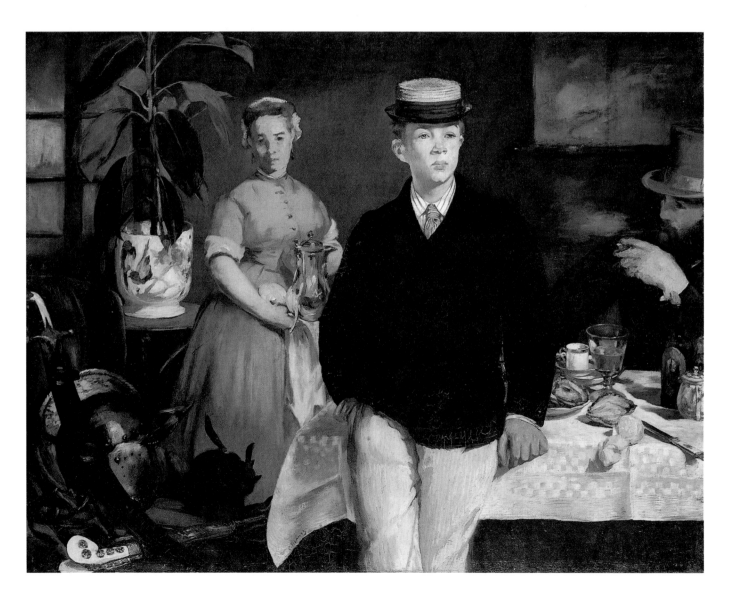

Edouard Manet, *Breakfast in the Studio*, oil on canvas, 118 x 154 cm, Neue Pinakothek, Munich

number of other categories – still life, architectural subjects and the presentation of people both in genre scenes and in portraits.

Impressionism is far removed, indeed fundamentally removed, from such universality in the representation of the visible. It raised landscape painting to new heights, but at the expense of subordinating every other category. One necessary outcome was the withdrawal of the human figure as the subject of painting. No apologist for Impressionism can overlook this fact. A type of painting that programatically excluded the intellectual, in the widest sense of that term, had thereby to sacrifice a more profound representation of humanity. Some consummate portraits were, of course, painted even within Impressionism. These, however, are exceptions – the few portraits by Renoir, for example, which are the work of a painter who can only partially be classified as an Impressionist. In French painting of the late nineteenth century it is only in the work of Toulouse-Lautrec, that is to say already at the boundaries of French Impressionism, that a representation of the human figure in the grand style is to be found. The place assigned to humanity within pure Impressionism is never more clearly evident than in the presentation of the human figure in the paintings of Manet. Works from the last years of his career, such as the female portrait reproduced here (illus. p. 73) and the only real history painting to be produced by the Impressionists – *The Execution of the Emperor Maximilian* (illus. p. 31) – evince enormous technical mastery but very little concern with intellectual content.

From the start, Impressionism's attitude of indifference to the problems of presenting the human figure offended many; and it provoked ever more negative criticism the clearer it became that it was also to be a determining factor in many aspects of Post-Impressionist art. This "expulsion of the human figure from art" was noted by both the well-informed and the unthinking, and in a spirit of both genuine concern and malevolence. It became, indeed, a criterion of value, albeit an invariably superficial one. This crucial aspect of the origin and development of Post-Impressionist painting is in fact far too complex to be dismissed as merely another episode in the attack on modern art. After all, critics were not the only ones to regret Impressionism's indifference to the representation of the human figure. There were Impressionist artists who shared this view; and it was indeed the sense of a certain insufficiency within Impressionism itself that prompted the emergence of a new image of man.

While Toulouse-Lautrec was in Paris evolving his own style, a style that accepted only the human figure as a subject to the extent that he entirely rejected landscape, Van Gogh was also in the city and painting his first portraits. There is probably no picture from those earliest days of "modern"

painting that reveals so clearly the juxtaposition of old and new as does the portrait of a woman sitting by a cradle painted in 1887. Here, the exemplarily strict Pointillist approach to rendering a sense of space is violated by a gaze and a gesture that belong to a new world. No bridge leads back to Impressionism from such a picture; it originates from a rift which has very little directly to do with the work of the Impressionists. It is astonishing to note the similarity between this figure – with its large-eyed face and its inward-directed gaze – and those found in Early Christian mosaics or in late Roman commemorative portraits shown in an illusionistic setting. This work by Van Gogh recalls nothing so much as these witnesses to the advent of a new view of humanity as the Eastern Christian spirit impinged on the intellectual universe of Late Antiquity.

At almost exactly the same time Seurat painted his *Sunday Afternoon on the Island of La Grande Jatte*, in which the human form may be seen to undergo a transformation of a quite different kind. Here we find an artist eschewing a record of the individual human face and the individual human figure as perceived by the senses, in order to replace these, not with a portrayal of the spiritual essence of humanity, but with a process of standardization resulting in figures resembling automata. Thus, precisely in that direct successor to Impressionism, and the one most deeply indebted to it – Neo-Impressionism – one finds the prelude for something new, and something pointing in two diametrically opposed directions.

One could, of course, see in this radical development the two extremes of a dichotomy only to be expected – a concern for depth and a preoccupation with surface. There is, however, something more to be discerned here. It was in fact the same urge that prompted the Impressionists to abandon an interest in the human figure that subsequently became the principal motivation of those painters who were concerned to create a new, spiritualized image – Van Gogh, Gauguin, Munch and the Expressionists of our century. The power and the new depth to be found in this image of humanity was owed, in large part, to the attempt to defend the individual as a human being from the assertive power of elemental forms. This occurred in a dramatic manner in the work of Van Gogh, who attempted to grasp the quality of individuality not only in the image of man but also in the representation of inanimate objects, which he infused with a peculiar spirit. In a picture such as the renowned *Chair with a Pipe* in the Tate Gallery in London, he was thus able to achieve something extraordinary: to offer a good deal of general information regarding the formal and physical properties of the object addressed and, in spite of this, to paint the "portrait" of such a chair.

In general, one could view this as a synthesis of two forces, that are in principle opposed to each other. Van Gogh's

concern to illustrate the dynamic energies in nature necessarily distracted him from attention to the individual entity on which these energies worked; but it was precisely such entities – whether animate or inanimate – that most moved Van Gogh, both as artist and as man, provoking in him the concentration and effort worthy of a fifteenth-century Primitive. This concern did not detract at all from Van Gogh's rendering of the turbulence imbuing natural forms, whether in an entire landscape panorama or in the smallest petal. The terrifying tension inherent in this synthesis, as also what we can only call its "heroic" quality, distinguishes every single work by this painter. Moreover, since Van Gogh's time a polarity of this type, and the problem that underlies it, has never been absent from painting. Out of the tension between an inevitable focus on the supra-human powers of natural phenomena (symbolized by a radically liberated form) and a reluctance to abandon the human figure altogether, the painting of our century has produced some of its most significant representations of humanity.

From this point of view, Impressionism may be found to have a negative aspect, but one that is only the necessary converse of something positive. This last is very clearly identifiable through the example of what it became in the uncompromising work of Cézanne, its most logical consequence. With a consistency at least as rigorous as that of Seurat, Cézanne abandoned a concern with the "human" experience of feeling that the Impressionists had still retained, even though the human figure was of little interest to them as the subject of representation. If Monet, in Cézanne's opinion, was "only an eye," an admirable eye, we must ask how Cézanne himself succeeded in getting beyond this element of "only," and what the new forms and the new types of content themselves signified.

These forms were readily understood, also in Cézanne's own assessment, as part of a new sense of pictorial order and a new mood of calm, as opposed to the carelessness and the painterly dynamism in Impressionism. Such changes alone effectively establish a new type of pictorial content. Beyond this we have to acknowledge that Cézanne did not extend the range of subject matter itself beyond that favored by the Impressionists. On the contrary, he reduced it – and at the expense of individual things. In this area we find that much of what still aroused the interest or concern of the Impressionists is missing from Cézanne's work; and this is clearly because his own interest is directed less at individual entities and much more at the relations between them. It is true that the ground for this change was prepared by Impressionism, above all through the dominating significance attained by atmosphere and light; but the change of approach initiated by this means found a more radical application in the work of Cézanne.

As a result of a series of reductions and renunciations Cézanne was able to come nearer than any of his contemporaries to the highest ideal of the new painting: depth without intellectual content, this latter being understood to embrace mood and associations. This ideal was not entirely alien to the Impressionists' aspirations when they insisted that painting should attend only to the visible. None the less, it is only when we compare Impressionism with the work of Cézanne that we can really perceive how much the former (in spite of its stated goal) still contained of bourgeois security in the form of the illustrative, the evocative, and of the Romanticism of subjective experience. This has to be recognized as true even of the work of Manet, as a characteristic setting a boundary to this artist's supposed "coolly" objective quality. This is why a painting such as *Breakfast in the Studio* (illus. p. 46) has so much atmosphere, while its figures, for all their still-life calm, have none of the symbolic indifference to nature we encounter in the pictorial universe of Cézanne and of so many who came after him.

Our fond retrospective admiration for Impressionism is by no means only a look back at its unselfconsciouness and sovereign technical ability. Equally central to the Impressionist view of the world was a very human responsiveness to the emotional aspect of experience – a quality apparent in the rendering of convivial social gatherings and in the drama of nature. These are very distinct from the quasi-scientific probing into the phenomena of light, atmosphere and space that the Impressionists were certainly also striving for. On the whole, the results of this endeavor were rarely austere in character, and they were often quite the reverse. The austerity consisted only in its resistance to any urge to investigate the mystery inherent in the sensorily perceptible world, and, it is this which distinguishes Impressionism from many other interpretations of art.

Impressionist painting might be regarded as a process of discovering the spirit of material, and the field in which it hoped to make its discoveries was the endless realm of visual phenomena as revealed by light. The enthusiasts for material painting in earlier periods – Hans Holbein The Younger, the seventeenth century Dutch painters of still life, and the Realists of the early nineteenth century – had combined their enthusiasm with their continued use of the hallowed tools of idealization: line and composition. The enthusiasts for the painting of light, however, understood the material and the spiritual – the appearance of individual objects and the overall construction of the picture – to be connected in quite another way. By means of light, a medium of the least materiality, the gravity of the three-dimensional body was itself rendered superfluous. However this is viewed, it can certainly be seen as a process of liberation.

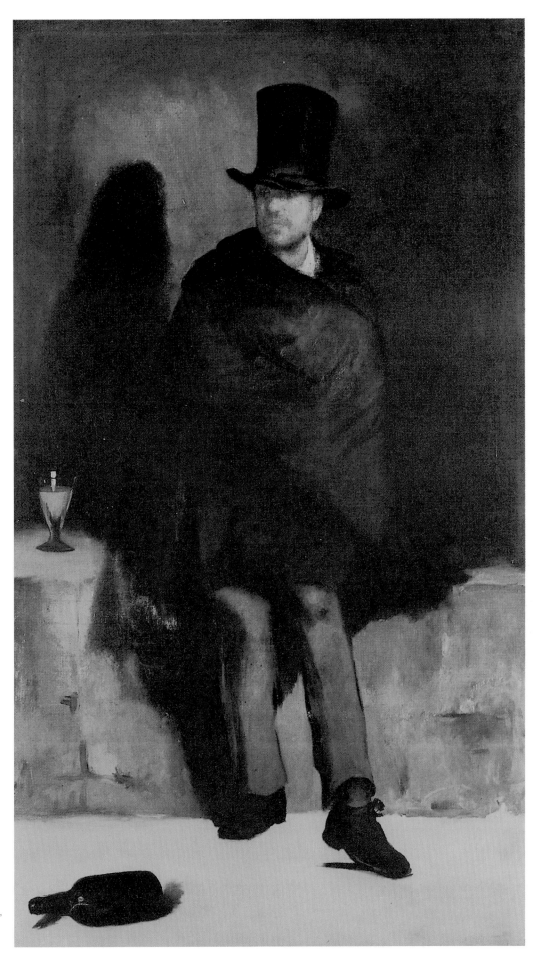

Edouard Manet, *The Absinthe Drinker*, 1858-59,
oil on canvas, 181 x 106 cm,
Ny Carlsberg Glyptothek, Copenhagen

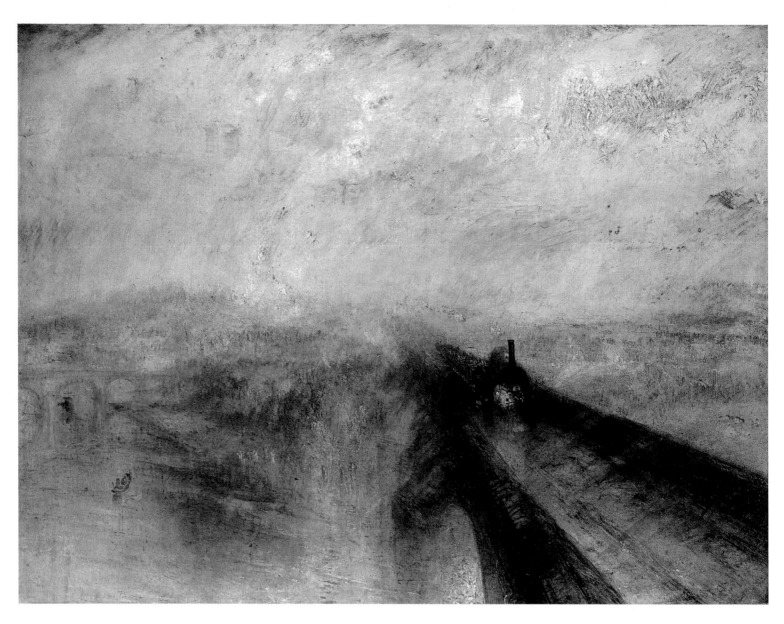

William Turner, *Great Western Railway (Wind, Steam and Speed)*, 1844, oil on canvas, 91 x 122 cm, National Gallery, London

The experience of light was never without its Romantic element. As revealed by Van Gogh's enraptured hymn to light, Impressionist painting was still capable of a significant degree of exaggeration, and it is very telling that Van Gogh not only adhered for so long to Pointillism (for it was out of this that he evolved his own personal style) but also returned to it in the last phase of his career. A Romanticism of light, however, is as valid a form of Romanticism as any. It is, of course, indisputable that there is a considerable distance between the Romanticism and dynamism of light in the work of J. M. W. Turner, one of the "fathers" of Impressionism, and Impressionism itself. None the less, the path from a picture such as Turner's *Great Western Railway (Wind, Steam and Speed)* to

the railway subjects painted by Monet is not so much the transition from the Romantic to the objective, but rather a shift illustrating the difference between an emotionally exaggerated form of Romanticism and a more subdued sort.

Even the most "genuine" Impressionist painters of landscape – Monet, Pissarro, Sisley or Eugène Boudin – cultivated, by means of light, a Romanticism of mood. If such Impressionists painted the bright shimmer of sunlight or of winter fog, the cool light along the sea coast or sunset viewed through mist, the life of the light itself outshone the objects it modeled, for these were seen to be of no importance in their own right. In Stanislas Lépine's landscape entitled *Bridge in a French Town* (illus. p. 65), by contrast, the haze of a summer morning

is presented with painterly virtuosity, but there is much here too of the street life of a French town. None the less, even in the Impressionist rendering of a tree in the distance or a house standing alone in the depth of a landscape the experience of the visible cannot easily be reduced to purely optical phenomena altogether divorced from the emotional associations they provoke. The colored smudge in terms of which we may encounter such entities in an Impressionist painting invariably comes to mean very much more to us than a mere brushmark and its concomitant illusion.

While the Impressionists' program sought no more than this, in practice few Impressionists were prepared to follow this program to its logical conclusion, even though they invariably departed from it no further than was required to accommodate the element of "mystery" seemingly inextricable from the effects of light they studied. Only with Van Gogh's aggressive use of form was the path laid to a new sort of depth and a new sort of objectivity going far beyond the Romanticism of the nineteenth century. Even where Van Gogh remained outwardly close to Impressionism, as for example in the view of a stretch of a sunlit street found in his picture *The Level Crossing*, it is clear that he had already broken through the boundary that the Impressionists themselves had not been able to traverse.

In as much as Impressionism had any interest in the human figure as a subject, this did not go beyond a concern with the subjective realm of the experience of mood. There were milder and more gradual forms of transition to new worlds of feeling. Within the system of the micro-structure it was possible, through the introduction of very slight alterations and displacements, to imbue the austere optical projection with a sense of both atmosphere and feeling. Some painters, moreover, used these as an expressive language for a new sort of content. Such a process can be observed in the work of James Ensor, in the late paintings of Lovis Corinth, in the early landscapes of Maurice Utrillo, and in the earliest works of Pablo Picasso.

This occurred in the sphere where Impressionism found its greatest development – in the realm of form, and above all that of color. We have already discussed how the freeing of form through the use of color closely links Impressionist painting to the art that followed. If one asks what it was that started in Impressionism and what is left of this in later painting, one would first of all have to see the most salient characteristic in the continuously radiating power of color, in its dazzling brightness and its increasing "wilfulness." In this respect, the art of the *Fauves* and of the *Nabis* may be understood to follow on directly from that of the Impressionists.

This continuity in formal terms is, moreover, accompanied by continuity in terms of content and associations. It is true that the freeing of form in painting coincided with the emergence of a newly somber element in the artist's vision of the world: one finds a ready acknowledgment of problems and profundities, of sadness, discontent and obsession, quite unknown to the Impressionist painters. However, one also finds an intensification of the festive and serene spirit justifiably regarded as central to Impressionism. A multiplicity of heartening examples is to be found in the work of the *Fauves*, of Henri Matisse, Bonnard and Edouard Vuillard, and in that of many other painters of our century.

The appealing independence and power of expression obtainable through the free use of color is not, however, the only legacy of Impressionism to serve as a means of overcoming the evident difference between a light and a dark world of feeling. Another point of connection between Impressionism and its heirs does not concern the world of form but rather the question of attitudes towards visible reality. To the casual observer of Impressionist and Post-Impressionist painting, there could surely be no sharper contrast than that between the fundamentally naturalistic attitude of the former and the unnaturalistic one of the latter in all its degrees, right up to the entire renunciation of the object in non-representational, or "abstract," art. This is a contrast that defies the manifold connections established in the realm of form. None the less, even the high degree of artifice in so much Post-Impressionist art derives from an approach to creation ultimately rooted in the transformation of *observed reality*.

Admittedly, there is much that is new in the subject matter of Post-Impressionist painting; but subjects extracted from the realm of everyday life (for Impressionism the only subject) remained extremely important, above all in the painting of landscape and of still life. In the case of still life, there even appears to have been an increase with the advent of Post-Impressionism. While the Impressionist indifference to the intellectual and the literary was ostensibly not shared by most of the Post-Impressionists, this change was on the whole to prove of less significance than might at first have been assumed. It had been the Impressionist painter's ambition to establish that the experience of the visible was an inexhaustible source of inspiration for the painter – the definition with which we started. He was thus able to adhere to a hedonistic pantheism. The principal concern of Post-Impressionist painting was with that which was hidden from view: it therefore sought to lay bare the laws of the construction of natural phenomena, thus making visible what had been invisible. For the most part the Post-Impressionist painter went about achieving this end by reference to the very same observed reality that had served as the focus for Impressionist attention.

We can more easily assess this fundamental characteristic if we step back to view the matter with the advantage of

historical distance, specifically by comparing the artifice of art removed from nature that *followed* Realism with the artifice that *preceded* the artistic discovery of Nature, that is, with medieval art – which so often appears to resemble it. When we do so we are immediately struck by the evidence of a very deep difference that can only be resolved in terms of a few very general principles. The creative process involved in the creation of a painting expresses the artist's relation not only to nature, but also to a particular art form. This latter is here understood not only as the form already associated with other artists or with a general stylistic trend that one strives to emulate. It is more than this: it is the artist's relation to the art form within which he works. At every moment during the making of a work of art a decision has to be taken as to whether a particular formal quality – an outline, a linear structure, a color composition – should comply, above all, with formal considerations or should accommodate what the artist has observed and experienced in the external world. It is not only a case of *experience* of a work of art from the point of view of nature and the point of view of art, but also the *creation* of a work of art from the same points of view.

Such a process of creation was alien to the artists at work in the Early and High Middle Ages, who referred exclusively to the example of other works of art in producing their own. The calligraphic style of a courtly miniature of the fourteenth century or the cubic formal simplification of a Romanesque sculpture do not have the same relation to the appearance of things in nature as do the seemingly similar transformations of natural entities to be found in modern painting. In analyzing the latter, one can make fruitful comparisons with sensorily perceptible reality, but, in considering works of the medieval period, one must acknowledge that their creation involved nothing of the consistent reference to nature that is a determining factor even in the most "artificial" modern painting. The works of the Middle Ages were created by means of reference to other works of art. In modern art, on the contrary, even the most fantastical and wildest decompositions and deformations of the external image of nature remain more closely derived from this image than were the much more minute degrees of abstraction to be found in medieval works. A modern Cubist picture is fundamentally distinct in its spiritual root from a cube-shaped Romanesque figure in that it was ultimately inspired by a visual experience.

The forms of simplification in the artificial art of the Middle Ages – the calligraphic, the arabeqsque, the cubic and so on – are significant as a means of articulating something of the world beyond. This sort of thing is, of course, also to be found in modern art; but, on the whole, this has few of the pre-established formulae and the elements of ornamental consistency so essential to the art of the Middle Ages. Such

features were of significance in certain early forms of modern art, in *Jugendstil* around 1900 and in Symbolist painting. However important within the context of the overall evolution of art, these now strike us as the least powerful expressions of modernity.

This all goes to show how much more there is to Post-Impressionist painting than formal innovation. We do, of course, feel that we get a lot out of modern painting if we experience it primarily from this point of view – from that of form. In fact, we thereby misunderstand it in much the same way that we misunderstand Japanese ink drawings if we admire them only as another sort of Impressionism.

Modern art, then, in comparison with the art of the medieval period, enjoys an entirely different relation to observed reality (above all, a close connection to it) and functions without reference to an idea of the beyond (in particular, without reference to a religious idea). It is now quite clear what a decisive influence on the character of modern art – above all its relation to reality – was exerted by the last of all the phases to divide the Middle Ages from modernity: Impressionism. In most of its subsequent phases, though admittedly not in all, art has retracted nothing of the Impressionist painter's rejection of the intellectual in favor of the perceptible. In addition to this, modern art has presumed to relinquish much that the Impressionists themselves regarded as indispensable, in order to make nature its subject in an entirely new sense. If the structures underlying the natural world can suffice for a painter's "subject" then this – or so at least is the intention – should require no further justification in terms of intellectual content except that which resides within the structure, in the form itself.

Such principles have now in the 1950s, led twentieth-century painting (this mixture of renunciation and audacity) to a stage of development where it is difficult to see its connections with Impressionism. There *is* continuity, however, in as far as there is still some form of reference back to perceptible reality, even if "perception" may now be understood in quite new ways – from scientifically demonstrable underlying structures to the freest possible interpretation of emotional response.

In limiting themselves to the representation of the everyday world that was at all times visible, the Impressionists wanted to demonstrate, more or less emphatically, that not "everything" could be painted. If we admire their work today, it is also on account of the uncompromising boldness of this attitude. We certainly respond to the strongly hedonistic element in the Impressionists' approach to their subjects; but, at a more intellectual level, we feel a strong fascination for the informing conviction that a painter should not concern himself with that which is not the business of painting in the strict

sense. This conviction too, was historically conditioned, but it also had a certain logic in its favor. We now see more clearly than did the immediate successors of the Impressionists how rich in possibilities this approach was.

The attempt to grasp in a single concept the content, the real vital content, the vital center of what we call Impressionism in painting ultimately comes down to one word: nature. This is of course a very vague term, and yet it has its point if one understands it to embrace everything that has no limits and that meets the painter's eye alongside, and outside, the human figure. A type of painting that, like none before it, committed itself to the exploitation of this limitless subject matter, is not on that account to be associated with a high degree of naturalism. It is, rather, to be viewed as an extreme form of landscape painting.

The rediscovery of landscape started at the beginning of the nineteenth century. It got underway with a sort of religious absorption, with the intoxication of a universal experience of feeling. At the end of that century – in Impressionism – we find an image of landscape in which the power of nature has become the painter's subject in a new sense. Even in the Romantic and heroic landscape painting of the early nineteenth century, the concern was to create an illustration of the power of nature. This power had its symbols in natural things, in mountains and water, in trees and clouds; and the effectiveness of such symbols was dependent on the artistic forms through which they were rendered. In Impressionism the objects of nature swiftly ceased to serve as vehicles conveying its power: this role was now assumed by the formal elements of the picture's construction. Sometimes, in the purest and highest achievements of Impressionist painting, there is even a hint of the reversal of this process: it appears as if the creative idea of a color composition had been the artist's real stimulus, while the image of nature served merely as the pretext and the foil for this – in a manner comparable to what one finds in ceiling paintings of the Baroque era or in the work of Watteau. Admittedly, the "earthiness" of Impressionism generally established much narrower bounds for it in this respect than were imposed on such products of the Baroque era.

Impressionism remained a living force until well into our century. As its last fireworks faded away, many of those who had gathered to watch the display were already turning their attention to other spectacles, in which the theories of a fascinatingly elaborate but, in its great moments, also enchantingly natural art had long started to bear fruit.

Eugène Delacroix

Arab Cavalry Practicing a Charge, 1847

Oil on canvas, 66 x 82 cm; signed: Eug. Delacroix 1847
Oskar Reinhart Collection, Winterthur

In almost every respect, the work of Eugène Delacroix, as
an expression of Romanticism, is the absolute opposite of
the painting of reality as practiced by the Impressionists. With
regard, however, to its most distinctive quality – color –
Delacroix's achievement may be regarded as having provided
one of the crucial preconditions for later developments. This
outcome was, perhaps, due not so much to the images them-
selves as to the ideas about the nature of color and the claims
for painting that Delacroix formulated in his notebooks. In the
paintings, meanwhile, much is achieved through the drama of
chiaroscuro; but even here color is crucial. In contrast to what
is found in the academically oriented paintings of Delacroix's
age, areas of both darkness and light are shot through with
color and thereby set into a specific relation with each other
as color in a manner that recalls what we find in the work of
the Venetians and the great colorists of the Baroque era. Com-
mentators have, accordingly, noted the internal connection in
this picture of Moroccan horsemen in terms of a chromatic
sequence: the two tones of the visible strip of sky, the blue-
green shadow of the mountains, the light blue-gray of the gun-
smoke and the deep black-brown of the flapping cloak at the
center of the composition, surrounded by brightly lit passages.
The Impressionists would surely have sensed the driving
force of color behind the dynamism of the chiaroscuro.

In early 1847 Delacroix made frequent notebook entries
regarding work on a composition variously called *Arabes en
course* and *Course d'Arabes*. We are probably justified in iden-
tifying this work with the picture illustrated here.

Théodore Géricault
The Lunatic, 1822/23

Oil on canvas, 81 x 65 cm
Oskar Reinhart Collection, Winterthur

If one understands the term "painterly" (in the sense of a pictorial construction made up of largely visible brushmarks) as describing one of the basic preconditions for Impressionism, then Géricault too must be seen as one of the precursors of this phase in the history of painting. In his work, the painterly is present in very varied degrees. Sometimes it is only a subsidiary phenomenon, and in this respect it is an instance of what could be termed "permanent Impressionism," examples of which are to be found in a number of the works of Classicist French painters such as Jacques-Louis David or Pierre-Paul Prud'hon. More often, however, Géricault's pictures are "painterly" in a far more fundamental way. It was on this foundation that Delacroix was able to build in his own work.

The Lunatic, which shows a man who suffered from delusions of military grandeur, is one of a series of portraits of the inmates of the Salpêtrière (the main Paris asylum for the insane). The principal physician there, Dr. Etienne-Jean Géorget, commissioned the series from Géricault, who carried out the work between about 1821 and his death in 1824.

Camille Corot

Landscape in Brittany: Gate beneath Trees
(also called The Gate of the Château*)*

Oil on paper, stuck to canvas, 32 x 45 cm; signed: Corot
Musée du Louvre, Paris, Bequest of Etienne Moreau-Nélaton, 1906

In European painting of the period 1820-40 an early form of
Impressionism appeared in many different places, its products
in each case being both distinct in character and independent
in their evolution. It was to be found, for example, in the land-
scapes of John Constable, in the early landscapes and interiors
painted by Adolph Menzel, in the work of certain of the Bie-
dermeier painters (Carl Blechen, Friedrich Wasmann, Friedrich
Loos or Adalbert Stifter) and, in France, above all in the land-
scape studies of François-Marius Granet and in a long series
of early works by Camille Corot.

The precision in the painting of light and air in this partic-
ular landscape was hardly to be surpassed in its effectiveness
by the Impressionism of the later nineteenth century, although
its impact is tempered here through a degree of Romantic
transformation. There is a close affinity between this early
form of Impressionism and many works from the first flower-
ing of the principal later variant, for example Alfred Sisley's
Small Square in Argenteuil (illus. p. 87).

PEGASUS
Library

Egon Schiele
Eros and Passion

By Klaus Albrecht Schröder

An exciting appraisal of Egon Schiele's sensual paintings. No other artist in early modern art depicted the body so candidly as Schiele, whose uncompromising truthfulness in allegedly pornographic imagery caused him to be imprisoned briefly in 1912.

120 pages with 60 full-color and 48 b/w illus. ISBN 3-7913-1383-5.

Monet at Giverny

By Karin Sagner-Düchting

In May 1883, the French Impressionist painter Claude Monet settled with his family in Giverny, north of Paris. There, amidst the romantic garden landscape (which he himself designed) the fascinating and influential works of his last 40 years were created.

120 pages with 56 full-color and 19 b/w illus. ISBN 3-7913-1384-3.

each only:
US$25 / Can.$35.95
UK£14.95 / DM 39.80
Hardcover volumes:
6 1/2 x 9 1/2 in.
16.5 x 24 cm

Marc Chagall
Daphnis and Chloe

Text by Longus

Inspired by a journey through Greece, Marc Chagall, one of this century's most popular painters, created a wonderful series of lithographs that brought new life to this ancient Greek love story - the first pastoral romance.

152 pages with 42 full-color illus. ISBN 3-7913-1373-8.

Picasso's World of Children

By Werner Spies

This "most interesting study" (*The Art Book*) examines the artist's treatment of the subject of children in relation to his complete oeuvre. The book has many original and stimulating insights, not only into Picasso's magical world of children, but also into the character of the artist himself.

128 pages with 61 full-color and 48 b/w illus. ISBN 3-7913-1375-4.

Edouard Manet
Images of Parisian Life

By Hajo Düchting

The work of Manet scandalized his contemporaries. It was not so much Manet's subject matter - the night life of Paris with its bars and cabarets - that offended French society as his means of depicting it. This finely illustrated book adds a new and refreshing perspective to his work.

128 pages with 70 full-color and 26 b/w illus. ISBN 3-7913-1452-1.

ART BOOKS

Titian

Prince of Painters

Edited by Susanna Biadene

The catalogue of the Venice and Washington exhibition (1990-091). "Like the exhibition, the catalogue teaches us much regarding pictorial techniques and conservation." *Journal of Art*

451 pp. with 207 full-color and 104 b/w illus. 8 1/2 x 11 5/8 in. / 21.5 x 29.5 cm. ISBN 3-7913-1102-6. Cloth.
US$85 / Can.$124 / £55 / DM 148

Rodin

Eros and Creativity

Edited by Rainer Crone and Siegfried Salzmann

"Each sculptural piece has been exquisitely photographed in black and white from multiple angles, to highlight selective details." *New York Times*

236 pp. with 32 full-color, 140 duotone, and 185 b/w illus. 9 1/2 x 12 1/4 in. 24 x 31 cm. ISBN 3-7913-1185-9. Cloth.
US$70 / Can.$101.95 / £45 / DM 128

Goya

The Complete Etchings and Lithographs
By Alfonso E. Pérez Sánchez and Julián Gállego

Wide-ranging in subject matter and of consummate technical mastery, Goya's prints provide an intimate record of the artist's response to the turbulent times in which he lived.
264 pp. with 298 b/w illus.
9 1/2 x 11 3/4 / in. 24 x 30 cm.
ISBN 3-7913-1432-7. Cloth.
US$75 / Can.$108.95 / £50 / DM 118

The Great Age of British Watercolours 1750-1880

By Andrew Wilton and Anne Lyles

"Book of the Year. A superb memento of a wonderful exhibition which should be produced everytime someone says the English have no visual sense."
The Spectator

340 pp. with 332 full-color and 57 b/w illus. 9 3/4 x 11 3/4 in. / 25 x 30 cm. ISBN 3-7913-1254-5. Cloth.
US$75 / Can.$108.95 / £48 / DM 128

Hokusai

Prints and Drawings

By Matthi Forrer

"Mr. Forrer Proves himself a sure guide."
New York Times
"Hokusai devotees...will be pleased with the high quality of color reproductions in this volume." *Print Collector's Newsletter*

224 pp. with 126 full-color and 28 b/w illus. 9 x 10 3/8 in. / 23 x 26.5 cm. ISBN 3-7913-1131-X. Cloth.
US$65 / Can.$95 / £42 / DM 118

ART BOOKS

PRESTEL

Munich · New York

Alberto Giacometti
Sculptures, Paintings, Drawings

Edited by Angela Schneider

Bringing together more than 250 sculptures, paintings, and works on paper, this extensive monograph provides an exemplary overview of Giacometti's work.

224 pp. with 31 full-color and 104 duotone, and 120 b/w illus. 9 1/2 x 11 13/16 in. / 24 x 30 cm. ISBN 3-7913-1371-1. Cloth. US$60 / Can.$87 / £40 / DM 98

Kandinsky
Watercolors and Drawings

Edited and with contributions by Vivian Barnett and Armin Zweite

"This treasury of more than 250 works on paper contains superb examples from every phase of Kandinsky's…oeuvre."
Booklist

232 pp. with 174 full-color and 69 b/w illus. 9 5/8 x 11 3/4 in. / 24.5 x 30 cm. ISBN 3-7913-1184-0. Cloth. US$70 / Can.$101.95 / £45 / DM 108

Oskar Kokoschka

Edited by Klaus Albrecht Schröder and Johann Winkler

"*Oskar Kokoschka* is a significant contribution to existing scholarship on this fascinating artist, and the first to treat his late work at length."
Library Journal

230 pp. with 103 full-color and 86 b/w illus. 9 1/2 x 11 3/4 in. / 24 x 30 cm. ISBN 3-7913-1132-8. Cloth. US$65 / Can.$95 £45 / DM 118

Egon Schiele and His Contemporaries
Austrian Painting and Drawing from 1900 to 1930 from the Leopold Collection, Vienna

Edited by Klaus Albrecht Schröder and Harald Szeemann

"…an extensive and beautifully illustrated survey of the art produced in Austria during a unique era." *Austrian Information*

296 pp. with 139 full-color and 59 b/w illus. 9 1/2 x 12 in. / 24 x 30 cm. ISBN 3-7913-0921-8. Cloth. US$65 / Can.$95 / £38 / DM 98

Marc Chagall: My Life - My Dream
Berlin and Paris 1922-1940

By Susan Compton

"Clear plates and intelligent text add insight into a neglected segment of Chagall's oeuvre." *Library Journal*

268 pp. with 80 full-color and 330 b/w illus. 9 1/2 x 11 in. / 24 x 30 cm. ISBN 3-7913-1064-X. Cloth. US$70 / Can.$101.95 £42 / DM 128

Max Ernst
Dada and the Dawn of Surrealism

By William Camfield

"A lavishly illustrated exploration of the life and work of one of the key figures in that eccentrically adventurous moment in modern art." *EFLN Radio*

376 pp. with 146 full-color and 277 b/w illus. 9 x 11 3/4 in. / 23 x 30 cm. ISBN 3-7913-1260-X. Cloth. US$70 / Can.$101.95 £48 / DM 128

Salvador Dalí
The Catalogue Raisonné of Etchings and Mixed-Media Prints, 1924-1980
Edited by Lutz W. Löpsinger and Ralf Michler, with a foreword by R.Descharnes This definitive guide provides all of the information one needs to distinguish authentic prints from forgeries. "If your print is included, it's authentic." *The Times*

262 pp. with 79 full-color and 973 b/w illus. 9 5/8 x 11 3/4 in. / 24 x 30 cm. ISBN 3-7913-1279-0. Cloth. US$120 / Can.$174 / £80 / DM 198

Jean-François-Millet
Summer, The Buckwheat Harvest, 1868-74

Oil on canvas, 85 x 111 cm; signed: J. F. Millet
Museum of Fine Arts, Boston, Gift of Quincy Adams Shaw

This picture by Millet (the second in a series depicting The Four Seasons) serves here as a counter-example. Even in pure landscape such as this, where the attempt to convey atmosphere does not (as is often the case in Millet's work) take on an intellectual or a symbolic value, light and atmospheric phenomena still do not dominate the pictorial conception. The role of the landscape painters of Barbizon in the development of the feeling for nature during the nineteenth century was, of course, considerable, and in this harvest scene the image of the sky, with the thick plume of smoke in the background and the thin grey strands of cloud, is evidence of a new way of seeing nature. Yet the concern here is not with optical entities and their interrelation, but rather with autonomous structures, across the firm surfaces of which the light, here a mild intangible element, playfully casts its spell.

The picture construction in parallel layers, staggered into foreground, middle distance and background, lends the image certainty and stability and, through its air of calm, underlines the sense of security and peace in village life.

Gustave Courbet
The Wave, 1870

Oil on canvas, 80.5 x 99.5 cm; signed: 70 G. Courbet
Oskar Reinhart Collection, Winterthur

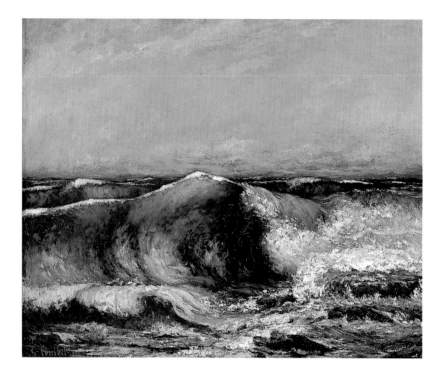

Courbet's Realism, as exemplified by this work, presents a specific natural process as the embodiment of the power of nature, which is to say that a fair amount of Idealism is contained within this Realism. The movement of a turbulent sea is here directed to capturing the "fruitful moment," that is the highest point of the wave's upward surge; this involves a very conscious act of selection in accordance with laws made sacred by tradition. No less conscious is the compositional structure used to convey the approaching masses of water: the edge of the large wave with its tumbling crown of spray is both parallel in position and opposed in terms of movement to the swelling body of the smaller wave in front and to the left. Similarly, one finds a juxtaposition of convex and concave curves. It is significant in connection with Impressionism that the rocks to the right are rendered by means of a looser painterly structure than is the water. Equally significant, as evidence of a new Naturalism, is the close cropping of the composition in spite of its conscious drama.

In the years 1869 and 1870 Courbet produced a number of compositions, some of them very similar to each other, based on the same motif.

Stanislas Lépine
Bridge in a French Town, ca. 1870

Oil on canvas, 51.2 x 41.2 cm
Belvedere-Österreichische Galerie, Vienna

The deep darkness and compactness in the lower section of this picture are characteristic of the early phase of Impressionism, as is also the strong sense of atmosphere in this extract from the street life of a small town. By means of the gray-violet film that veils the sky, the carriages and the more distant houses, and of the dark silhouettes of the pedestrians set off against this background, Lépine succeeds in evoking a sense of painterly lyricism in the everyday world. This is a quality that may be found to accompany the element of Realism in city scenes painted during the first flowering of French Impressionism.

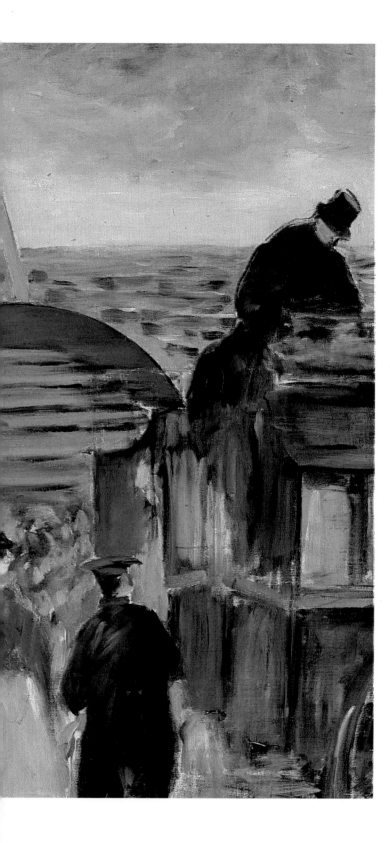

Edouard Manet
The Departure of the Folkstone Boat, 1869

Oil on canvas, 62 x 100.5 cm
Oskar Reinhart Collection, Winterthur

This picture was produced after Manet's great programmatic works of the 1860s, *Olympia* (1863), *Le Déjeuner sur l'herbe* (1863) and the *Portrait of Emile Zola* (1867-68). The monumentality of these images is recalled here in the use of strict parallels in the composition of the superstructure of the steamer. This device is characteristic of Manet's treatment of exterior space from the time of his early bull-fight scenes to the late pictures of the garden of his country house at Rueil. The parallel sloping forms of the funnels serve not only as powerful pillars of the composition but also as an emphatic expression of controlled energy. While it is true that their form and arrangement are pre-determined by the requirements of technology, it is telling that Manet exploits these to the full in this picture, while in later Impressionist painting such elements are often rendered indistinctly or altogether suppressed. In other respects it is clear that the freed forms of fully developed Impressionism have already been achieved in this picture. Manet painted this work during a summer stay at Boulogne-sur-Mer. The figures at the center of the foreground are Manet's wife, Suzanne, and her son Léon Leenhoff.

Edouard Manet

Claude Monet Painting in His Studio, 1874

Oil on canvas, 82.5 x 100.5 cm; signed: Manet
Neue Pinakothek, Munich

This is one of a series of boat scenes produced by Manet in the early and mid-1870s (others include *Argenteuil* and *In the Boat*). It shows Claude Monet and his first wife, Camille, in the boat moored by the bank of the Seine near Argenteuil that he used as his floating studio. Monet is here clearly engaged in painting the opposite river bank.

In the painterly treatment of the water – the free, short parallel brushstrokes very effectively evoking a surface reflecting light – we can already detect evidence of Monet's influence on Manet's own technique.

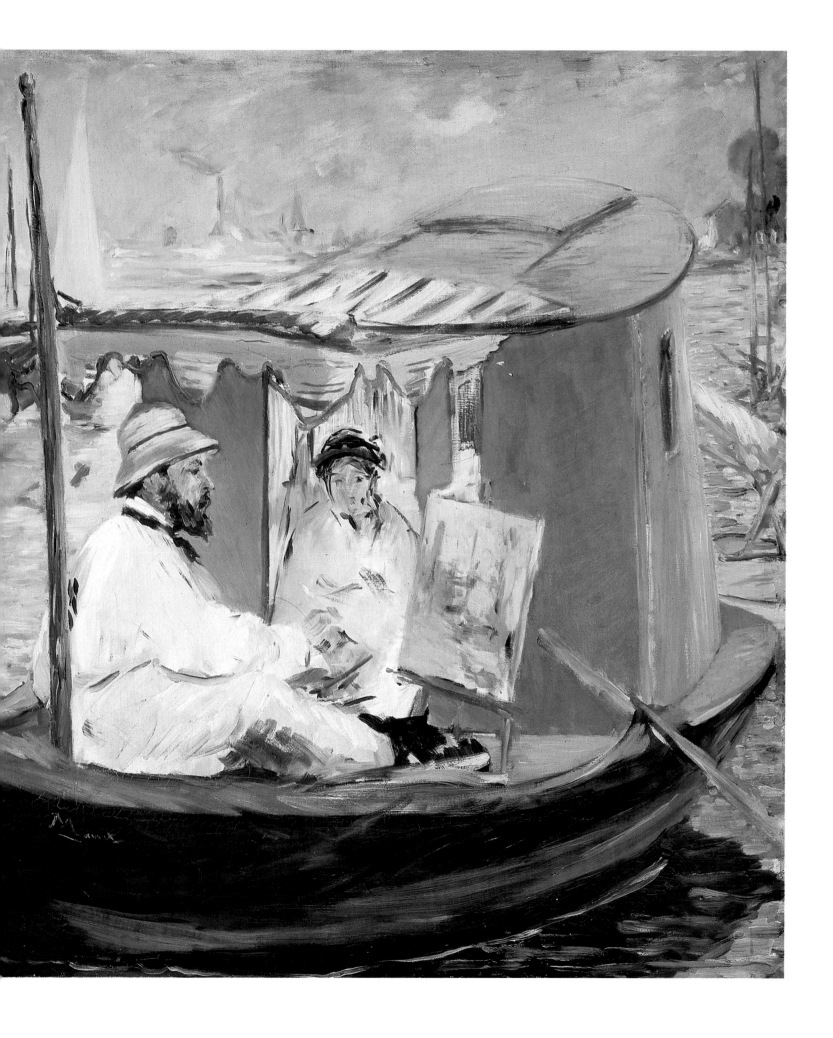

Edouard Manet

Lady in a Fur, ca. 1880

Pastel on canvas, 55.8 x 45.8 cm; signed: Manet
Belvedere-Österreichische Galerie, Vienna

This pastel is one of a group of female portraits (it also includes records of Méry Laurent, Irma Brunner and others) produced by Manet towards the end of his career. These portraits and the late flower still lifes (illus. p. 74) strike us now as the climax of Manet's art. In these images, a moment is elevated into timeless universiatity, a transformation that does not often succeed in Impressionist painting. The monumentality that is to be found throughout Manet's work and his sovereign skill in the rendering of material qualities are here united in a rarely encountered synthesis. In details such as the glint on cheek and ear, the magic of a momentary effect of light is captured with an indulgent degree of verisimilitude, while the qualities of the black hair and the black fur are distinguished in a virtuoso manner. At the same time, the improvised treatment of the background of green foliage and lilac flowers offers us no clue as to whether to interpret this as a real bush or simply a pattern on wallpaper.

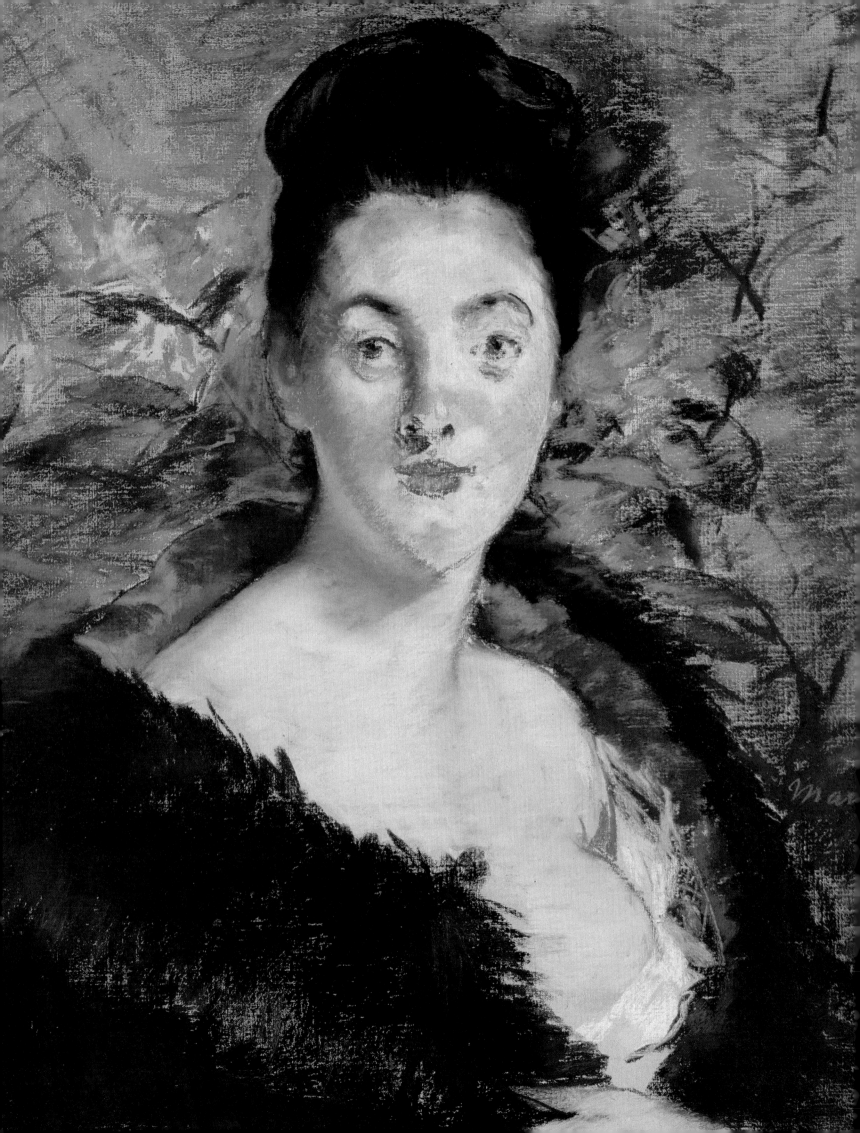

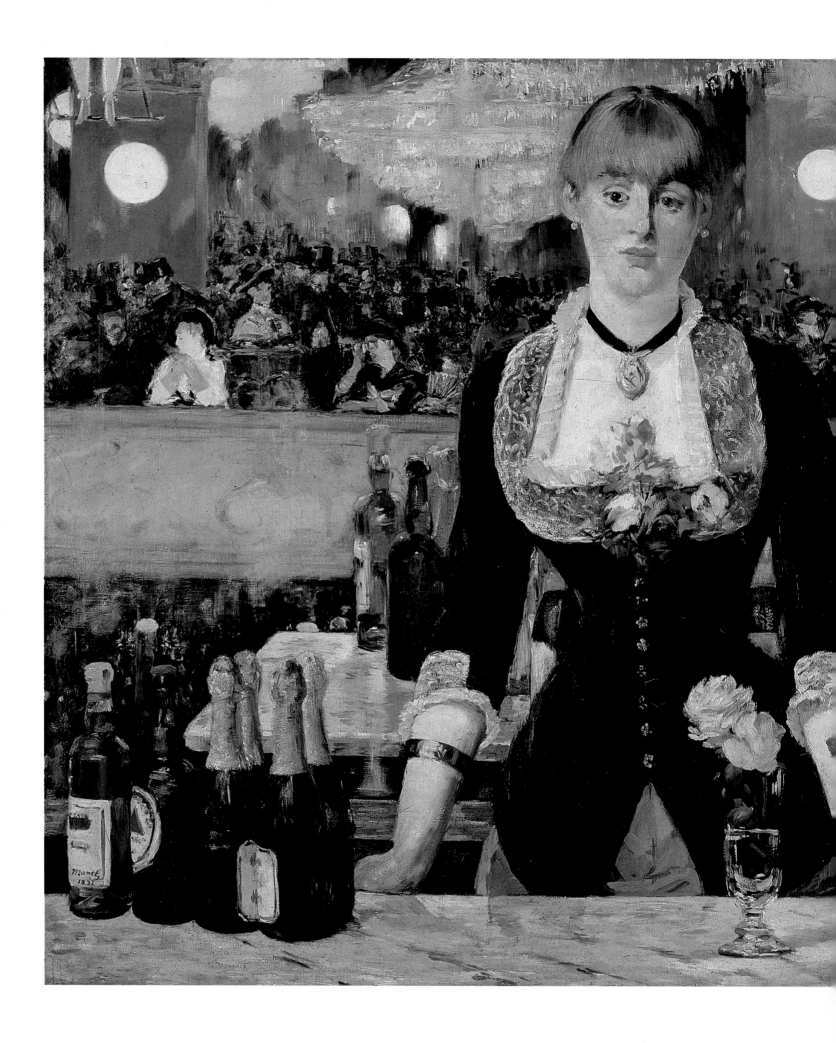

Edouard Manet
A Bar at the Folies-Bergères, 1881-82

Oil on canvas, 96 x 130 cm
Courtauld Institute Galleries, London

This scene from the Paris music hall "Folies-Bergères" is the last and most important of a series of café scenes painted by Manet in the 1870s and 1880s, others including *At the Café-Concert* (1878) and *A Café in the Place du Théâtre-Français* (1881).

In *A Bar at the Folies-Bergères* we again find that strict parallel arrangements dominate the composition, these now intensified in effect through their reflections in the mirror that forms the background. This picture is particularly striking not only for the psychological characterization of the young woman behind the counter, "Suzon" (who engages the spectator with her impassive gaze), but above all for the ambiguous character of the picture construction. It is impossible to locate with certainty any aspect of either the real or the reflected scene. A study for this picture, made in 1881, is now in the collection of the Stedelijk Museum in Amsterdam. E.D.

Edouard Manet

Carnations and Clematis in a Crystal Vase, 1880-83

Oil on canvas, 55 x 34 cm; signed: Manet
Musée d'Orsay, Paris

In this flower piece, too, the background may to be under-
stood as an element of the unreal: in front of its uncertainty,
a fragment of nature blossoms and sparkles with all the clarity
and freshness of reality. Such a contrast is already to be found
in Manet's earlier work, for example in the figure of the *Fifer*
(1866), who stands in front of an undifferentiated blue-gray
background, by no means distinguished from the floor.

Manet's reliance on this device (also to be found in the
work of the Old Masters, for example in Vermeer's *Girl with
a Pearl Earring*, now in the Mauritshuis in The Hague) shows
how, in certain respects, he was not an Impressionist. Yet, this
still life reaffirms the greatness of Manet as an Impressionist,
above all in his virtuoso treatment of light and the material
qualities of the crystal vase.

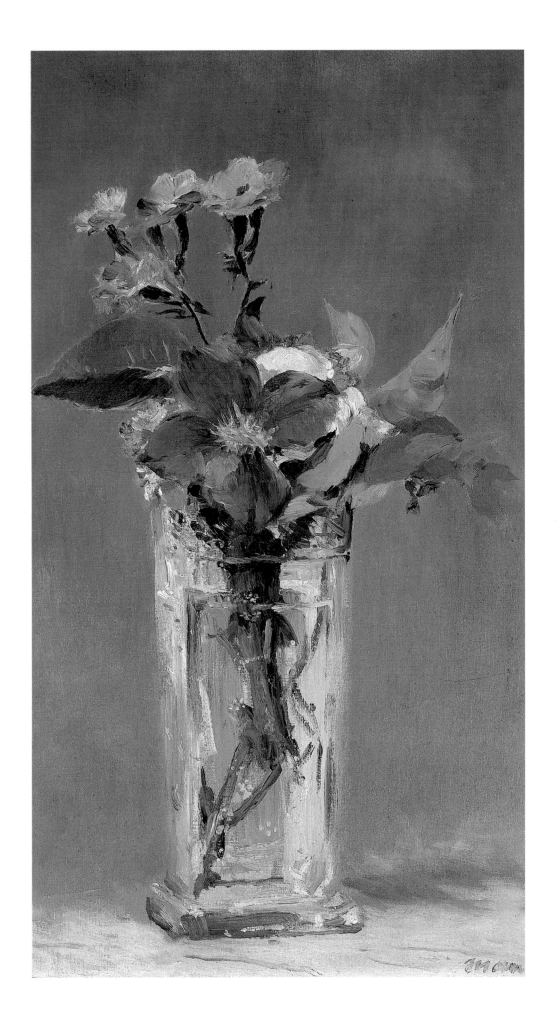

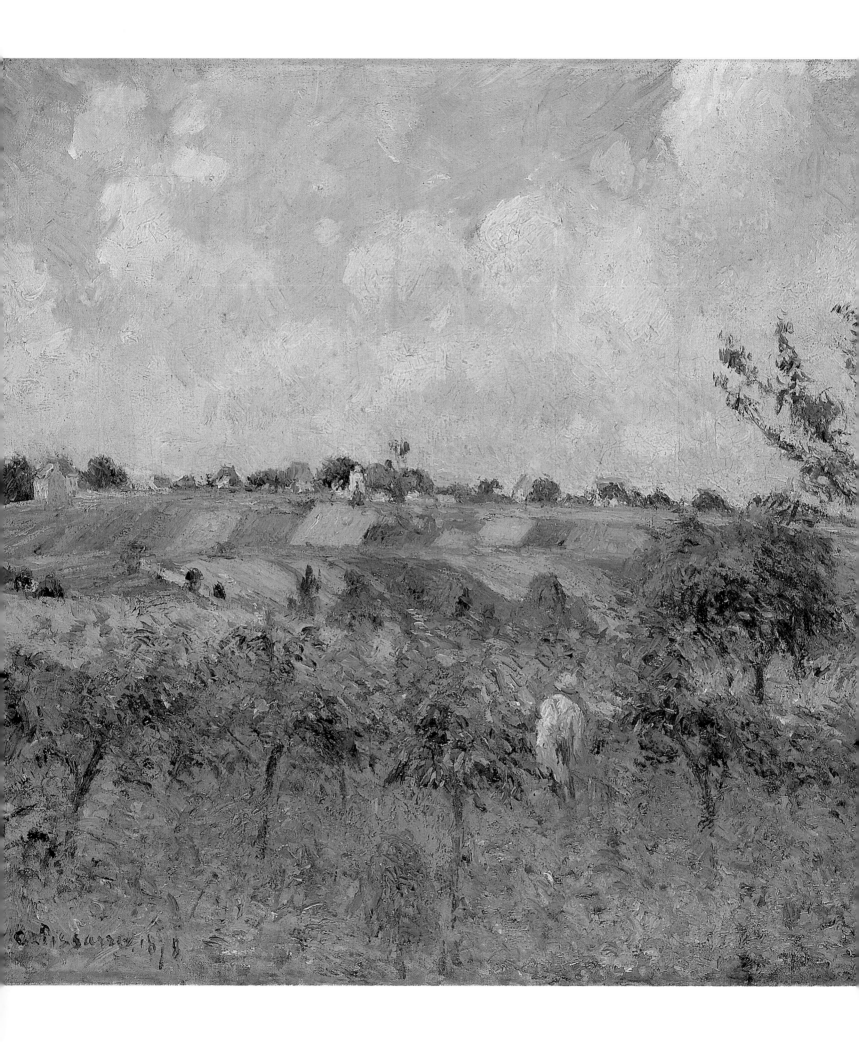

Camille Pissarro
Landscape near Pontoise, 1874

Oil on canvas, 61 x 81 cm; signed: C. Pissarro 1874
Oskar Reinhart Collection, Winterthur

While it is true that this landscape anticipates much subsequent development towards an Impressionist loosening of structure and lightening of tone (in the rendering of the foliage, for example, or of the cloudy sky), it evinces non-Impressionist characteristics in its overall structure. This is above all the case with the emphatic parallel layering in the arrangement of the houses and the stretch of land in front of them and with the marked lack of fluidity in the curve of the path in the foreground. The sense of movement in the perspectival recession of space is subdued in favor of a calm graduation in depth, basically echoed by the colors. For this reason, this landscape may be regarded as one of a group of works in which Pissarro (as never before and like no other Impressionist) approached certain tendencies in the painting of Cézanne, who reciprocated in adopting elements of Pissarro's style. This phenomenon is at its most striking in several landscapes painted by Pissarro in Pontoise in the later 1870s.

Camille Pissarro
The Evening of Mardi Gras in Boulevard Montmartre, 1897

Oil on canvas, 54 x 65 cm; signed: C. Pissarro 97
Kunstmuseum, Winterthur

When the Impressionists painted scenes of Paris or London, they saw a particularly exciting challenge in mastering the representation of street life. Here there was the chance to combine a sense of the life of a milling crowd that of atmosphere and light. In the process the predominance of nature and the subordination of man within his environment could be demonstrated. This approach rarely succeeded to such an extent within Impressionist painting as in this street scene by Pissarro, it being evident that this extent is largely dependent on the character of the event depicted. We are shown not only the bustling metropolitan crowd in Boulevard Montmartre (a street often depicted by Pissarro) but an extreme form of this crowd – caught in the clamor of the evening of mardi gras. The confusion and the crush is here conveyed through the application of strips and spots of color. In the strands and tangles of ribbon in the trees, one can still recognize wind-tossed streamers; but out of the muddle of blue-black spots, even those of the foreground, no single human figure can be distinguished.

If measured against the work of Pissarro's preceding period, where colors from right across the spectrum were pointillistically applied, this picture of 1897 appears restrained; but the austere tones evocative of coming spring provide a very effective contrast with those of the sparkling throng. This sort of multi-layered composition demonstrates the rich possibilities open to Impressionist painters seeking to render the spirit and life of a city scene, in spite of their determination to restrict themselves to what could be perceived by the eye.

Claude Monet
La Gare Saint-Lazare, 1877

Oil on canvas, 75.5 x 104 cm; signed: Claude Monet 77
Musée d'Orsay, Paris

In 1877 Monet painted a series of views of the Gare Saint-Lazare. This was not the first time that he had rendered a single motif in a number of variations, and this approach was not unknown previously. By this means, it was possible to represent systematically the alteration to which things were subjected as the light, the time of day or the season itself changed. Monet employed this approach most rigorously in the various celebrated series on which he embarked in the 1890s – in the views of Rouen Cathedral, in the "Haystacks" and in the "Water-lilies" (illus. p. 84). In his series of pictures of the Gare Saint-Lazare, Monet does not yet pursue the implications of this approach to their logical conclusion, above all in that the human figures, and the engines and carriages of the trains are obtrusively different on each occasion. The concept of variation is thus only concentrated in a less doctrinaire way, on the mutability of the phenomenon of light; the picture is, moreover, concerned with the incessant coming and going observable at any large metropolitan terminus. On ist own, such a picture contains as much characterization of individual things as can be reconciled with the predominance of the painting of light.

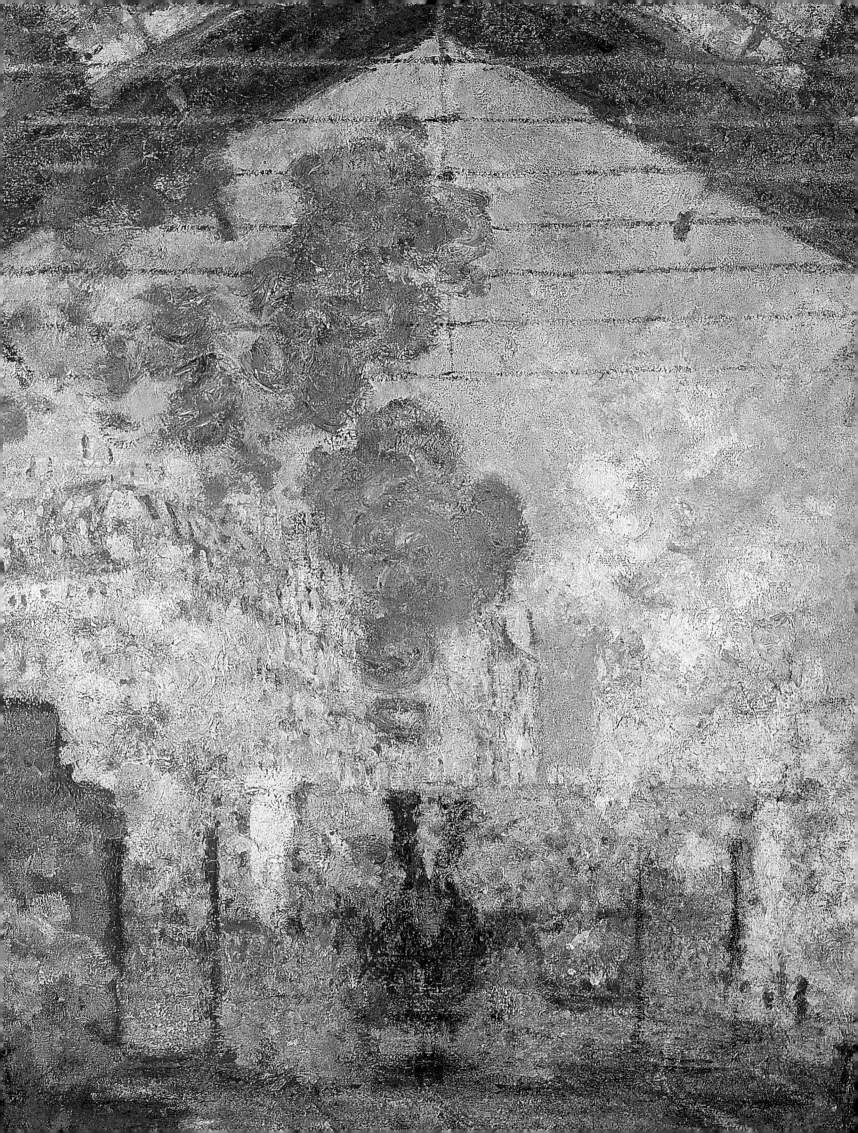

Claude Monet
A Path in the Artist's Garden, 1902

Oil on canvas, 89.5 x 92.3 cm; signed: Claude Monet 02
Belvedere-Österreichische Galerie, Vienna

This picture, showing part of Monet's garden at Giverny, is
a representative example of the style of his last decades. A
relatively stable compositional structure is still in place here,
although the painterly veiling is far more exaggerated than
in earlier works. A particularly notable new element is the
intense degree of brightness deriving from the juxtaposition
of strong colors, above all the emphasis on the violet of the
flowering bushes. This introduces a new value into Monet's
work – the decorative.

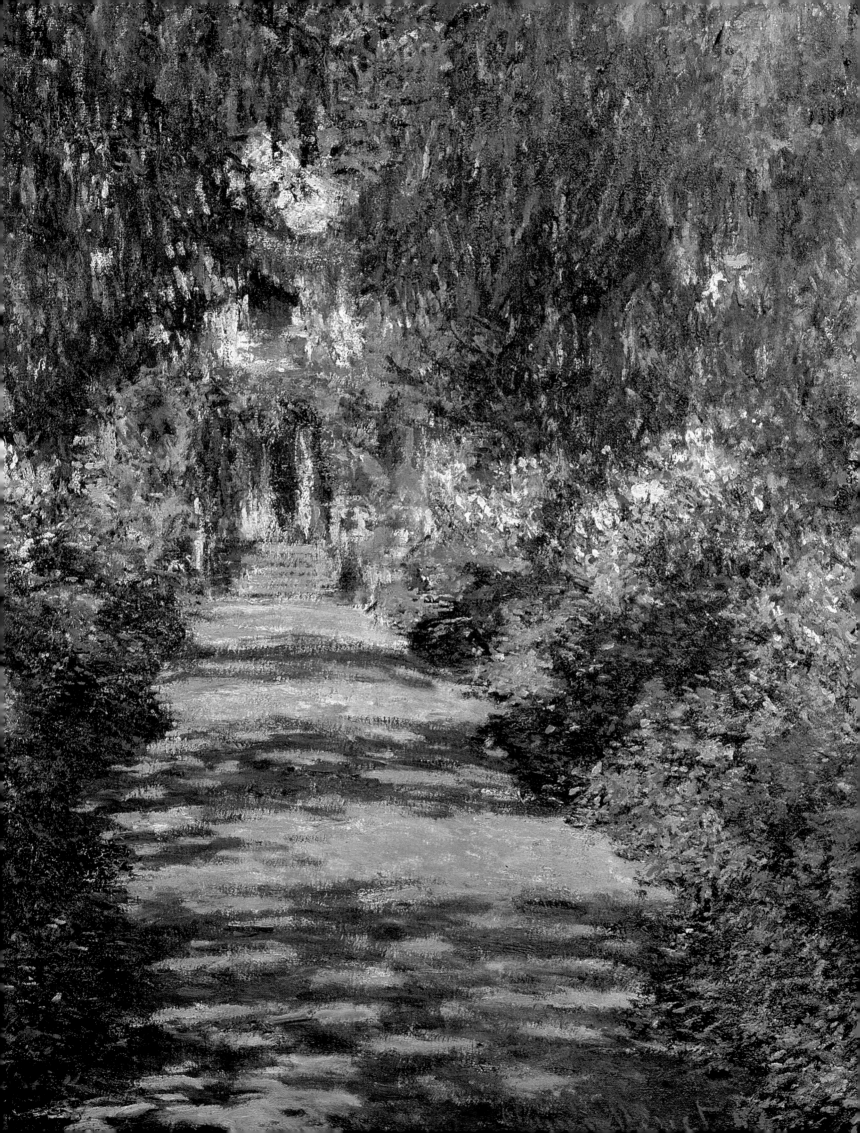

Claude Monet
Water-lilies (Nymphéas), 1904

Oil on canvas, 90 x 92 cm
Musée des Beaux-Arts, Caen

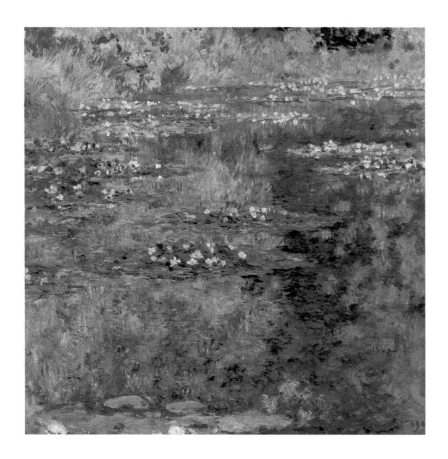

Monet's late work culminates in the series of water-lily pic-
tures, painted from 1897 onwards at Giverny. Everything
surrounding the pool itself – dangling twigs and branches,
plants growing along the bank, clouds in the sky above – is
reflected in the smooth surface of the water, thus producing
an independent "mirror landscape." Any real sense of what is
"above" or "below" is confused; objects become their own
reflections. Monet's reduction of his subject to an ostensibly
limited extract from the observed natural world, the equal
value invested in the real and the reflected, and the large
scale and lack of obtrusive framing all make the water-lily
series an important precursor of the devices characteristic of
Modernism.

In 1927, nineteen water-lily pictures, donated by Monet to
the French state, were put on public display in the Orangerie
des Tuileries in Paris. E.D.

Alfred Sisley
Small Square in Argenteuil, 1872

Oil on canvas, 46.5 x 66 cm; signed: Sisley 1872
Musée d'Orsay, Paris

This view of a small town is a characteristic example of the classical early phase of French Impressionism. Sisley, who is regarded as the most lyrical of the Impressionist landscape painters of France, has here conveyed the idyllic quality of his motif in a thoroughly Impressionist spirit, above all as regards the magic of the light, in this case a dull gold sunlight that casts long shadows. Here, light and the bodies on which it falls have already become one: virtually the whole composition appears as if calmly assembled out of lit and shaded planes and bright reflections. The elongated diagonals of the cast shadows, the sloping lines of the tiled roofs and the perspective recession of the street thus all appear to belong to the same category in the overall construction of the scene, whether this is considered in terms of depth or of the picture plane. The strong sense of perspectival recession is represented without any great alteration to the many broken edges and facetted planes; yet the foreshortening and the low viewpoint are not used to prompt a sense of movement, but rather the overall system of weights and counter-weights creates a feeling of calm and balance. In the treatment of the figures there none the less remains a trace of the anecdotal.

Alfred Sisley

The Bridge at Moret-sur-Loing in Stormy Weather, ca. 1887

Oil on canvas, 50 x 65 cm; signed: Sisley
Musée des Beaux-Arts, Le Havre

In many respects this picture embodies the opposite of what is most essential in the scene of *Small Square in Argenteuil* (illus. p. 87). In the view of Moret-sur-Loing the light appears to be as animated and flowing as the water of the river and the wind driving the clouds. In the same way the diagonal lines of the bridge and the low viewpoint this time function as unsettling elements. Though the light and masses within the composition constitute no less of a unity than in the other picture, Sisley here renders another sort of lighting, quite apart from the many differences in his means of representation. This development allows us to perceive how different types of light were favored at different periods in the course of Impressionism; and this is an essential aspect of its history and that of the various further developments to which it led. Clear, calm sunlight casting sharp shadows and the shimmer of illumination that appears to "dance": these, respectively, are the first and last manifestations of the Impressionist rendering of light.

Sisley lived at Moret-sur-Loing (not far from Fontainebleau) for the last twenty years of his life. The small town itself, its old bridge and the surrounding river landscape provided him with the subjects for a long series of paintings made during this time.

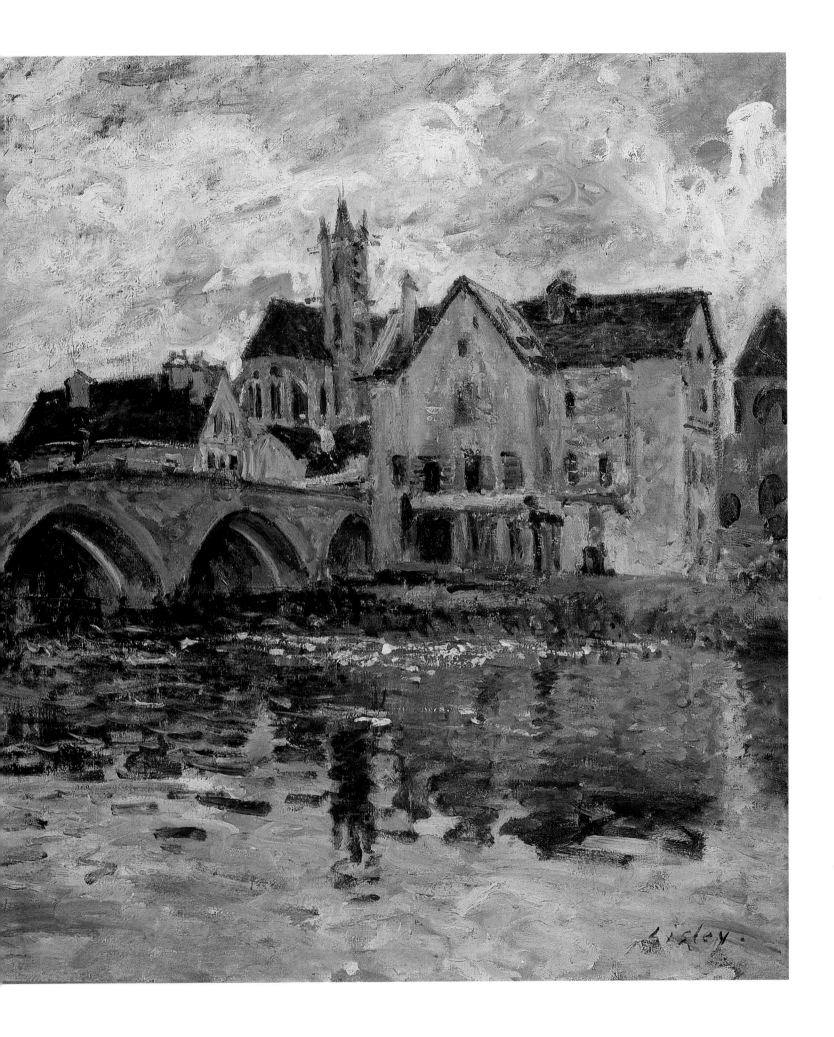

Alfred Sisley

Spring at Moret-sur-Loing, 1892

Oil on canvas, 38 x 55 cm; signed: Sisley
Musée d'Orsay, Paris

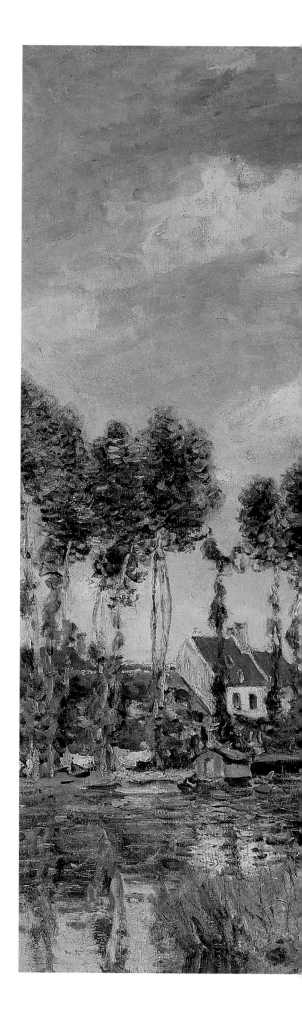

This spring landscape is one of those pictures from the late stage of Impressionism in which all the contrasts that establish the liveliness of the two earlier pictures by Sisley (illus. pp. 87-88) are subdued in the interests of a unifying fullness of light. Gentle, warm sunlight on bright spring foliage – this is the real subject, the essence of this landscape. There is a telling contrast contained within the composition, however, between the complementary colors green and red, that more or less openly pervades the entire color construction of the picture. This has nothing of the strictness of the Neo-Impressionist division of color. Sisley never adopted this approach in his work. In many of his late landscapes, however, he did introduce simplifications of form and intensifications of color that brought both decorative elements and a distinct planarity to his compositions.

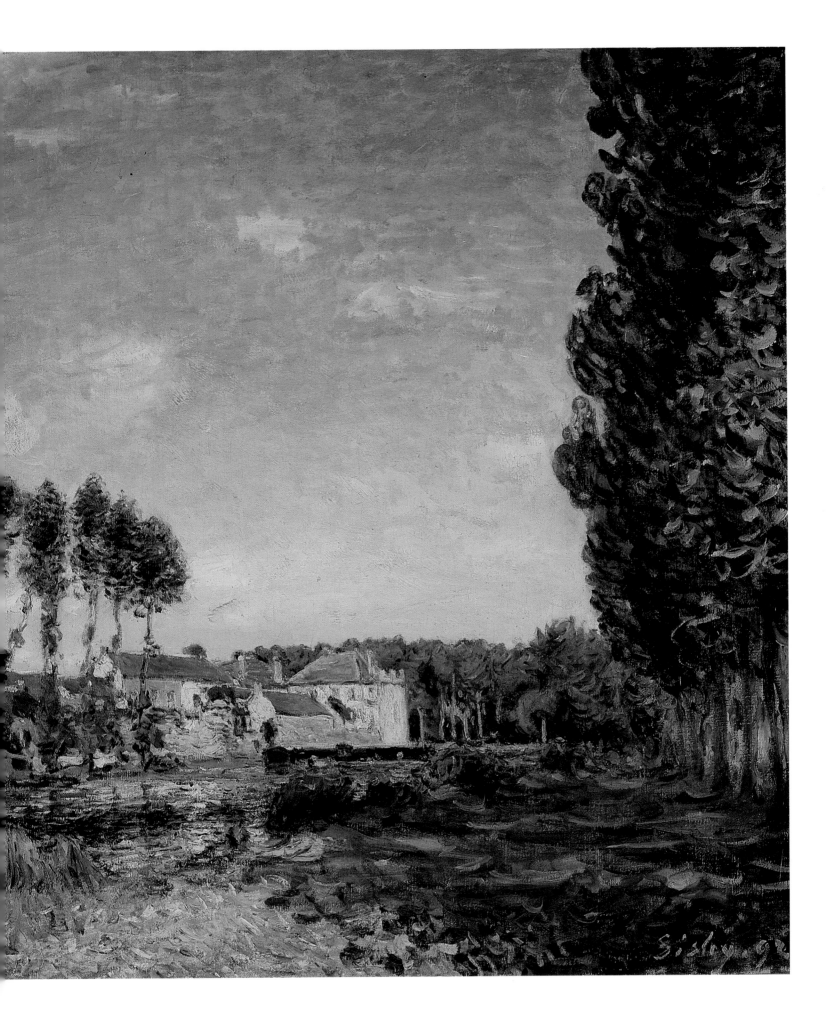

Edgar Degas

Jockeys Lining Up for the Start, 1862; overpainted 1882

Oil on canvas, 48.5 x 61.5 cm; signed: Degas 1862
Musée d'Orsay, Paris

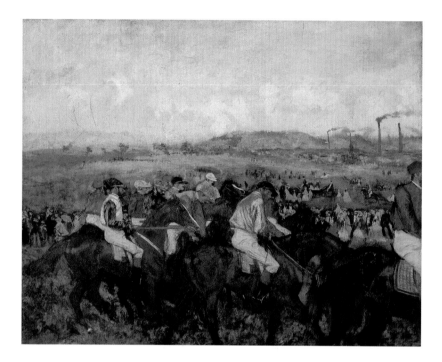

This is one of the earliest in a long series of pictures by Degas
recording aspects of life at the racecourse. As in all the artist's
work, outline and line in general are the principal elements in
the composition, everything else being subordinated to them.
This characteristic is especially clear here in the emphatic di-
vision between the group of jockeys in the foreground and
the landscape beyond, peopled with much smaller figures.
As in many contemporary works by Edouard Manet, we find
here none of the spatial continuity within the picture or the
unity of figure and landscape that seems to occur as a matter
of course in fully developed Impressionism. The sketchy rep-
resentation of the spectators is in sharp contrast to the graphic
treatment of the figures in the foreground. Momentary im-
pressions of the movement of animals and human figures are
captured with the utmost precision; and, in the frieze-like row
of jockeys in the foreground and the crush of figures in the
background, it is clear that Degas had taken the Old Masters'
lessons of classical composition to heart. One is reminded of
the stately cavalcade in Benozzo Gozzoli's *Adoration of the
Magi* fresco in Palazzo Medici in Florence.

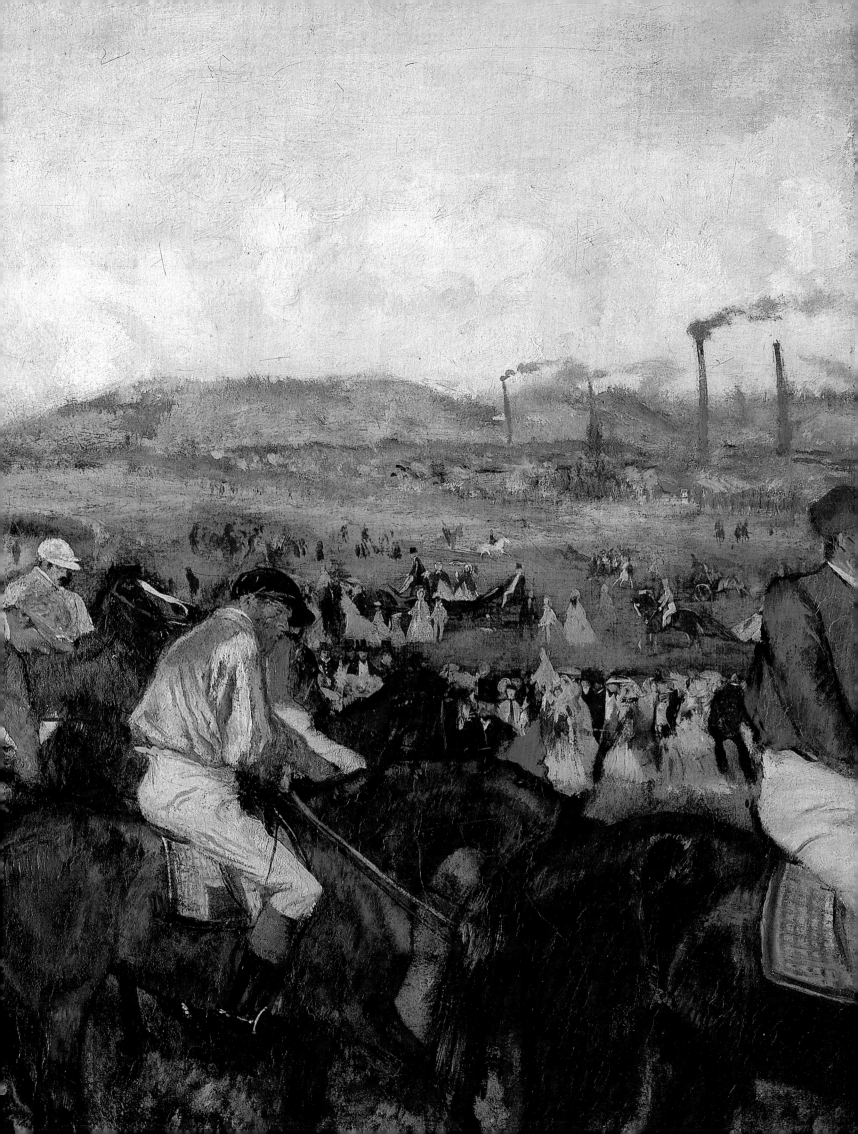

Edgar Degas
Dancer in a Green Tutu, 1880-85

Pastel on paper, 46.9 x 33 cm; signed: Degas
The Art Institute of Chicago, Bequest of Mrs. Diego Suarez

The work of all the great Impressionist painters may be found to end in the exaggerated use of color. The distinguishing characteristic in the later phase of the career of Degas is to be seen in the perpetual modification of the treatment of a small number of subjects – ballet dancers and women bathing – with color taking over from line as the principal means of capturing these. It is true that certain elements endure throughout the œuvre, for example the enchantingly smooth and effortless play of curves. None the less, the modeling of form that is so important an element in the early work, and that still contributes to the gently schematic alterations in pictures such as *Laundresses Ironing* (illus. p. 97) and *Harlequin and Columbine* (illus. p. 98), is now almost entirely subsumed in a veritable storm of incandescent hatching strokes and marks, while the figure outlines are often submerged in clouds of color. This is an effect achieved by Degas through the process of smudging and rubbing the pastel markings, this None the less resulting in yet another sort of modeling. In the extreme example of these pictures with ballet dancers standing in the wings, the more important function of this approach is the play of colors that almost attain the intensity of fireworks. Their use is in keeping with the very summary treatment of the bodies and the rendering of space. Such simplification is, however, distinct from characteristically Impressionist processes of reduction. In these scenes with ballet dancers, the bodies are in fact reduced to their most basic form; but, as they are as precisely fixed in the artful poses of dance as are those to be found in the earlier work of Degas, they are often suggestive of visions of ghostly creatures. This is one of the few cases where elements of Impressionism are accompanied by an air of the demonic. (A similar phenomenon is to be found in painting before Impressionism, in the work of Adolphe Monticelli.)

The refined use of pastel, as a means of achieving such effects, plays an especially important part in the late work of Degas. His technique, none the less, often came near to his use of oil paints at this time, and he often mixed the two.

Edgar Degas

Laundresses Ironing, 1884-85

Oil on canvas, 82.2 x 75.6 cm; signed: Degas
The Norton Simon Arts Foundation, Pasadena

Degas took up the theme of women washing or ironing clothes in a small group of pictures painted in the 1880s. In these one can detect the penchant for the literary, the narrative, that was to recur in various forms until the end of his career, even though terms such as "literary" or "narrative" are almost exaggerations in view of the self-imposed restraint to be detected in such works. In Degas's pictures there is always some narrative, unavoidable in the work of a Realist who seldom portrayed anything but human figure. Only occasionally – as in the example shown here – is narrative rather more significant. Even here, however, the crucial factor remains the outer appearance of the figures and their activity; the painter is not concerned with this activity or its deeper meaning beyond his concern with these as his motif. The virtuoso use of line is here combined not with relatively dense modeling (as in the previous example), but rather with delicately shimmering planes of color.

Edgar Degas

Harlequin and Columbine, ca. 1884

Pastel on paper, 42.8 x 42.8 cm; signed: Degas
Belvedere-Österreichische Galerie, Vienna

The figures here are inserted into the square picture format
with the certainty and stability of composition of a metope in
Antiquity. Both outlines are filled out with the glimmer of
rather unrefined, broken colors, which are then gradually
intensified: to a warm yellow in the pierrot's costume and
to a sky blue in Columbine's stockings and skirt.

Auguste Renoir
Woman in a Veil, ca. 1877

Oil on canvas, 61 x 51 cm; signed: Renoir
Musée d'Orsay, Paris

Renoir's most truly Impressionist period occurred around the mid-1870s, its most mature and richest fruits being *La Loge* of 1874 and *Moulin de la Galette* of 1876 (illus. p. 102). His picture of a woman in a spotted veil has the same painterly charm as these works, but here we find the resonant splendor of color replaced by the gentler tones suited to a more intimate portrayal. A large section of the picture, that taken up by the checkered shawl, is black and white; but this area of monochrome is incorporated within a setting of relatively subdued colors and is thus itself perceived as an area of colored tone. (There are well-known models for such a solution, for example in Goya's *Portrait of Queen Maria Luisa*.) In Renoir's picture, the shimmering web of dry brushmarks effectively unifies the different parts of the costume. It naturally also engenders an impression of space and airiness, but such illusionism, derived from the structure of Impressionist painting, rarely serves as the expression of so much spirit as is to be found in this momentary image of a woman passing by, her "lost profile" worthy of a figure painted by Watteau in its delicacy and tenderness.

Auguste Renoir
Moulin de la Galette, 1876

Oil on canvas, 131 x 175 cm; signed: Renoir. 76
Musée d'Orsay, Paris

This, one of Renoir's greatest paintings, is a record of the famously high-spirited gatherings at the "Moulin de la Galette," a celebrated open-air café-dansant in Montmartre.

In spite of both the crush of figures in the scene and the dynamism of the movement, the overall effect is not one of unrest because of a balanced composition that ensures that the individual figures fall into roughly circular groupings. A few of these figures, among them several of the artist's painter friends, emphatically look out at the spectator.

A very close variant, painted in the same year, and originally owned by Victor Choquet, was sold to a private collector in Tokyo in 1990. E.D.

Henri de Toulouse Lautrec

Yvette Guilbert Singing "Linger, Longer, Loo", 1894

Oil thinned with turpentine on cardboard, 58 x 44 cm;
signed: T-Lautrec 94
Pushkin Museum of Fine Arts, Moscow

As a frequent visitor to the cabarets, cafés and dance halls of
Montmartre, Toulouse-Lautrec recorded many of the perform-
ers he encountered there, including the singer Yvette Guilbert.
This image was used as one of sixteen plates in Toulouse-
Lautrec's album of lithographs devoted to Yvette Guilbert
(published 1894) and also appeared as an illustration in the
Paris magazine *Le Rire.* The sense of the momentary in the
treatment of gesture and the distinct arabesque of the outline
reveal the influence of Japanese wood-block prints, while
also aligning the image with the contemporary devices of Art
Nouveau. The work is at its most distant from Impressionsim in
the loose, sketchy quality of the application of color, which is
very effectively suggestive of incompleteness. Many of the of-
ten unusual forms of cropping employed by Toulouse-Lautrec
were inspired by the effects obtained by photography.

Vincent Van Gogh
View of Paris from Montmartre, 1886

Oil on canvas, 38.5 x 61.5 cm; signed: Vincent
Kunstmuseum, Basel

Van Gogh's engagement with Impressionism during the two years of his stay in Paris (from March 1886 to February 1888) resulted in work that was quite varied in character, reflecting distinct aspects of Impressionism itself. Particularly notable is the contrast between the use of color in restrained, graduated tones and a Pointillist readiness to juxtapose colors from right across the spectrum.

In this view from Montmartre with its many gentle gradations of gray, ocher and a broken terracotta, the colors – above all, the use of olive green tones – recall those of Van Gogh's earlier, Dutch period. Another contrast within Van Gogh's Impressionist works is that between an impulsive,

personal graphic "handwriting" in the brushwork and the consciously impersonal, more "objective" method of Pointillism. Although this method attracted Van Gogh's interest he soon made its devices very much his own with the power and restlessness of his graphic expression. In this picture, we find Van Gogh's distinctive use of line – the real province of his art – already almost fully developed. All that has yet to emerge is the emphatic use of contour. Within Van Gogh's œuvre, a work such as this may be seen as both an early and a late form of Impressionism. It has much in common with the early variant of Impressionist painting to be found in the late work of Charles-François Daubigny.

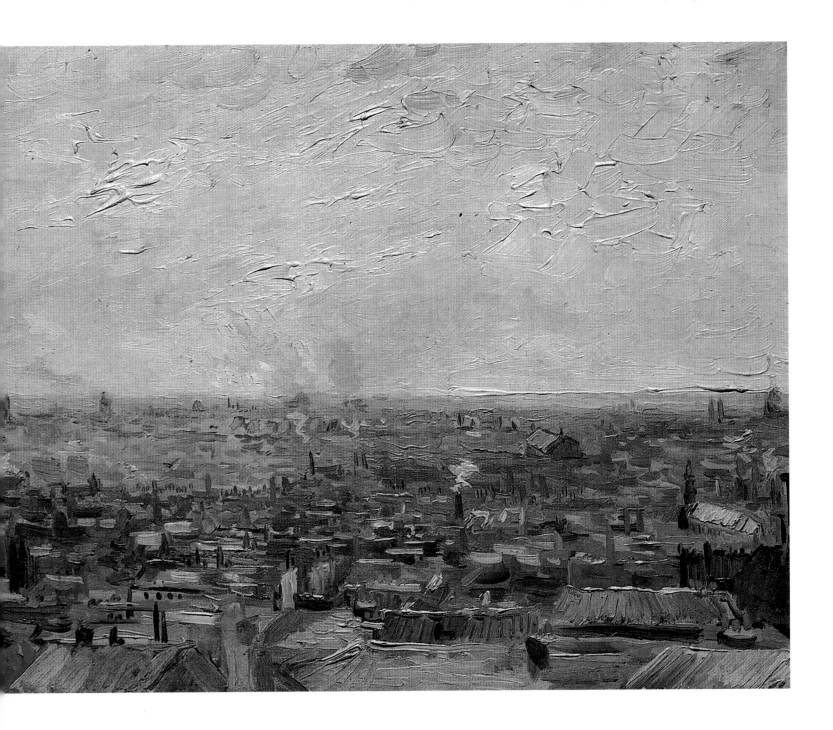

In Van Gogh's picture, as was later increasingly to be the case in his views of Arles and the plains around that city, the artist has used the strong line of the horizon to establish a sharp demarcation between earth and sky; in this case he has merely somewhat softened the sharpness of the division by interposing a veil of haze. More crucial to this view of Paris, in comparison with later works by Van Gogh, is a sense of certain aspects of his response to the view being held in check (this corresponds to what is found in the treatment of space in a particular type of Impressionist landscape painting). Here, only the roof and sails of the windmill at the extreme left rise above the horizon, while in comparable later pictures entities in the foreground are opposed to the sharp straight line of the horizon, their rapid sequence of foreshortenings generating a sort of arpeggio of spatial depth. In contrast to the large differences of scale between foreground and background in the later pictures, the layered depth of the Paris panorama allows only relatively insignificant shifts of this sort.

This is one of a small group of similarly expansive views from Montmartre that Van Gogh painted while he was in Paris. In these works topographical detail is recorded with a relative degree of accuracy, and particular buildings – the windmill "Le Radet," the dome of the Panthéon and the roof of the Opéra – can be identified.

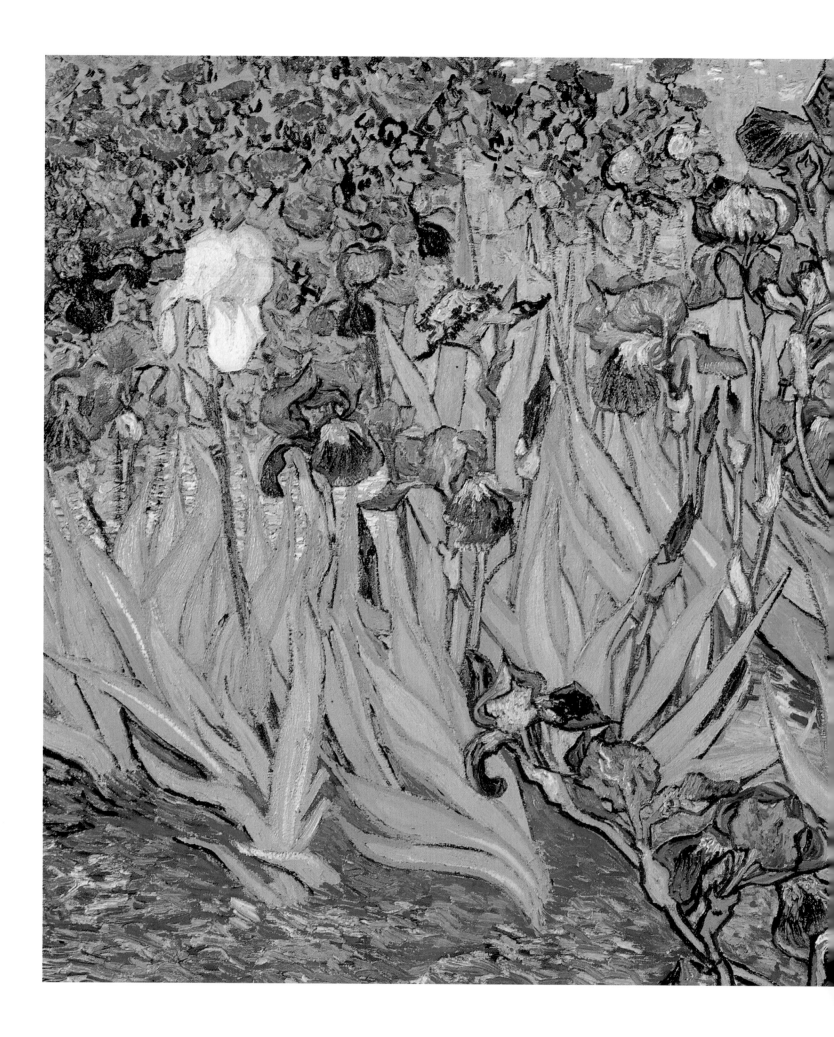

Vincent Van Gogh
Irises, May 1889

Oil on canvas, 71 x 93 cm; signed: Vincent
Joan Whitney Payson Gallery of Art, Westbrook College,
Portland, Maine

letters to his brother Théo from the asylum at Saint-Rémy, dated 9 May 1889, Van Gogh speaks of working on two pictures, "on violet irises and on a lilac bush, two motifs that I found in the garden here." This picture of irises is a "piece of turf" of the type often painted by Van Gogh during his stay at Saint-Rémy. These were small pieces cut out of flower beds and cornfields, sometimes complete with insects; and the resulting pictures are effectively hybrids, located somewhere between still life and landscape. This is an unusual genre. In effect, it is a particular form of the sharply cropped view down on to the subject that frequently occurs in Impressionism; and, in its treatment of space, it has one of its sources in the model of the rendering of plants in Japanese wood-block prints. Van Gogh's close-ups and enlargements of this sort are, however, essentially different from comparable Impressionist examples in that he is less concerned with the surprising forms of cropping than with the object itself (the single plant, a bunch of flowers or, as in several celebrated still lifes, a pair of peasant's clogs or a bowl with fruit), which is presented to the viewer with an almost blunt immediacy.

Vincent Van Gogh

The Plain at Auvers-sur-Oise, June 1890

Oil on canvas, 50 x 101 cm
Belvedere-Österreichische Galerie, Vienna

In a letter to Théo dated 30 June 1890, Van Gogh speaks of working on this picture, also mentioning a pen drawing made after the finished painting. The subject treated here – the visual and emotional encounter with a wide plain broken up into variously colored long plowed strips – had been adopted on countless occasions by painters during the 19th century, as also in a more classical, earlier period associated with such themes, in Holland in the 1600s. While the content of the picture in terms of significance or experience was not at all new by 1890, Van Gogh's response to this subject does make use of an entirely novel painterly language. The technique alone – in essence, less a form of painting than of drawing, a sketchily pastose brush drawing of rare brutality – has the effect of a radical renunciation of the entire 19th-century inheritance. This graphic brushwork goes beyond the virtuoso techniques of foreshortening associated with Impressionism, just as the brightness of the picture as a whole surpasses the brightness of the Impressionist painting of light. In this image of the plain, the multiplicity of the greens, yellows and blue-greens of the fields yet to be sown or already harvested are not to be understood (as in a comparable Impressionist landscape) as optical gradations in a shimmering web of color that fills out of the entire picture plane, but rather as tones determined by the specific plants that each represents. These tones are elements in an exceptionally communicative chromatic language: the unrealistically even, dense greenish blue of the sky, like the other colors on to which it radiates, corresponds to the characteristic summer coloration of the plain. In painting of this kind, however realistic in essence, illustrative Realism no longer has a role to play. The very opposite of Impressionism

in Van Gogh's work can be detected in the character of this sky alone. It is so emphatically green in tone because the green here has the brutal force of a dominant color that inundates everything in the composition. A chromatic inundation, or impregnation, of this sort frequently also overcomes the human figures in Van Gogh's pictures, for example some of the peasants painted after Millet or the green image of the man in Rowing Boats on the Banks of the Oise.

In Van Gogh's picture, however, even the power of the color is perhaps surpassed by the violence of the graphic means of conveying spatial perspective. We seem to be confronted with exposed currents of force that form the waves of the plowed land and, at the same time, draw them into the depth of the composition. Where these lines meet the horizon, Van Gogh adopts two different solutions: in the left half of

the picture the sharp foreshortenings eventually disappear, but on the right a dark row of bushes sets the land off against the sky in the form of two shallow arcs. This device recalls the way in which the masters of the Danube School showed the undulation of a row of hills as a sequence of flat curves against the sky. In Van Gogh's picture this outcome may be associated with a new and particularly expressive Primitivism, while the diminishing foreshortenings on the left belong to the sort of perspective that also defines the rendering of space in Impressionism. The latter is more naturalistic than the former, but in both one finds the same impact of the opposition between the turbulent forms of the terrain and the emptiness of the sky. In both pictures the chromatic harmony and the fine gradations in the green tonality make clear to what extent Van Gogh as a colorist was indebted to Impressionism.

Paul Cézanne
The Little Bridge, ca. 1880

Oil on canvas, 58.5 x 72.5 cm
Musée d'Orsay, Paris

This is one of the pictures from that period in Cézanne's career when the evolution of his specific approach to painting can be regarded as newly complete. In as far as Cézanne's further development brought forth all manner of intensification and modification, the solutions established around 1880 cannot be termed "definitive." None the less, Cézanne's style of this period is definitive in the sense that everything essential in distinguishing his work from Impressionism is already present. One would have to acknowledge that the Impressionist basis of such a picture still emerges clearly at every point, and certainly much more clearly than was later to be the case. It is even possible that, on a cursory examination, The Little Bridge might well be classified as an Impressionist landscape. On closer inspection, however, one finds, throughout the composition, the evidence of a new way of seeing nature (in comparison with that of Impressionism) and of an entirely new significance invested in the pictorial "organism."

Paul Cézanne
Seven Bathers, ca. 1900

Oil on canvas, 37.5 x 45.5 cm
Beyeler Collection, Basel

One of the largest thematic groups within Cézanne's œuvre consists of paintings of bathers. He started to produce such compositions in the 1870s and a total of over a hundred very varied oil paintings, drawings and water colors have survived. The harmonic integration of the figures into the landscape, deriving from the pastoral tradition, may be found to give way to an increasingly carefully incorporated language of gesture and pose. This development culminated, in and after 1900, in the rigorously triangular composition of the "Large Bathers" pictures. E.D.

Paul Cézanne
Château Noir, 1904-06

Oil on canvas, 73.6 x 93.2 cm
The Museum of Modern Art, New York, Gift of Mrs. David M. Levy

This is a characteristic picture from the last phase of Cézanne's career. It also takes as its subject a motif which is among those most frequently recurring in his later work: the Romantic château near Aix, built in about 1850 but left unfinished, and shown surrounded by woods and against the background of Mont Sainte-Victoire.

Cézanne here goes beyond his approach to composition in an earlier picture such as *The Little Bridge* (illus. p. 113) in only two respects. Firstly, the later picture is less compact, both in terms of its technique and thus also in terms of the treatment of material qualities. We may associate this development with the frequently evidenced path towards an increasing dematerialization and an easing of technical and formal strictness. Secondly, a much admired peculiarity of Cézanne's painting is here evolved to its final perfection: the absolute equality in value of all parts of the picture. These are not only the defining characteristics of particular works; they are also aspects of a new principle of creation, new above all in relation to Impressionist painting, for there the principle of construction based on the emphasis on distinct parts of the picture led to an entirely different result.

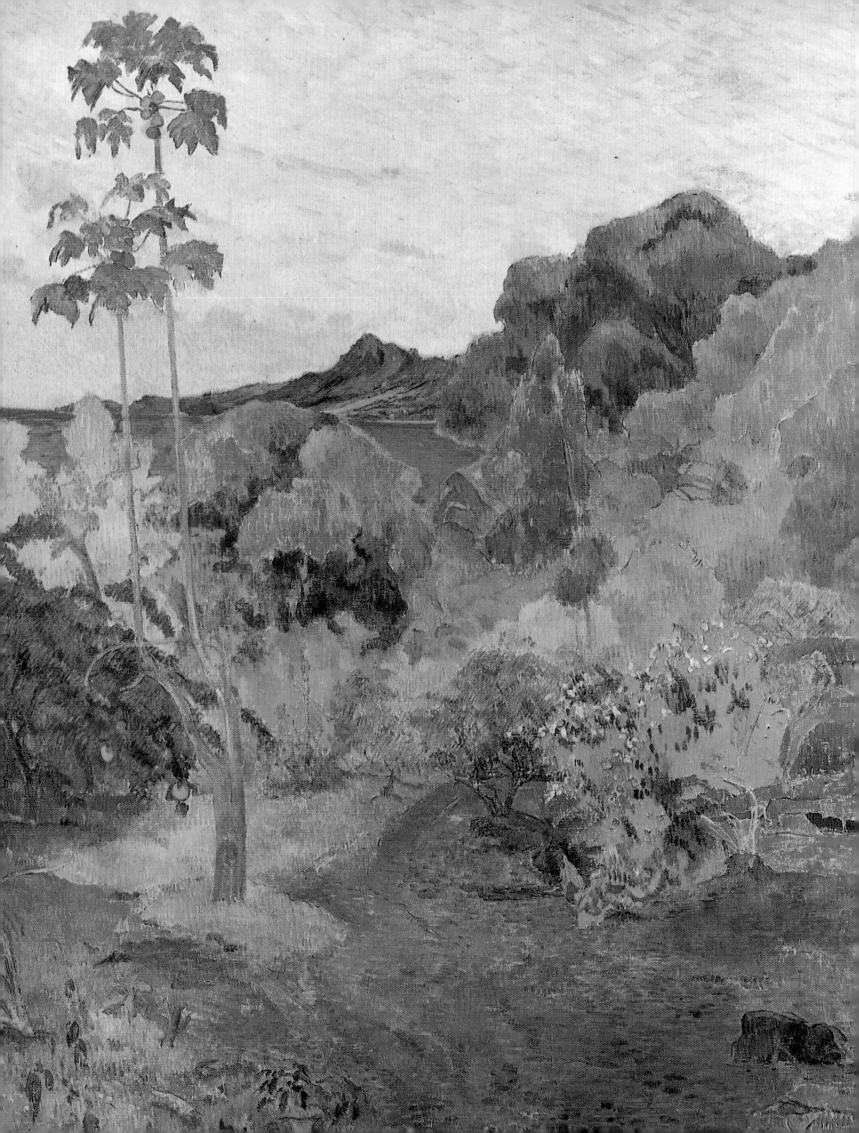

Paul Gauguin

Tropical Vegetation on Martinique, 1887

Oil on canvas, 115.5 x 89 cm
National Galleries of Scotland, Edinburgh

In a landscape such as this, which we may presume to have been painted during Gauguin's stay on Martinique, there is much that still has a close connection with Impressionism: the perspective arrangement of the motifs in the distance, the sky painted in pale tonal nuances, and the systematic application of vertical brushstrokes over the entire picture plane. Yet, we can already detect aspects of a certain revaluation of function, in particular in the arrangement of the web of brushstrokes (akin to what one finds in Neo-Impressionism) as a layered structure made out of separate planar segments. In the outlines of these segments, the vertical emerges more or less distinctly. This reveals Gauguin on the way towards a decorative pictorial form; and this, indeed, might well have seemed particularly appropriate for a tropical landscape. In reality, however, Gauguin had as yet made little use of decorative form at this stage of his adoption of exotic subjects, and, in this picture, there is much besides the decorative to secure the desired overall effect. Other aspects of the composition evince a problematic ambiguity: in the representation of the sky one finds the lighting and the atmosphere of a cool twilight, while it is not absolutely clear whether the bright rust-red patch alongside the flowering bush on the right is to be understood as reflected light or, rather, soil of a brighter tone. To the right of the middle distance, meanwhile, the treatment of the valley with wooded hills above it is evidently derived from the "color modulation' employed by Cézanne, whom Gauguin much admired. All of this results in a somewhat austere, subdued and melancholy embodiment of the exotic. Towards the foreground, where stronger color contrasts are used, most notably the violet hue of the soil, we may detect the application of new laws of pictorial construction. These consist above all in a particular form of colorism, in which the individual tones are determined not by the real appearance of things but, rather, for example, by the effects obtainable through the antithetic power of color contrast – cool and warm green, blue-red and yellow-red – both as a spur to the imagination and as a vehicle for symbolic expression.

Paul Gauguin
Aha oe feii? (What! Are You Jealous?), 1892

Oil on canvas, 68 x 92 cm
Pushkin Museum of Fine Arts, Moscow

In this figure painting from Gauguin's last period we find the most radical rejection of the Impressionism that had been so decisive a factor in his development. The work thus marks a complete break with the element of Realism or apparent Realism that is still to be found in his landscapes (illus. p. 119). This is evident not only in the use of color and the monumental silhouettes of the figures with their lapidary simplification, but also in the treatment of space. Here, this resembles a stage set incorporating planar forms, which are arranged entirely in accordance with the dictates of the picture's overall surface pattern.

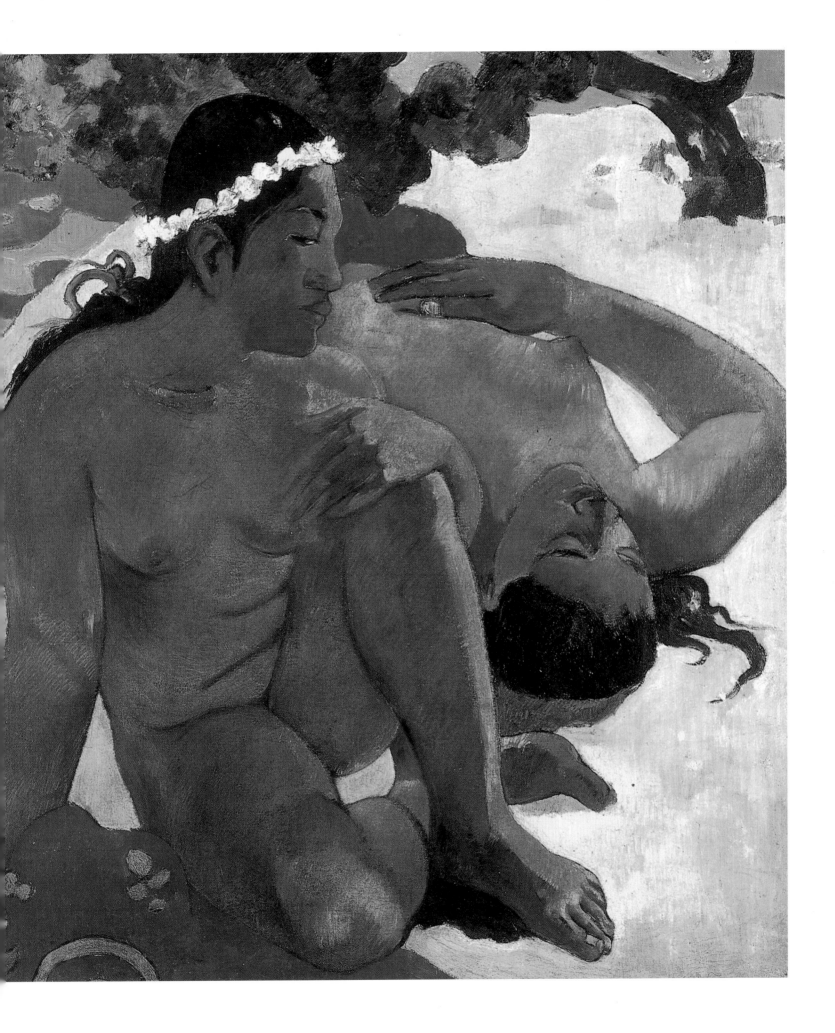

Georges Seurat

The Beach of Bas-Butin, Honfleur, ca. 1886

Oil on canvas, 66 x 78 cm; signed: Seurat
Musée des Beaux-Arts, Tournai, Gift of Henri van Cutsem

In comparison with Seurat's painting of 1884-86, *A Sunday Afternoon on the Island of La Grande Jatte* (illus. p. 38), the Neo-Impressionist interventions into reality that occur in this landscape are of a restrained character, except for the strict system of the overall Pointillist structure. The stretch of beach, the crumbling cliff-face and the grassy slope are not distinguished in their arrangement from comparable motifs to be found in the foreground of Impressionist compositions. It is only in small details that the man-made forms parallel the free rhythms of the image of nature: in the posts along the shore, the jetty beyond the small steamer, the two sailing boats, and the gentle brightness of the three breakwaters, set in relation to the solitary cloud in the sky.

Paul Signac

Evening in Antibes, 1914

Oil on canvas, 73 x 90 cm; signed: P Signac 1914
Musée des Beaux-Arts de la Ville, Strasbourg

The clarity and simplicity associated with fully developed Neo-Impressionism are to be found in this picture: in the use, on the whole, of unbroken colors, in the systematic application of paint in more or less equally sized and shaped rectangular spots, with their arrangement dependent on the objects represented, and the predominance of large forms in the composition as a whole, reiterating, in accordance with Neo-Impressionist theory, the simplicity of the micro-structure itself. By and large, this is the principle of composition in mosaic. In the course of the development of Neo-Impressionism, however, a contradiction was soon to emerge: the gain in terms of pictorial stability was indisputable (and that is the historical achievement of Neo-Impressionism), but it was apparaent that the illusion of light could not be harmonized with such strictness in composition. It is on this account that some important works of Neo-Impressionist painting are curiously monumental and visionary in effect: this is true of all of the paintings of Seurat and in some of those by Signac. In this scene of the port of Antibes the distant Alpes Maritimes take on a visionary character that could not have been achieved with the means available to the Impressionists.

Pierre Bonnard
The Bath, ca. 1935

Oil on canvas, 93 x 147 cm; signed: Bonnard 35
Musée du Petit Palais, Paris

When, in the general process of freeing color, a certain point had been reached, there inevitably occurred profound alterations in other aspects of the treatment of visible reality. In the work of Cézanne and Seurat, of Van Gogh and Gauguin, this had such an impact on every aspect of the subjects painted that one would have to speak of a discovery of new worlds, or at least of the establishment of entirely new ways of regarding the old world in the realm of painting. For the late work of Degas or Edouard Vuillard, as also for Bonnard, this was not the case, in spite of the fantastical color that these artists employed. They remained, accordingly, much more closely bound to the Impressionist approach, and their paint-

ings may be seen as the most rigorous and consequent continuation of Impressionism, its progression rather than any form of renunciation.

Like Degas, and frequently when treating the same motifs – interiors with women at dressing tables or shown bathing – Bonnard retained the peculiarity of the Impressionist extract from space. With the perspective, the view down on to the subject and foreshortening retaining their old significance. Bonnard's unrestrained use of color does have an extreme impact on the character of his line. This too is freed to an extent not found in the work of the Impressionists or their immediate followers. The tendency implicit in Impressionism to use color,

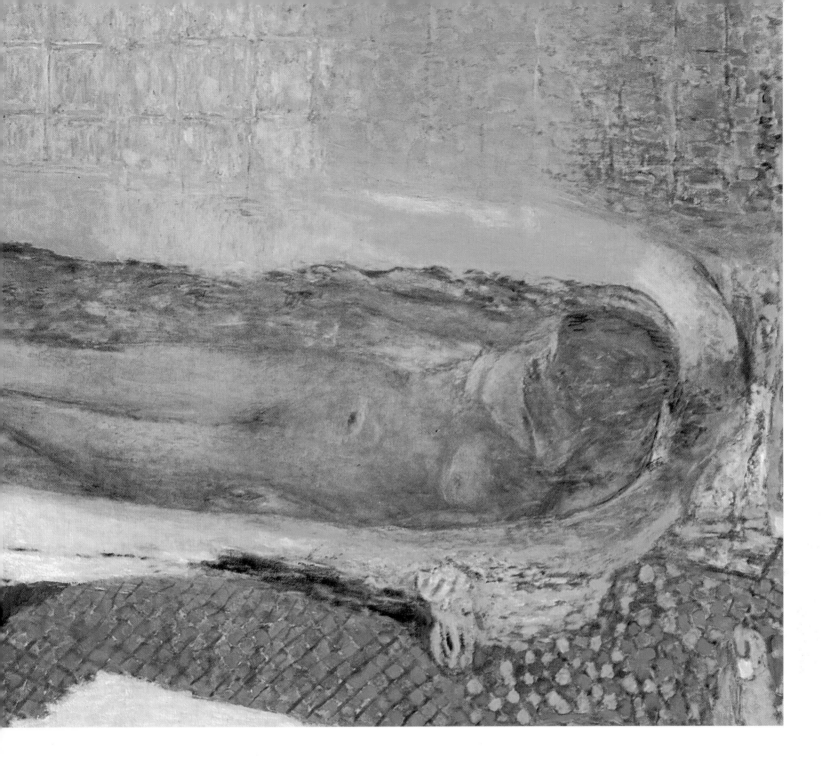

wherever possible, as the only element of construction – that is to say, to do without line – here achieves its definitive embodiment. None the less, the dominance of color does not mean, as in the case of Cézanne, that it functions as the antagonist of line. The edge of any given color in the work of Bonnard does not signify a point of confrontation between two distinct areas and their respective powers, but rather only the point where one retreats in the face of another.

In spite of this, the various colors used by Bonnard are assembled within a few large silhouettes, but these are without any emphatic contours and are thus utterly without weight. The striking characteristic of Bonnard's large curved forms is

that they are so completely lacking in pathos. In Bonnard's work, the outline of objects, in as far as this is expressed in terms of vigor and proportion, is diametrically opposed to the curved structures in the work of Degas. While the latter continued to employ the classic curve, Bonnard adopted an entirely unclassical variant which resulted in a predominance of bulky forms. In principle, Bonnard's curves are related to the expressive curves of Gauguin or of Edvard Munch.

Despite this connection, the lack of pathos (as also of the ornamental and the decorative, as found in Neo-Impressionism) ensures that Bonnard's work is informed by a spirit of serene resignation.

Albert Marquet

The Pont-Neuf at Evening, 1935; slightly reworked 1939

Oil on canvas, 81 x 100 cm; signed: Marquet
Musée Nationale d'Art Moderne, Centre Georges Pompidou, Paris

The work of Marquet (more than that of the other *Fauves*) is
as carefree as that of Bonnard, and of a comparable sovereign
simplicity. Marquet too, of course, succeeded in extracting
such simplicity from the considerable refinement of the Im-
pressionist vision of color, in effect as a reaction against this
refinement. The large, homogeneous planes of his cool views
of ports and large cities may be identified as the consumma-
tion of the Impressionist painting of light; out of the system
of Impressionist foreshortening he evolved planar form of
composition, although this did not for a moment imply that
he wished to render any less of the totality of the visually
perceived world than had the Impressionists. His work, more-
over, has the virtues of the type of painting that retreats from
programs and classifications.

The image of Pont-Neuf at evening does not contain the
extremes of the sort of compositional and illustrative simplifi-
cation to which Marquet on the whole tended. It none the
less offers an inexhaustibly rich impression of its subject: the
glittering streets of the metropolis in the rain, mastered
through the sheer "generosity" of both composition and the
application of paint to produce the ultimate experience of
the city by night. This sort of painting goes far beyond
Impressionism in the way that large and small forms are set
in relation to each other; as with the way the narrow street to
the left of the glittering department store recedes, in its red-
brown reflected glow, into the depths of the picture.

Henri Matisse
The River Bank, 1907

Oil on canvas, 73 x 60.5 cm; signed: Henri Matisse
Kunstmuseum, Basel

This Moroccan scene is one of a series of landscapes in which
it is clear that Matisse has already moved far from Impres-
sionism. The segments of color, applied on the whole thinly
and with apparent carelessness, cloudily smudged, and with
overlapping leaf outlines, establish the general effect of an
unemotional dematerialization and serene weightlessness.
One is at first moved to detect here a principle opposed to
the painterly homogeneity of Impressionism. It had always
been the ambition of the Impressionist painters to retain a
certain evenness in the application of paint, however extreme
the effect of light in "freeing" and "dematerializing" the objects
on which it fell. This is also true of the painting technique of
the Neo-Impressionists Van Gogh, Bonnard and Marquet. In
their work, as also in the late work of Degas, one can al-
ready find examples of the devices and solutions that were to
prove central to the transformation of reality in pictures such
as this landscape by Matisse. What occurs in both cases is,
indeed, a comparable manner of transposing observed reality
into the language of pictorial form, except for a sort of rever-
sal. In the case of the Impressionists, in spite of the rendering
of material qualities in terms of the phenomenon of light, we
find these last rendered in compact form, as painterly struc-
ture. In the case of Matisse, in spite of the omission of any
representation of light, we find that individual objects do not
regain their original weight but are often depicted as almost
transparent.

With this, for the second time in the development of art
since Impressionism, the treatment of objects and of land-
scape again approaches Japanese art. During the first period
of such "fertilization," it was the Impressionist treatment of
perspectival space that revealed how much inspiration had
been found in Japanese techniques of cropping and compo-
sition: this is demonstrated by the work of Monet, Degas and
Van Gogh. With Matisse, after the end of Impressionism and
the disappearance of its particular form of perspectival space,
it is in the freely rhythmic composition, and in the role of
accents and of color within lightly organized pictorial space,
that European painting may again be seen to take on the spi-
rit of the Japanese model.

Pierre Bonnard 1867-1947

1867 Born at Fontenay-aux-Roses on 3 October.

1885 Embarks on law studies in Paris.

1886 Attends classes at the Académie Julian. Meets Paul Sérusier, Maurice Denis, Paul Ranson and others.

1888 Takes law examinations. In October, under Sérusier's leadership, the artists' group *Les Nabis* (The Enlightened Ones) is formed; its members, following Paul Gauguin, favor a flat decorative manner of painting.

1889 Bonnard is accepted at the Ecole des Beaux-Arts, where he meets Edouard Vuillard and Xavier Roussel. Is impressed by the work of Vincent Van Gogh included in the exhibition held at the Café Volpini. Takes up a post as a lawyer. Is impressed by the Japanese woodcuts shown at the Ecole des Beaux-Arts.

1891 Shares a studio at 28 Rue Pigalle with Denis and Vuillard. Exhibits five paintings at the Salon des Indépendants. His design of 1889 for the poster *France Champagne* is enthusiastically accepted. Meets Henri de Toulouse-Lautrec. Abandons his career as a lawyer. Works increasingly on motifs derived from Japanese wood-block prints.

1892 Contributes to second and third *Nabis* exhibitions.

1894 Designs poster for the journal *La Revue blanche*, to which he is to continue to contribute illustrations, and befriends its editor Thadée Natanson. Meets Odilon Redon.

1896 Takes a studio in the Batignolles district of Paris. First solo show at the Paris gallery of the art dealer Paul Durand-Ruel; also exhibits for the first time at the Salon of the journal *La Libre esthétique* in Brussels. Produces designs for the stage, also book illustrations.

1900 Exhibits with the *Nabis* at the Galerie Bernheim-Jeune. Starts spending summers in the country. Begins to lighten his palette. Provides illustrations for a volume of poems by Paul Verlaine, *Parallèlement*.

1901 Trips abroad, including visits to Spain and Holland.

1902 Completes 156 lithographs for *Daphnis et Chloë*.

1903 Exhibits at the Salon d'Automne in Paris.

1904 Start of his friendship with Henri Matisse.

1906 Solo exhibition at the Galerie Vollard. Also exhibits at the Galerie Bernheim-Jeune.

1908 Trip to North Africa.

1909 First long stay in the South of France.

1913 Creative crisis: searches for new means of rendering perceived reality, especially in his accommodation of color.

1915 Lives largely at Saint-Germain-en-Laye.

1918 Bonnard and Auguste Renoir are elected Honorary Presidents of the artists' group *Jeune peinture française*.

1923 Brilliant success at the Salon d'Automne with the large painting of 1918, *La Terasse à Vernon*.

1924 Retrospective exhibition at the Galerie Druet.

1926 Buys a country house at Le Cannet in the South of France. Travels to the USA to serve on the jury of the International Competition of the Carnegie Institute.

1928 First large solo show in New York. From this year on he takes part in numerous international exhibitions.

1936 Wins second prize in the Carnegie Competition.

1947 Dies at Le Cannet on 23 January.

1948 A large retrospective exhibition is held at The Museum of Modern Art in New York.

Eugène Boudin 1824-1898

1824 Born on 12 July in Honfleur.

1835 The family moves to Le Havre.

1836 Boudin is apprenticed to a printer. He starts drawing. Is employed in a shop selling artists' materials.

1844 Opens his own shop of the same kind and exhibits there works by Eugène Isabey, Thomas Couture, Jean-François Millet and Constant Troyon.

1847 Devotes himself entirely to painting. Makes copies of the work of the Old Masters in the Louvre.

1850 Shows two works at the exhibition mounted by the Société des amis des arts du Havre.

1851-53 A stipend from the city of Le Havre enables Boudin to make a longer stay in Paris.

1852 Exhibits ten paintings at the Musée du Havre.

1855 Various trips along the French Atlantic coast, where he paints landscape studies.

1858 In Le Havre meets Claude Monet, whom he encourages to join him in painting *en plein air*.

1859 Meets Gustave Courbet and the poet and critic Charles Baudelaire. Exhibits for the first time at the Paris Salon. Embarks on a series of cloud studies.

1862 Stays in Trouville. Paints beach scenes, under the influence of Isabey. Meets Johan Barthold Jongkind.

1863 From this year on, he exhibits regularly at the Salon.

1868 Successful public sale of his pictures in Paris.

1869 Is commissioned to provide four paintings for the Château de Bourdainville.

1870/71 Stays in Brussels and Antwerp during the Franco-Prussian War.

1874 Shows his work at the first Impressionist exhibition in Paris. Also shows pictures at the official Salon.

1881 Contact with the art dealer Paul Durand-Ruel who formally agrees to exhibit Boudin's work.

1883 Boudin's first solo exhibition takes place at Durand-Ruel's Paris gallery.

1889 Shows five paintings at the *Exposition Universelle* in Paris, where he wins a gold medal.

1892 By now paints principally in the South of France, travels to Venice. Is awarded the *croix de la Légion d'Honneur.*

1898 Dies in Deauville, Normandy, on 8 August.

Paul Cézanne 1839-1906

1839 Born in Aix-en-Provence on 19 January.

1852-58 Attends the Collège Bourbon in Aix, where he meets and befriends Emile Zola and Baptistin Baille.

1858-59 Attends drawing classes.

1859 Embarks on study of law at Aix University.

1861 Abandons his law studies and goes, at Zola's urging, to Paris. Meets Camille Pissarro at the Académie Suisse. Takes up a post at his father's bank.

1862 Leaves the bank and again resolves to devote himself to painting, but fails the entrance examination for the Ecole des Beaux-Arts in Paris.

1863 His work is rejected at the official Salon; exhibits at the Salon des Refusés.

1864 At the Louvre, makes copies of works by Poussin, Eugène Delacroix and others. From this time onwards, he lives alternately in Paris and in Aix.

1866 Edouard Manet praises Cézanne's still lifes.

1870 Encouraged by Pissarro, Cézanne starts painting *en plein air* and lightens his palette.

1872 With Manet, Pissarro, Auguste Renoir, Johan Barthold Jongkind and others, Cézanne formally demands proper exhibition space for the Salon des Refusés. Moves to Pontoise and paints there with Pissarro.

1873 Paints in Auvers-sur-Oise. The collector, Dr. Gachet, provides him with financial and material support.

1874 Shows his work at the first Impressionist exhibition.

1877 Shows sixteen paintings at the third Impressionist exhibition, but begins to free himself from the influence of the Impressionists.

1881 Meets Paul Gauguin in Pontoise.

1882 Paints with Renoir in l'Estaque in the South of France. For the first and only time has works accepted for exhibition at the official Salon through the help of his friend Guillemet, who is a member of the Salon jury.

1883 From this year onwards, lives principally in Aix and its environs. Gauguin buys two of Cézanne's paintings.

1886 Breaks with Zola.

1889 Exhibits with *Les Vingt* in Brussels. His pictures are shown at the *Exposition Universelle* in Paris.

1890 Again exhibits with *Les Vingt.* Is diagnosed as suffering from diabetes.

1892 Paints in the forest of Fontainebleau.

1895 Solo exhibition of 150 works at the Paris gallery of Ambroise Vollard.

1899 Shows three paintings at the Salon des Indépendants. Paul Durand-Ruel acquires numerous works by Cézanne. Second solo show at Vollard's gallery.

1900 Exhibits in the *Exposition Centennale* in Paris. Bruno Cassirer organizes a Cézanne exhibition in Berlin.

1903 His work is included in exhibitions in Vienna and Berlin.

1904 Shows works at the exhibition of the journal *La Libre esthétique* in Brussels and at the Salon d'Automne in Paris. Second solo show at the Galerie Cassirer in Berlin.

1905 Claude Monet testifies to his admiration for Cézanne as "one of the masters of the present day."

1906 Exhibits for the second time at the Salon d'Automne in Paris. Dies in Aix on 22 October.

1907 Memorial exhibition of 56 works is shown as part of the Salon d'Automne. Cézanne is recognized as the pioneer of modern painting, proving an especially important influence on the Cubists.

Jean-Baptiste-Camille Corot 1796-1875

1796 Born in Paris on 17 July.

1807 Attends the Lycée in Rouen.

1812-14 Attends a boarding school in Poissy.

1815 In accordance with his father's wishes, he embarks on an apprenticeship as a cloth merchant.

1822 An inheritance enables him to give up business and to devote himself entirely to painting. He studies under the landscape painters Achille-Etna Michallon and Jean-Victor Bertin and starts to paint *en plein air*.

1824 Is impressed by the landscapes of John Constable that are shown at the Salon in Paris.

1825-28 In Italy. Paints with Caruelle d'Aligny and Edouard Bertin. After his return to France, Corot paints at various other locations, especially Fontainebleau.

1833 Wins a second-class medal at the Salon.

1834 Second trip to Italy.

1835 From this year onwards he exhibits regularly at the Salon, where his work is well received. He starts to add religious and mythological figures to his landscapes, in the tradition of Poussin. Travels through France and Switzerland. The French state acquires several of his pictures. Over the following years Corot carries out several commissions for wall paintings.

1843 Last trip to Italy. Paints in Rome and its environs.

1846 Is made a *chevalier de la Légion d'Honneur*.

1848 Wins a second-class medal at the Salon.

1849 Becomes a member of the Salon jury. Starts to paint atmospheric landscapes of a more Romantic character.

1852 Meets Charles-François Daubigny.

1855 Exhibits successfully at the *Exposition Universelle* in Paris. The French Emperor acquires one of Corot's paintings.

1861 Berthe Morisot becomes Corot's pupil.

1862 Meets Gustave Courbet.

1867 Shows his work at the *Exposition Universelle* in Paris, where it is especially praised. Is awarded the rank of *officier de la Légion d'Honneur*.

1875 Dies at Ville-d'Auray on 22 February.

Gustave Courbet 1819-1877

1819 Born in Ornans, near Besançon on 10 June.

1831 Attends the local *petit séminaire*. Is encouraged by his drawing teacher to make painted studies from nature.

1837 Drawing courses at Academy of Art in Besançon.

1838 Provides four lithographs to illustrate his friend Maximin Buchon's *Essais poétiques*.

1839 Moves to Paris. Attends classes at the studio of Carl Steuben. Makes copies of works by 16th- and 17th-century masters in the Musée du Louvre, also of the work of Géricault, Delacroix and Ingres. Paints many portraits, genre scenes and landscapes.

1844 Exhibits at the Salon for the first time.

1846 Trip to Holland.

1847 Meets the French poet and critic Charles Baudelaire.

1848 Frequents Republican circles.

1849 Wins a medal at the Salon; this guarantees his future participation in exhibitions there without the need to submit his work to the jury.

1850 From this year onwards takes part in numerous exhibitions outside France. His work at the Salon arouses anger on account of its socially critical content.

1855 Shows eleven pictures at the *Exposition Universelle* in Paris. Exhibits 40 works in a rival exhibition, organized by himself, in a pavillon called *le Réalisme*.

1858 Paints numerous hunting scenes.

1859 Travels along the Normandy coast; paints seascapes.

1861-62 Teaches in his own studio in Paris.

1865 During a three-month summer stay in Trouville, meets Claude Monet and James McNeill Whistler.

1867 Shows several pictures at the *Exposition Universelle* in Paris. Also mounts a second solo exhibition of 115 paintings; this is greatly admired by the painters who are to become the Impressionists.

1869 Wins a gold medal in Brussels. Exhibits in a room of his own at the *Internationale Kunstausstellung* in Munich, where his work is enthusiastically received by the circle of young artists around Wilhelm Leibl.

1871 He is arrested for supporting the Paris commune.

1873 Lives in exile in Switzerland.

1877 Dies at La Tour-de-Peilz, near Vevey, on 31 December.

1882 Retrospective exhibition at the Ecole des Beaux-Arts in Paris.

Edgar Degas 1834-1917

1834 Born (as Edgar-Hilaire-Germain de Gas) in Paris on 19 July, the son of an art-loving banker.

1852 Makes his first drawings.

1853 Embarks on law studies. Simultaneously studies with the painter Félix-Joseph Barrias. Also makes copies fromengravings by Dürer, Mantegna and Rembrandt.

1854 Attends classes at the studio of Louis Lamothe, a pupil of Jean-Auguste-Dominique Ingres.

1855 Visits Ingres. Abandons his law studies and is accepted at the Ecole des Beaux-Arts (class for painting and sculpture). Associates with Léon Bonnat and Ignace-Henri Fantin-Latour. Travels in the South of France.

1856/57 Trip to Italy, where he mostly makes copies of works by 15th-century masters.

1859 Returns to Paris. Takes his own studio and works there on history paintings.

1861 Makes his first studies at racecourses.

1862 Meets and befriends Edouard Manet.

1865 Exhibits for the first time at the Salon, showing a medieval battle subject.

1867 Paints scenes with ballet dancers.

1868/69 Paints musicians and takes up the motif of washerwomen.

1869-72 Makes studies of horses and jockeys.

1870 Registers for military service in the artillery.

1870/71 Trip to London.

1872 Paints frequently at the Paris Opéra. Again visits London, where Paul Durand-Ruel is exhibiting works by Degas, Auguste Renoir and Claude Monet, though largely without success. Degas travels on to New Orleans.

1874 Is one of the organizers of the first Impressionist exhibition.

1876 Shows 24 works at the second Impressionist exhibition. Is to take part in all but one of this series of shows.

1877 Favors work in pastel, his colors becoming increasingly stronger.

1878 The Musée de Pau acquires his painting *The Cotton Exchange*.

1880 Trip to Spain.

1881 The works he shows at the sixth Impressionist exhibition include the wax figure *Small 14-Year-Old Dancer*. The sequence of photographs of a galloping horse by Eadweard Muybridge, published in *The Globe*, informs the treatment of motion in the artist's subsequent work.

1882 Stays at Etretat on the coast of Normandy.

1883 Works by Degas are again exhibited in London by Durand-Ruel.

1884 Stays at Le Havre and Dieppe.

1885 Shows three pastels at the Impressionist exhibition organized in Brussels by Durand-Ruel. Meets Paul Gauguin.

1886 Durand-Ruel exhibits works by Degas in New York and establishes an exclusive contract with him.

1887 Degas travels to Spain and Mexico.

1892 Virtually abandons painting in oils. First exhibition of his landscapes at Durand-Ruel's gallery. Worsening of his eyesight leads to a simplification in his style.

1895 Series of "Bathers" and "Dancers."

1900 Works by Degas are included in the *Centennale d'art français* within the *Exposition Universelle* in Paris.

1908 Degas becomes almost totally blind.

1911 Solo exhibition at Harvard, Mass.

1917 Dies in Paris on 27 September.

Eugène Delacroix 1798-1863

1798 Born in Charonton-Saint-Maurice on 26 April.

1806 After the death of his father, the family moves to Paris. Delacroix attends the Lycée Impérial, receiving there an excellent education in the Classics.

1815 Embarks on training as a painter at the Ecole des Beaux-Arts under Paul-Narcisse Guérin, at whose studio he is to meet Théodore Géricault two years later.

1816 Paints watercolor studies.

1822 Shows his *Barque of Dante* at the Salon.

1824 Contact with the circle of the Romantics. Is especially inspired by the work of John Constable exhibited in Paris. Is deeply moved by the death of Géricault.

1825 Spends four months in London. Takes a great interest in Shakespeare, Milton and Byron.

1826 Turns more eagerly to Oriental themes.

1827 His *Death of Sardanapalus*, exhibited at the Salon, provokes an outcry.

1829 Publishes his first art critical essays.

1830 During and immediately after the July Revolution, he paints *Liberty Leading the People*.

1832 Trip to Morocco and Algiers, which has a lasting influence on his work.

1842 Becomes ill with a recurrent goitre of the throat.

1855 Shows 35 works at the *Exposition Universelle* in Paris. Edouard Manet makes a copy of *The Barque of Dante*.

1857 Is elected a member of the Académie des Beaux-Arts. Moves to an apartment in the Place du Fürstenberg (now the Delacroix museum).

1859 Exhibits for the last time at the Salon, his work being judged "unfinished" by critics.

1861 Completes the large murals for the Chapelle des Anges in the Paris church of Saint-Sulpice.

1863 After another attack of his illness, Delacroix dies in his Paris apartment on 13 August.

1864 Memorial exhibition of 300 works is organized by the "Société Nationale des Beaux-Arts."

Paul Gauguin 1848-1903

1848 Born in Paris on 7 June.

1849 The family goes to Peru, his father dying *en route*.

1854 The rest of the family returns to France. Gauguin attends a boarding school in Orléans.

1865-71 He signs on as a sailor and goes to sea.

1872 After his return to France, he obtains a post with the banker, Paul Bertin. He starts drawing and painting.

1874 Friendship with Emile Schuffenecker, who also paints.

1876 Exhibits for the first time at the Salon and acquires paintings by the Impressionists. Leaves the bank.

1879 Is employed by the banker André Bourdon. Shows his work at the fourth Impressionist exhibition. In the summer paints with Camille Pissarro at Pontoise.

1883 Resolves to commit himself exclusively to painting.

1884 Lives with his wife and his five children in Rouen and Copenhagen.

1885 Returns to Paris. Has great financial difficulties.

1886 Produces his first ceramics. Stays in Pont-Aven, Brittany, where he meets Emile Bernard.

1887 Travels to Panama and Martinique with his friend the painter Charles Laval.

1888 Again goes to paint in Pont-Aven. In the autumn visits Vincent Van Gogh in Arles. Evolves his planar style of painting with emphatic contours (*Synthétisme*).

1889 Exhibits with the artists' group *Les Vingt* in Brussels. Together with Schuffenecker, he organizes the *Exposition de peintures du Groupe Impressioniste et Synthétiste* at the Cafe Volpini to coincide with the Paris *Exposition Universelle*.

1890/91 Close contact with the Parisian Symbolist circle around Albert Aurier, Charles Morice, Odilon Redon and others. Plans to settle in the South Seas.

1891 Arrives in Tahiti in June.

1893 Returns to France. Exhibits paintings, with little success, at the Paris gallery of the dealer Paul Durand-Ruel.

1895 Sets out again for the South Seas, where he is to live and to write as well as to paint, until his death.

1898 After a prolonged period of ill health and depression, seriously considers suicide.

1900 Thanks to a contract with the Paris art dealer Ambroise Vollard, Gauguin is for the first time able to make a living from his paintings.

1901 His health continues to worsen (syphillis, alcohol poisoning).

1902 Is arrested for opposition to the colonial authorities.

1903 Dies at Atuona Hivaoa (Marquesas Islands) on 8 May.

Théodore Géricault 1791-1824

1791 Born in Rouen on 26 September, the son of wealthy parents.

ca. 1796 The family moves to Paris, where Géricault attends the Lycée Impérial and starts drawing.

1808 Completes his schooling. Against his father's wishes, he resolves to become a painter. He attends classes at the studio of Carle Vernet. Death of his mother, the fortune she leaves her son ensures his financial independence.

1810 Also studies at the studio of Pierre Guérin, an exponent of the official Classical style in the tradition of Jacques-Louis David. Géricault produces figure studies. Under Vernet he continues to paint genre scenes.

1811 In the Louvre, he makes copies after works by masters of the era of the Baroque.

1812 Produces his first independent works. Is accepted at the Ecole des Beaux-Arts. Exhibits a picture at the Salon for which he wins a gold medal.

1814 Turns to subjects from Antiquity. Exhibits three pictures at the Salon.

1814-16 Serves in the French army (Royal Musketeers).

1816 After again unsuccessfully competing for the Prix de Rome, he goes at his own expense to Italy. Studies the works of Antiquity, and those of Michelangelo and Raphael, and paints scenes of everyday life in Rome. He visits Jean-Auguste-Dominique Ingres.

1817 Returns to Paris in the autumn. Contact with the circle around Horace Vernet. Produces his first lithographs. Adopts a realistic rendering of modern subjects.

1819 *The Raft of the Medusa* is exhibited at the Salon; Géricault wins a medal but the public reaction is largely negative.

1820/21 Trip to England. *The Raft of the Medusa* is widely and successfully exhibited. Géricault enters a period of psychological crisis.

1822 Returns to Paris. Becomes ill with tuberculosis.

ca. 1823 Is commissioned by Dr. Georget to record the inmates of the Paris insane asylum in a series of painted sketches. His health seriously deteriorates following a fall from a horse and he undergoes several operations.

1824 Dies in Paris on 26 January. The following November an auction of Géricault's work raises an enormous sum.

Vincent van Gogh 1853-1890

1853 Born in Groot-Zundert, Holland, on 30 March, son of a priest.

1869 Joins the Paris-based international art dealer Goupil & Co., working at the branches in The Hague and, from June 1873, in London.

1876 Works as a teacher and part-time preacher in Isleworth, near London. In Amsterdam, he embarks on, but soon abandons, the study of theology.

1878/79 Works as a lay preacher in the Belgian coal-mining area, the Borinage. Because of his poverty, his younger brother Theo, himself still working for Goupil, starts to provide him with financial support.

1880 Resolves to become an artist. Moves to Brussels, where he begins to make copies from reproductions of work by Millet. Later moves to The Hague.

1882 Works with the painter Anton Mauve, who later provides instruction in drawing. Moves to the Hague. Van Gogh produces his first oil paintings and lithographs.

1883-85 In northern Holland he paints scenes of rural life in somber tones, including *The Potato Eaters*.

1885 Goes to Antwerp. Is impressed by the paintings of Rubens and others in the museums there. First encounter with Japanese wood-block prints.

1886 Goes to Paris, sharing Theo's apartment. Meets Henri de Toulouse-Lautrec and Emile Bernard. The bright colors used by these artists have a crucial influence on his own style of painting.

1887 Takes part in several group exhibitions. Makes copies of Japanese wood-block prints.

1888 Moves to Arles. A plan to live and work with Paul Gauguin falls through after serious disagreements between the two. Van Gogh cuts off his own left ear.

1889 Stays at the psychiatric clinic at Saint-Rémy. His works are exhibited at the Salon des Indépendants in Paris.

1890 Exhibits with *Les Vingt* in Brussels. Makes his first sale of a painting. In May moves to Auvers-sur-Oise. Here, on 27 July, he shoots himself in the chest. He dies two days later.

Stanislas Lépine 1835-1892

1835 Born in Caen on 3 October, son of a skilled craftsman. There is no record of his artistic training.

1859 Exhibits a picture at the Salon (a view of the port of Caen). From this point on he shows works there every year.

ca. 1866 Studies under Jean-Baptiste-Camille Corot, who sets Lépine to copy his own work. Enthusiastically paints the banks of the Seine and views of ports.

1874 Shows three works at the first Impressionist exhibition,

where he is well received by the critics. He None the less remains bound to Naturalism and distances himself from the Impressionist group. He sends 32 pictures to the public auction at the Hôtel Drouot.

1881 Wins a second-class medal in Madrid.

1884 Honorable mention at the Salon.

1886 Two of his pictures are included in the Impressionist exhibition organized by the Paris-based dealer Paul Durand-Ruel in New York.

1889 Wins a first-class medal at the *Exposition Universelle* in Paris and a third-class medal at the Salon.

1892 Dies in Paris, in extreme poverty, on 28 September.

Edouard Manet 1832-1883

1832 Born in Paris on 23 January, son of a high-ranking official in the Ministry of Justice and a diplomat's daughter.

1844-48 Attends the Collège Rollin. Becomes a friend of Antonin Proust.

1848/49 In defiance of his father's wishes that he study law, Manet signs on as a sailor and goes to sea.

1850 With the agreement of his family, he studies in Paris under Thomas Couture.

1852/53 Trips to Holland, Italy and other countries.

1855 Makes a copy of Delacroix's *Barque of Dante.*

1856 Leaves Couture's studio. Takes his own studio, which he shares with the animal painter Albert de Bàlleroy.

1857 Meets Ignace-Henri Fantin-Latour.

1859 His painting *The Absinthe Drinker* is rejected by the Salon despite the recommendation of Eugène Dela-

croix. Manet meets Edgar Degas in the Louvre.

1860 Moves to the Batignolles district of Paris.

1861 Exhibits two pictures at the Salon. *The Spanish Singer* is admired by a group of young painters and writers, including Fantin-Latour and the poet and critic Charles Baudelaire.

1862 Together with Fantin-Latour, Jongkind and others, establishes the "Société des Aquafortistes." Makes *plein air* studies in the Jardin des Tuileries.

1863 Fourteen pictures by Manet are exhibited at the Galerie Martinet. Exhibits six works at the Salon des Refusés, including *Le Déjeuner sur l'herbe*, which sets off a wave of indignation.

1865 Two paintings are accepted by the official Salon. *Olympia* provokes a further outcry. During a trip to Spain, he discovers the work of Goya and Velázquez.

1866 Meets Paul Cézanne, Claude Monet and Emile Zola.

1867 Zola writes a biography of Manet. The artist exhibits his work in his own pavilion on the fringe of the *Exposition Universelle.*

1869 Exhibits at the Salon.

1870/71 Serves in the French artillery as a volunteer.

1872 The dealer and gallery-owner Paul Durand-Ruel acquires 24 paintings by Manet. The Café La Nouvelle-Athènes becomes the new regular meeting place for Manet and his artist friends. Trip to Holland.

1873 Success at the Salon and friendship with the poet and critic Stéphane Mallarmé.

1874 Manet refuses to take part in the first Impressionist exhibition. Paints with Monet *en plein air* at Argenteuil.

1875/76 Prepares etchings for Mallarmé's translation of Edgar Allan Poe's poem "The Raven."

1877 The dealer Giroux exhibits Manet's painting *Nana* (rejected by the Salon) in the window of his gallery in the Boulevard des Capucines.

1879 Manet presents to the Paris authorities a design for murals with city scenes for the new Paris Hôtel de Ville. Becomes ill with consumption.

1879/80 Shows his work in exhibitions at the gallery of the journal *La Vie moderne.*

1881 Wins a second-class medal at the Salon. Is awarded the rank of *chevalier de la Légion d'Honneur.*

1882 His picture *A Bar at the Folies-Bergères* is accepted for exhibition at the Salon.

1883 After increasing paralysis and the amputation of a leg, dies in Paris on 30 April.

Albert Marquet 1875-1947

1875 Born in Bordeaux on 26 March. Starts drawing enthusiastically as a child.

1890 Attends the Ecole des Arts Décoratifs.

1892 Meets Henri Matisse, a fellow student.

1897 Marquet moves to the Ecole des Beaux-Arts. Here, first studies under Aimé Morot, and subsequently under Gustave Moreau, his fellow pupils including Manguin and again Matisse. Finally joins the class of Fernand Cormon.

1901 Exhibits for the first time at the Salon des Indépendants.

1903 In the summer he paints with Manguin and Charles Camoin in the South of France.

1905 Spends the summer painting with Manguin near Saint-Tropez and with others elsewhere in the South of France.

1906 Paints with Raoul Dufy in Le Havre.

1907 First solo exhibition at the Galerie Druet in Paris. With Matisse, Camoin and Othon Friesz.

1908 Takes over Matisse's Paris studio on the Quai Saint-Michel. Trip to Naples with Manguin.

1909 Spends several months in Germany then the summer in Naples.

1910/11 Pictures by Marquet and Matisse are included in the London exhibition "Manet and the Post-Impressionists."

1915 Moves to Marseilles.

1920 Meeting with Paul Signac in La Rochelle.

1925 Trip to Norway. Paints increasingly in watercolor.

1934 Trips to Soviet Georgia and Moscow.

1940-45 Stays in Algiers.

1945 In Paris, together with Pierre Bonnard, exhibits watercolors, gouaches and drawings.

1947 Dies in Paris on 13 June

Henri Matisse 1869-1954

1869 Born in Le Cateau-Cambrésis in the north of France on 31 December.

1887/88 Studies law in Paris.

1889 Works as a clerk in Saint-Quentin. Studies drawing.

1890 Confined to bed for several months because of illness. During his convalescence starts to paint.

1891/92 In Paris first enrolls at the Académie Julian and studies under William-Adolphe Bouguereau. Meets Gustave Moreau. Subsequently attends classes at the Ecole des Arts Décoratifs, where he meets Marquet.

1895 In March is accepted at the Ecole des Beaux-Arts and studies under Moreau. Starts painting en plein air.

1896 Exhibits at the Salon of the "Société Nationale des Beaux-Arts" and is nominated an associate member.

1897 Encounters the work of the Impressionists at the Musée du Luxembourg (Caillebotte Bequest).

1898 In London studies the work of J. M. W. Turner. Spends six months on Corsica with a break in Paris in June to see exhibitions. Spends latter part of year in Toulouse.

1899 Returns to Paris. Studies under Fernand Cormon, (Moreau having died the previous April). Leaves the Ecole des Beaux-Arts at the end of the year.

1900 Attends sculpture and painting classes at various art schools. At La Grande Chaumière studies under the sculptor Antoine Bourdelle. At the Académie Carrière meets André Derain and Jean Puy.

1901 Sees the Vincent van Gogh retrospective at the Galerie Bernheim-Jeune. Derain introduces him to Maurice Vlaminck. Exhibits for the first time at the Salon des Indépendants.

1903 Founding of the Salon d'Automne, where Matisse exhibits two paintings. Makes his first etchings.

1904 First solo show at the Paris gallery of Ambroise Vollard. With Signac in Saint-Tropez.

1905 Exhibits at the Salon d'Automne with Derain, Marquet, Vlaminck, Georges Rouault and others. The critic Louis Vauxcelles refers to these as *Les Fauves* (the wild ones).

1906 Trip to Algeria. Growing interest in African art. Meets Pablo Picasso. Makes lithographs and woodcuts.

1907 Exchanges pictures with Picasso. Is disturbed by the latter's *Demoiselles d'Avignon*.

1908 Opens the Académie Matisse (this continues until mid-1911). Exhibits in Moscow in the first of three shows of French and Russian art. In December publishes his *Notes d'un peintre* defending his work against its detractors.

1909 Three-year contract with the Galerie Bernheim-Jeune in Paris.

1910/11 Large retrospective exhibition at the Galerie Bernheim-Jeune. Is strongly influenced by an exhibition of Islamic art he sees in Munich. His work is included in the London exhibition "Manet and the Post-Impressionists."

1912 Trip to Morocco.

1948 Makes his first *gouaches découpées* (painted paper cut-outs).

1951 Completes his last great commissioned work, the murals for the Chapelle du Rosaire at Vence, in the South of France.

1954 Dies in Nice on 3 November.

Jean François Millet 1814-1875

1814 Born in Normandy on 4 October, the son of a farmer. Encouraged and sponsored by the village priest.

1833 Is sent to Cherbourg to study in the studio of a portrait painter. Subsequently studies under Lucien Langlois, curator of the city museum.

1837 Goes to Paris and is admitted to study at the Ecole des Beaux-Arts in the class of the history painter Paul Delaroche.

1840 One of his portraits is exhibited at the Salon. Millet settles in Cherbourg as a portrait painter.

1845 Long stay in Le Havre, where he paints portraits, pastoral idylls and other works.

1847 First significant success at the Salon. He turns to peasant subjects, gradually adopting more somber tones.

1849 Settles at Barbizon (in the forest of Fontainebleau) and continues to paint peasant subjects.

1850 Exhibits the paintings *The Sower* and *The Binders* at the Salon.

1854 Shows several works in an exhibition in Boston.

1855 Takes part in the *Exposition Universelle* in Paris.

1867 Much greater success in the *Exposition Universelle* of this year, when he shows a large group of works; these include *The Angelus* (1857-59), which is enthusiastically acclaimed. Wins a Salon medal.

1870 Shows at the Salon for the last time. Leaves Paris for Cherbourg. Contract with the Paris-based dealer and gallery-owner Paul Durand-Ruel, now in London, who becomes his principal representative.

1871 Moves back to Barbizon.

1874 Public commission to take part in providing decorations for the Panthéon. Millet's health is now rapidly failing and he produces only a few drawings.

1875 Dies at Barbizon on 20 January.

Claude Monet 1840-1926

1840 Born in Paris on 14 November.

1845 The family moves to Le Havre, where Monet spends his childhood and youth.

1856-58 Draws caricatures, which sell well. Meets Eugène Boudin.

1859 Monet goes to Paris. Studies at the free Académie Suisse, where he meets Camille Pissarro. Contact with Realist circles.

1861/62 Military service based in Algiers, then spends six months in Le Havre recovering from typhus. Paints *en plein air* with Boudin. Becomes a friend of Johan Barthold Jongkind's, in whose work he finds many new ideas for his own. Having returned to Paris, he attends classes at the studio of Charles Gleyre.

1863 Is much impressed by the work of Edouard Manet that he sees in an exhibition.

1865 Exhibits two seascapes at the Salon.

1866 His painting *Camille* (*The Green Dress*), shown at the Salon, is greatly praised by Emile Zola and others.

1867 Lives with Bazille in Paris. Great financial difficulties.

1869 Paints with Renoir at La Grenouillière, a fashionable bathing place on the Seine near Bougival.

1870 His paintings are rejected by the Salon. Paints with Boudin in Trouville. After the outbreak of the Franco-Prussian War leaves for London, where he is impressed by the paintings of Turner and Constable and where he paints with Daubigny and Pissarro.

1871 In May leaves London for Holland. In October returns to France. Becomes leader of the group who are later to be known as the Impressionists.

1872 Begins to sell a great deal of work to Durand-Ruel.

1873 With others he establishes a group of artists united in their rejection by, or indifference to, the official Salon.

1874 In April this group (Renoir, Pissarro, Sisley, Boudin, Degas, Cézanne and others), taking the name *Société anonyme cooperative d'artistes peintres, sculpteurs et graveurs*, holds an exhibition in rooms rented from the photographer Félix Nadar. The critic Louis Leroy calls the group "Impressionists," in allusion to Monet's painting *Impression, soleil levant.* (The *Société anonyme* is disbanded the following December but a further seven Impressionist exhibitions are to take place, the last in 1886.)

1876 Ernest Hoschedé, a wealthy Paris cloth merchant, commissions Monet to provide several paintings to decorate his country home, the Château de Rottembourg.

1877 Monet paints a series of views of the Gare Saint-Lazare in Paris.

1878 Moves to Vétheuil. Period of financial difficulties and general discouragement.

1880 For the first time in over a decade submits work to the Salon.

1881 Durand-Ruel again starts buying a large number of works by Monet. Monet feels able to abandon the Salon and shows at the sixth Impressionist exhibition. In December leaves Vétheuil and moves to Poissy.

1882 Takes part in the seventh Impressionist exhibition.

1883 Paints at Etretat on the Normandy coast. Solo show at Durand-Ruel's gallery. Little public response. In April settles at Giverny near Vernon.

1885 Shows work at the annual international exhibitions held at the Galerie Georges Petit.

1886 Durand-Ruel exhibits work by Monet in New York.

1890 Decides to buy the house and garden at Giverny.

1891 Durand-Ruel exhibits a group of Monet's "Haystack" paintings.

1892 Paints series of views of Rouen Cathedral.

1893 Acquires a further plot of land at Giverny in order to lay out a water garden.

1895 Trip to Norway.

1896-97 Negotiations for the Caillebotte Bequest to be acquired by the state and put on public display at the Musée du Luxembourg. Eight pictures by Monet are exhibited there.

1897 Begins to work on the "water-lily" series, the "Nymphéas," the great work of his last decades.

1905 Takes part in an important Impressionist exhibition in London.

1908 Monet suffers from cataract in both eyes.

1909 Durand-Ruel exhibits 48 water-lily pictures at his Paris gallery.

1922 Monet formally donates 19 large water-lily pictures to the state.

1923 Successful eye operation. Resumes work on water-lily pictures.

1926 Dies at Giverny on 6 December.

Berthe Morisot 1841-1895

1841 Born on 14 January in Bourges.

1852 The family settles in Paris.

1855 Berthe attends a private school.

1857 Together with her sister Edma she receives classes in drawing from Chocarne and later from Guichard (pupils of Delacroix and Ingres).

1858 Guichard lets his pupils copy the works of – amongst others – Titian and Veronese in the Louvre.

1861 The sisters decide to dedicate themselves to painting *en plein air*, and receive classes from the landscape painter Corot. They are supported in their studies by their parents. In the summer of this year the sisters paint with Corot in Ville d'Avray.

1963 After Corot leaves Paris, the sisters continue their studies with Achilles François Oudinot.

1864 The family moves to a new house with an *atelier*.

1867 Fantin-Latour introduces the sisters to Edouard Manet. Berthe paints frequently with Manet and becomes a model for him.

1868 Friendship with Degas and Puvis de Chavannes.

1869 Edma marries and gives up painting.

1870 Berthe starts experimenting with watercolors.

1872 Trip to Spain.

1874 Berthe takes part in the first Impressionist exhibition with nine of her own works, and continues to exhibit with the Impressionists up until 1886 (with the exception of 1879 at the birth of her daughter Julia). Despite resounding acknowledgment in the Salon she decides not to exhibit there any more. She marries Edouard's younger brother, Eugène, in December of this year.

1875 Her pictures fetch a high price at an auction in the Hôtel Drouot. She travels to England and is impressed by Turner and Whistler.

1882 Trip to Italy.

1883 Trips to Holland and Belgium, impressed – above all – by Rubens.

1885 Visit from Renoir, through his influence she dedicates herself more to drawing. Durand-Ruel exhibits her works in New York.

1887 She takes part in Georges Petite's *Exposition Internationale* in Paris, where her sculptures are also exhibited. Exhibits with *Les Vingt* in Brussels.

1888/89 Spends the winter in the south of France.

1892 Her first very successful solo exhibition at Boussod et Valadon.

1894 Received by *La Libre esthètique* in Brussels with enthusiasm. Mallarmé acts as agent in the selling of some of her pictures to the Musée Luxembourg.

1895 Dies on the 2 March of pneumonia.

1896 Large exhibition with Durand-Ruel, catalogue by Mallarmé. Numerous exhibitions in years to follow.

Camille Pissarro 1830-1903

1830 Born (as Jacob Abraham Camille Pissarro) in Charlotte-Amalie on the island of Saint-Thomas (Danish Antilles) on 10 July.

1842-47 Attends a boarding school in Passy, Paris. Takes first drawing classes.

1847 Returns to Saint-Thomas. Joins his father's trading company.

1852-54 Travels with the Danish painter Melbye in Venezuela.

1855 Abandons his post in the compnay and goes to Paris in order to become a painter.

1856 Takes his own studio. Meets Corot and some of the Barbizon painters.

1857 Spends the summer at Montmorency. Encouraged by Corot, he makes landscape studies from nature.

1859 Attends classes at a free studio and also at the private Académie Suisse, where he meets Claude Monet. Exhibits for the first time at the Salon.

1861 His work is rejected by the Salon. Meets Armand Guillaumin and Paul Cézanne at the Académie Suisse.

1863 Makes his first prints. Becomes a member of the "Société des Aquafortistes." Exhibits at the Salon des Refusés.

1864 Exhibits again at the official Salon.

1866 Settles in Pontoise.

1869 At Louveciennes.

1870 At the outbreak of the Franco-Prussian War leaves Louveciennes, first for Montfoucault then for London.

1871 Meets the dealer Paul Durand-Ruel and studies the work of J. M. W. Turner and John Constable. A large part of Pissarro's earlier work, left in Louveciennes, is destroyed during this period.

1872 In Pontoise again. From this point on works frequently with Cézanne.

1873 Discusses with Manet their plan to establish an independent cooperative society of artists.

1874 Shows five pictures at first Impressionist exhibition.

1879 Paints with Paul Gauguin in Pontoise. Frequents the Impressionists' café in Paris, La Nouvelle-Athènes.

1882 Shows pictures at the Impressionist exhibition organized by Durand-Ruel in London.

1883 First solo show at Durand-Ruel's Paris gallery.

1884 Settles definitively at Eragny. Expresses sympathy with anarchism.

1885 Contact with Georges Seurat and Paul Signac; is influenced by their theories.

1886 Durand-Ruel exhibits pictures by Pissarro in New York. First Pointillist works.

1888 His eyesight weakens.

1889 Exhibits for the first time with *Les Vingt* in Brussels.

1892 Very successful one-man show at Durand-Ruel's Paris gallery.

1893 Series of city scenes (a single motif seen from various points of view). Meets Henri de Toulouse-Lautrec.

1896 Abandons Pointillism.

1897 Takes part in a number of international exhibitions.

1903 Dies in Paris on 13 November.

1904 Large retrospective at Durand-Ruel's Paris gallery.

Pierre-Auguste Renoir 1841-1919

1841 Born in Limoges on 25 February.

1844 The family moves to Paris.

1854-58 Is apprenticed to a porcelain painter, also attends drawing classes.

1859 Works as a decorative painter of fans and heraldic designs, subsequently of blinds.

1860 Makes copies of works in the Louvre.

1861/62 Studies under Charles Gleyre.

1862 Is admitted to the Ecole des Beaux-Arts. Meets Monet, Sisley and Bazille. Is introduced to the painters of the

Ecole de Fontainebleau and, under their influence, begins to paint *en plein air.*

1864 Exhibits at the Salon.

1866/67 His paintings are rejected by the Salon.

1868 With Bazille, moves into an apartment in the Batignolles district of Paris.

1869 Paints with Monet at "La Grenouillière," a fashionable bathing place on the Seine near Bougival. Under Monet's influence, Renoir lightens his palette.

1870/71 Active military service (Tenth Cavalry Regiment).

1872 With the help of the dealer and gallery-owner Paul Durand-Ruel, he makes his first sales. After his work is again rejected by the Salon, he signs a petition (together with Manet, Fantin-Latour, Pissarro, Cézanne, Jongkind and others) demanding the formal establishment of a Salon des Refusés.

1873 In the studio of Edgar Degas he meets the critic Théodore Duret. In the summer Renoir paints with Monet at Argenteuil.

1874-77 Shows six paintings in the first Impressionist exhibition.

1875 Together with Monet, Sisley and Berthe Morisot, he organizes a sale of work at the Hôtel Drouot.

1877 To counter anti-Impressionist criticism, Renoir proposes the publication of a review, *L'Impressioniste.*

1878-81 Renoir again exhibits at the Salon.

1881 Trip to Italy. Studies the work of Raphael and the murals at Pompeii.

1882 Stays in Algiers, where he largely produces figure paintings.

1883 Solo show (the first of several) at Durand-Ruel's Paris gallery. Paints with Monet on the French and Italian Riviera.

1886 Durand-Ruel includes pictures by Renoir in an exhibition he organizes in New York.

1889 Renoir refuses to take part in the *Exposition Centennale* within the *Exposition Universelle* in Paris.

1890 Exhibits at the Salon for the last time.

1892 The state makes its first acquisition of a painting by Renoir. Retrospective at Durand-Ruel's Paris gallery.

1894 Takes part in the exhibition organized by the journal *La Libre esthétique* in Brussels.

1899 Moves to the South of France.

1900 Initially refuses to exhibit at the *Exposition Universelle* but relents and shows 11 paintings.

1902 Suffers constant deterioration of his health, in particular partial atrophy of the left optic nerve and severe attacks of rheumatism.

1904 Exhibits 35 paintings in his own room at the Salon d'Automne in Paris.

1905 works by Renoir are included in the Impressionist exhibition organized by Durand-Ruel in London.

1907 Becomes Honorary President of the Salon d'Automne.

1910 Retrospective exhibition at the ninth Venice Biennale.

1911 Becomes an officier de la Légion d'Honneur.

1913 Under the guidance of Richard Guino (a pupil of Aristide Maillol), Renoir makes his first sculptures.

1919 A portrait by Renoir is hung in the Louvre. Renoir dies at Cagnes on 3 December.

Georges Seurat 1859-1891

1859 Born in Paris on 2 December.

1874/75 Starts to draw and to take an interest in the color theories of Jean-Baptiste-Camille Corot.

1876 Studies drawing under the sculptor Justin Lequieu.

1878 Is admitted to the Ecole des Beaux-Arts.

1880 Takes a great interest in the theoretical writings of the history painter Thomas Couture. Military service.

1883 Exhibits a drawing at the Salon. Embarks on his first large painting, *Bathers at Asnières*.

1884 This work is rejected by the official Salon. Seurat exhibits it at the Salon des Indépendants. Takes part in the founding of the "Société des Indépendants" and in the exhibitions subsequently held by it.

1885/86 Completes this painting, his most significant work and the perfection of his technique of breaking up the picture plane into juxtaposed spots of complementary color. Exhibits works at the Impressionist exhibition in New York. The dealer Paul Durand-Ruel arranges for Seurat to take part in the eighth and last Impressionist exhibition in Paris. Seurat's nine works include *A Sunday Afternoon on the Island of La Grande Jatte*.

1887 Seven paintings by Seurat are shown with the artists' group *Les Vingt* in Brussels. Seurat is also to exhibit there over the following years.

1891 Dies in Paris, probably of diptheria, on 29 March.

Paul Signac 1863-1935

1863 Born in Paris on 11 November. Attends the Collège Rollin and initially plans, in accordance with his parents' wishes, to become an architect.

1879 Copies works by Degas included in the Impressionist exhibition of this year.

1880 Is inspired by the exhibition of works by Monet at the gallery of the dealer Paul Durand-Ruel. He immediately starts painting en plein air.

1881 He makes the decision to devote himself exclusively to painting.

1882/83 Intermittently attends classes at the Ecole des Arts Décoratifs, then at the free studio of Jean Baptiste Bin. Meets Armand Guillaumin. During the summer he paints at Port-en-Bessin, Brittany.

1884 His work is rejected by the official Salon. He is among the founders of the "Société des Artistes Indépendants." Becomes a friend of Georges Seurat.

1885 Meets Camille Pissarro.

1886 Through Pissarro's mediation, Signac is able to show his work at the eighth Impressionist exhibition. He shows the painting *The Milliners*, which is strongly influenced by Seurat in its technique. Together, Signac and Seurat evolve the theoretical basis of Neo-Impressionism.

1887 Provides illustrations for the journal *La Vie moderne*.

1888 Exhibits with the artists' group *Les Vingt* in Brussels.

1889 Provides designs to illustrate the writings on color theory of the physicist Charles Henry. Visits Van Gogh.

1890 Becomes a member of *Les Vingt.*

1891 After the death of Seurat, Signac becomes the leader of the Neo-Impressionists.

1893 Mainly in Saint-Tropez. He writes occasionally for the anarchist journal *Le Cri du peuple.*

1899 Publishes his theoretical essay "D'Eugène Delacroix au Néo-Impressionnisme." Durand-Ruel exhibits Signac's five variations on the view of Mont Saint-Michel.

1909-34 Is President of the "Société des Artistes Indépendants."

1913 Lives mostly in Antibes but retains his Paris studio.

1935 Dies in Paris on 15 August.

Alfred Sisley 1839-1899

1839 Born in Paris on 30 October, the son of a wealthy English textile merchant.

1857 Is sent to England to embark on a commercial apprenticeship but is more interested in painting. Admires the work of J. M. W. Turner and John Constable that he sees in the museums.

1862 Returns to Paris. Devotes himself entirely to painting. At the Ecole des Beaux-Arts he attends classes in the studio of Charles Gleyre.

1863 Sisley leaves Gleyre's studio and starts painting *en plein air* in the forest of Fontainebleau.

1865 Renoir moves temporarily into Sisley's Paris apartment. Sisley paints with Renoir and Pissarro in Marlotte, near Fontainebleau.

1866 Exhibits for the first time at the Salon.

1867 His work is rejected by the Salon and he supports Bazille's demand for a formally recognized Salon des Refusés. Trip to Honfleur.

1868 Exhibits a picture at the Salon.

1869 His work is again rejected by the Salon.

1870 Shows two views of Paris at the Salon, but these attract little attention.

1872 With Monet at Argenteuil. Sisley makes his first sale to the dealer Paul Durand-Ruel, who also exhibits works by the artist in London. From this point on, principally paints landscape along the Seine.

1874 Shows six pictures at the first Impressionist exhibition.

1875-77 Lives at Marly-le-Roi. Shows pictures at the second and third Impressionist exhibitions.

1875 Takes part in the auction of paintings held at the Hôtel Drouot. Public reaction to his work is negative.

1876 Paints some of his best work at Port-Marly.

1877 Moves to Sèvres. Frequents the artists' tavern owned by Eugène Murer and befriends the publisher Georges Charpentier.

1879 Sisley's work is rejected by the Salon.

1880 He moves to Veneux near Moret-sur-Loing.

1881 First solo show organized by Charpentier's journal *La Vie moderne.*

1882 Shows his pictures at the seventh Impressionist exhibition: He settles in Moret-sur-Loing.

1883 Unsuccessful solo show at Durand-Ruel's Paris gallery.

1885/86 Durand-Ruel exhibits works by Sisley abroad, including the USA.

1887 Works by Sisley are included in the international exhibition held at the gallery of Georges Petit.

1890 Exhibits with *Les Vingt* in Brussels. Becomes a member of the newly founded "Société Nationale des Beaux-Arts." Takes part in various exhibitions.

1898 Becomes gravely ill.

1899 Dies at Moret-sur-Loing on 29 January.

Henri de Toulouse Lautrec 1864-1901

1864 Born in Albi on 24 November, the son of the Comte de Toulouse Lautrec Monfa.

1872-75 Attends the Lycée Fontanes in Paris (leaves because of ill health).

1878 Breaks left thigh bone in an accident, as a result of which he retains throughout his life the stature of a dwarf. Starts painting.

1882 In Paris he first attends classes at the studio of Léon Bonnat, then continues his studies under the history painter Fernand Cormon.

1884 Rents an apartment in Monmartre.

1886 Publishes drawings in newspapers and journals.

1888 Exhibits with the artists' group *Les Vingt* in Brussels.

1889 Exhibits at the Salon des Indépendants.

1891 Takes up lithography. Designs posters. Takes part in the first *Exposition des Peintres Impressionistes et Symbolistes*.

1893 Large show of work by Toulouse-Lautrec and Charles Maurin at the Galerie Bossoud-Valadon.

1894 Makes various trips: to Belgium, Holland, England and Spain. Takes part in various exhibitions. Contact with the artists' group *Les Nabis*.

1895 Exhibits posters at the Salon de l'Art Nouveau and at the centenary exhibition of lithography held at the Ecole des Beaux-Arts.

1898 Solo show at the Goupil Gallery, London.

1899 Suffers a nervous and physical breakdown brought on by excessive indulgence in alcohol. Stays in a psychiatric clinic.

1900 Moves to Bordeaux.

1901 After suffering a stroke, dies in the presence of his mother at her home, the Château de Malromé, on 9 September.

Fritz Novotny

Fritz Novotny (1903-83) was one of the most intelligent and unconventional people that I have ever known. Modest, unpretentious, with a refined, dry sense of humor, he was an out and out individualist. He loved the philosophy of Kant, old steam engines, roses, the *Lieder* of Schubert, the work of Adalbert Stifter, the great Russian novelists, the actors Karl Valentin, Buster Keaton, and Charlie Chaplin, old Westerns, and, of course, Cézanne. The experience of nature was one of his greatest pleasures. The landscapes described by Stifter and painted by Cézanne – the Bohemian forest and Provence – were closest to his heart. Anyone who had not known him would have had difficulty in understanding how such diverse tastes could be united in one personality. But when one had met him, this diversity became quite understandable.

Novotny studied art history in Vienna under Josef Strzygowski and wrote his doctoral dissertation on the sculptural decoration of the Romanesque apse of the church at Schöngraben. The subject was very much in line with the interests of his teacher, a figure as controversial as he was brilliant and eccentric, from whose influence Novotny profited more than any other student (in this, too, he was an individualist), not least in his scholarly orientation to the late nineteenth century.

Novotny's *Habilitationsschrift* of 1938 – *Cézanne und das Ende der wissenschaftlichen Perspektive* (Cézanne and the End of Scientific Perspective) – was anything but easy reading, but it was nonetheless swiftly acclaimed. Its penetrating analysis established it as one of the fundamental works of commentary on the great pioneer of modern art. The art historian Meyer Schapiro, in his own book on Cézanne, cites two scholars to whom he owed his most important insights: Roger Fry and Fritz Novotny.

From 1938 until the late 1970s Novotny taught at the University of Vienna. In his lectures – and these covered not only the nineteenth century but also artists from other periods, such as Frans Hals, Velázquez, or Vermeer – he made do with very few slides. Persistent in his patience, he was determined to analyze every individual work and to tackle from every angle the problems it posed. Just as in his essay in this volume he makes assertions that he may then qualify, refine, even partly retract, in order to be yet more precise in his formulation, so in his lectures he adopted a very "open," one might even say "sketchy," method. He would return repeatedly to certain ideas in order to modify and sharpen them with each reworking. His listeners profited enormously through the process of thinking and looking along with their teacher.

In 1939 Fritz Novotny was appointed to a post at the Österreichische Galerie, where he eventually serverd as Director from 1961 to 1968. The late 1930s and earlier 1940s cannot have been an easy time for a young art historian who never denied his distaste for Faschism.

Novotny's museum work gave him the opportunity to engage more deeply with his area of specialist interest – the painting of the late nineteenth and early twentieth centuries. This interest was also reflected in his publications: there were monographs on Ferdinand Olivier, Adalbert Stifter, Anton Romako, Gustav Klimt, and Henri de Toulouse-Lautrec. In 1952 he published *Die grossen Impressionisten* and in 1960, in the Pelican History of Art series, *Painting and Sculpture in Europe, 1780-1880*.

To those who did not know Novotny, it may seem surprising that, alongside texts on great figures such as Cézanne and Brueghel, he also published on much less widely known Austrian artists – Georg Ehrlich, Oskar Laske, or Gerhard Frankl. For Novotny, however, the choice of topic was an entirely personal question. He had known intimately most of the contemporary Austrian artists on whom he wrote. For Novotny, there were no "great" or "small" subjects, but simply subjects that interested him. With a truth to the inconspicuous that was truly worthy of Stifter, he brought to lesser known artists the same diligence and attention that he devoted to great ones.

The fact that Novotny, in pursuing his research, always followed his own inclinations rather than fashionable trends, often made him into a pioneer. His monographs on Romako, on Stifter as a painter, and on Wilhelm Busch as a painter and draftsman appeared at a time when relatively little attention was paid to these figures. At the heart of every monograph by Novotny there lay, as its real subject, the principal questions that he asked himself in connection with the artist concerned.

Novotny paid no more attention than was necessary to art historical scholarly literature, preferring an intense and thoughtful engagement with the works of art themselves. The essay reprinted in this volume also reflects this approach. In this text Novotny makes no reference to the state of art historical research in the early 1950s, but addresses himself, as a man of both humanity and refinement, to the phenomenon of Impressionism, to which he had already devoted considerable thought – and it is precisely this that assures Novotny's text its contemporary relevance.

Artur Rosenauer

Bibliography

A) Books and catalogues on Impressionism, Post-Impressionism, and related topics.

Lionello Venturi, *Les Archives de l'Impressionnisme,* 2 vols. (Paris and New York, 1939; repr. New York, 1968)

John Rewald, *The History of Impressionism* (New York and London, 1946; 4th rev. ed. New York and London, 1973; repr., 1980)

John Rewald, *Post-Impressionism: From Van Gogh to Gauguin* (New York and London, 1956; 3rd rev. ed. New York and London, 1978)

Linda Nochlin, ed., *Impressionism and Post-Impressionism, 1874-1904* (Englewood Cliffs, N. J., 1966; rev. ed. Englewood Cliffs, N. J., 1979)

Neo-Impressionism, exh. cat., ed. Robert L. Herbert; Solomon R. Guggenheim Museum, New York (New York, 1968)

Kermit S. Champa, *Studies in Early Impressionism* (New Haven, Mass., and London, 1973)

Centennaire de l'Impressionnisme / Impressionism: A Centenary Exhibition, exh. cat., ed. Anne Dayez, Michel Hoog, Charles S. Moffett; Grand Palais, Paris; The Metropolitan Museum of Art, New York; 1974-75 (Paris, 1974)

Japonisme: Japanese Influences in French Art 1854-1910, exh. cat., ed. Gabriel Weisberg et al.; Cleveland Museum of Art, Cleveland, Ohio; The Rutgers University Art Gallery, New Brunswick, N. J.; The Walters Art Gallery, Baltimore; 1975-76 (Cleveland, 1975)

Bernard Dunstan, *Painting Methods of the Impressionists* (New York and London, 1976)

Sophie Monneret, *L'Impressionnisme et son époque: Dictionnaire internationale illustré,* 4 vols. (Paris, 1978-81; reprinted as 2 vols. Paris, 1987)

The Crisis of Impressionism 1878-1882, exh. cat., ed. Joel Isaacson et al.; University of Michigan Museum of Art, Ann Arbor; 1979-80 (Ann Arbor, 1979)

Post-Impressionism: Cross Currents in European Painting, exh. cat., ed. John House and MaryAnne Stevens; Royal Academy of Arts, London; 1979-80 (London, 1979)

Hélène Adhémar et al., eds., *Chronologie impressionniste 1863-1905* (Paris, 1981)

Anthea Callen, *Techniques of the Impressionists* (London and Secaucus, N. J., 1982)

Belinda Thomson, *The Post-Impressionists* (Oxford and New York, 1983; 2nd ed. Oxford and New York, 1990)

A Day in the Country: Impressionism and the French Landscape, exh. cat., ed. Richard Brettell et al.; Los Angeles County Museum of Art; 1984 (Los Angeles, 1984)

John Rewald et al., eds., *Studies in Impressionism* (London, 1985)

John Rewald et al., eds., *Studies in Post-Impressionism* (London, 1986)

The New Painting: Impressionism 1874-1886, exh. cat., ed. Charles S. Moffett et al.; National Gallery of Art, Washington, D.C.; The Fine Arts Museum of San Francisco: M. H. de Young Memorial Museum; 1986 (San Francisco, 1986)

Robert L. Herbert, *Impressionism, Art, Leisure, and Parisian Society* (New Haven, Mass., and London, 1988; 2nd ed. New Haven and London, 1991)

Art in the Making: Impressionism, exh. cat., ed. David Bomford et al.; National Gallery, London (New Haven, Mass., and London, 1991)

Norma Broude, *Impressionism, a Feminist Reading: The Gendering of Art, Science and Nature in the Nineteenth Century* (New York, 1991)

Thomas Parsons and Iain Gale, *Post-Impressionism: The Rise of Modern Art* (London, 1992)

Bernard Denvir, *The Chronicle of Impressionism* (London, 1993)

Monet to Matisse: Landscape Painting in France 1874-1914, exh. cat., ed. R. Thomson et al.; National Gallery of Scotland, Edinburgh; 1994 (Edinburgh, 1994)

Impressionnisme: Les Origines / The Origins of Impressionism, exh. cat., ed. Henri Loyrette and Gary Tinterow; Grand Palais, Paris; The Metropolitan Museum of Art, New York; 1994-95 (Paris, 1994; rev. English ed. New York, 1994)

B) Books and catalogues on the principal artists discussed in the text.

BONNARD

Jean and Henry Dauberville, *Bonnard: Catalogue raisonné de l'œuvre peint,* 4 vols. (Paris, 1965-74)

Bonnard, exh. cat., ed. Jean Clair et al.; Centre Georges Pompidou, Paris; Phillips Collection, Washington, D.C.; Dallas Museum of Art; 1984 (Paris and Washington, D.C., 1984)

Sasha Newman, ed., *Bonnard* (New York and London, 1984; published in connection with the 1984 exhibition)

Julian Bell, *Bonnard* (London, 1994)

BOUDIN

Robert Schmit, *Eugène Boudin 1824-1898: Catalogue raisonné,* 3 vols. (Paris, 1973)

Louis Eugène Boudin: Precursor of Impressionism, exh. cat., ed. Mahonri Sharp Young & Katherine Wallace Paris; Santa Barbara Museum of Art; Art Museum of South Texas, Corpus Christi; Museum of Fine Arts, St. Peterburg, Fla.; Columbus Gallery of Fine Arts, Columbus, Ohio; Fine Arts Gallery of San Diego; 1976-77 (Santa Barbara, 1976)

Jean Selz, *Eugène Boudin* (Paris, 1982)

CEZANNE

Lionello Venturi, *Cézanne: Son art, son œuvre*, 2 vols. (Paris, 1936; 2nd ed. San Francisco, 1989)

Cézanne: The Late Work, exh. cat., ed. John Rewald, William Rubin, et al.; The Museum of Modern Art, New York; Museum of Fine Arts, Boston; Grand Palais, Paris; 1977-78 (New York, 1977; Paris, 1978)

Cézanne: The Early Years, exh. cat., ed. Lawrence Gowing et al.; Royal Academy of Arts, London; Musée d'Orsay, Paris; National Gallery of Art, Washington, D.C.; 1988-89 (London and Paris, 1988)

Richard Shiff, *Cézanne and the End of Impressionism* (Chicago and London, 1984)

John Rewald, *Cézanne: A Biography* (New York, 1986)

Richard Verdi, *Cézanne* (London, 1992)

COROT

Alfred Robaut, *L'Œuvre de Corot: Catalogue raisonné et illustré*, 4 vols. (Paris, 1905); 2 vol. supplement (Paris, 1948, 1956)

Hommage à Corot, exh. cat., ed. Hélène Toussaint, Geneviève Monnier, and Martine Servot; Orangerie des Tuileries, Paris; 1975 (Paris, 1975)

Germain Bazin, *Corot* (Paris, 1973)

Michael Clarke, *Corot and the Art of Landscape* (London, 1991)

Peter Galassi, *Corot and Italy: Open-Air Painting and the Classical Landscape Tradition* (New Haven, Mass., and London, 1991)

COURBET

Robert Fernier, *La Vie et l'œuvre de Gustave Courbet: Catalogue raisonné*, 2 vols. (Lausanne and Paris, 1977)

Gustave Courbet 1819-1877, exh. cat., ed. Hélène Toussaint; Grand Palais, Paris; Royal Academy of Arts, London; 1977-78 (Paris 1977; London, 1978)

Courbet Reconsidered, exh. cat., ed. Sarah Faunce and Linda Nochlin; Brooklyn Museum, New York; Minneapolis Institute of Arts; 1989 (New York, 1988)

Jack Lindsay, *Gustave Courbet: His Life and Work* (New York, 1973)

Linda Nochlin, *Gustave Courbet: A Study in Style and Society* (New York, 1976)

DEGAS

Paul André Lemoisne, *Degas et son œuvre*, 4 vols. (Paris, 1946-49; reprinted with supplement New York and London, 1984)

Degas, exh. cat., ed. Jean Sutherland Boggs et al.; Grand Palais, Paris; National Gallery of Canada, Ottawa; The Metropolitan Museum of Art, New York; 1988-89 (Paris, 1988)

Ian Dunlop, *Degas* (London, 1979)

Denys Sutton, *Edgar Degas: Life and Work* (New York, 1986)

Jean Sutherland Boggs and Anne Malheux, *Degas Pastels* (London, 1992)

Edgar Degas 1834-1917, exh. cat., ed. Ronald Pickvance; Fondation Pierre Gianadda, Martigny; 1993 (Martigny, 1993)

DELACROIX

Lee Johnson, *The Paintings of Eugène Delacroix: A Critical Catalogue*, 4 vols. (Oxford, 1981 and 1986)

Eugène Delacroix, exh. cat., ed. Gunter Metken; Kunsthaus, Zurich; Städtische Galerie im Städelschen Kunstinstitut, Frankfurt; 1987-88 (Zurich, 1987)

Lee Johnson, *Delacroix* (London, 1963)

GAUGUIN

Daniel Wildenstein and Raymond Cogniat, *Paul Gauguin: Catalogue*, vol. 1 [of continuing series] (Paris, 1964)

Gauguin, exh. cat., ed. Richard Brettell, Françoise Cachin, Claire Frèches-Thory, and Charles F. Stuckey; National Gallery of Art, Washington, D.C.; Art Institute of Chicago; Grand Palais, Paris; 1988-89 (Washington, D.C., 1988; Paris, 1989)

Mark Roskill, *Van Gogh, Gauguin and the Impressionist Circle* (London, 1970)

Belinda Thomson, *Gauguin* (London, 1987)

GERICAULT

Germain Bazin, *Théodore Géricault: Etude critique, documents, et catalogue raisonné*, 5 vols. (Paris, 1989-92)

Géricault, exh. cat., ed. Sylvain Laveissière and Régis Michel; Grand Palais, Paris 1991-92 (Paris, 1991)

Lorenz E. A. Eitner, *Géricault: His Life and Work* (London, 1983)

VAN GOGH

Jacob Baart de la Faille, rev. Abraham M. Hammacher et al., *The Works of Van Gogh: His Paintings and Drawings* (New York, 1970; based on de la Faille catalogue of 1928, rev. 1939)

Vincent Van Gogh: Paintings, exh. cat., ed. Evert van Uitert, Louis van Tilborgh, and Sjraar van Heugten; Rijksmuseum Van Gogh, Amsterdam; 1990 (Amsterdam, 1990)

Vincent Van Gogh: Drawings, exh. cat., ed. Johannes van der Wolk, Ronald Pickvance, and E. B. F. Pey; Rijksmuseum Kröller-Müller, Otterlo; 1990 (Amsterdam, 1990)

Mark Roskill, *Van Gogh, Gauguin and the Impressionist Circle* (London, 1970)

Van Gogh at Saint Rémy and Auvers, exh. cat., ed. Ronald Pickvance; The Metropolitan Museum of Art, New York; 1986-87 (New York, 1986)

Van Gogh à Paris, exh. cat., ed. Françoise Cachin and Bogomila Welsh-Ovcharov; Musée d'Orsay, Paris; 1988 (Paris, 1988)

Vincent Van Gogh und die Moderne, exh. cat., ed. Ronald Dorn et al.; Museum Folkwang, Essen; Rijksmuseum Van Gogh, Amsterdam; 1990-91 (Freren, 1990)

MANET

Denis Rouart and Daniel Wildenstein, *Edouard Manet: Catalogue raisonné*, 2 vols. (Paris, 1975),

Manet 1832-1883, exh. cat., ed. Charles S. Moffett, Françoise Cachin, and Juliet Wilson Bareau; Grand Palais, Paris; The Metropolitan Museum of Art, New York; 1983 (Paris and New York, 1983)

Anne Coffin Hanson, *Manet and the*

Modern Tradition (New Haven, Mass., and London, 1977)

Françoise Cachin, *Manet* (Paris 1990); English ed. trans. Emily Read (London, 1991)

MARQUET

Albert Marquet 1875-1947, exh. cat., ed. François Daulte et al.; Fondation de l'Hermitage, Lausanne; 1988 (Lausanne, 1988)

Francis Joudain, *Marquet* (Paris, 1959)

Albert Marquet 1875-1947, exh. cat., ed. Hélène Adhémar et al.; Galerie des Beaux-Arts, Bordeaux; Orangerie des Tuileries, Paris; 1975-76 (Paris, 1975)

Marquet, exh. cat., ed. Marcel Sembat et al.; Galerie Wildenstein, New York; Galerie Wildenstein, Paris; 1985 (New York and Paris, 1985)

MATISSE

Matisse: A Retrospective, exh. cat., ed. John Elderfield et al.; The Museum of Modern Art, New York; 1992-93 (New York, 1992)

Lawrence Gowing, *Matisse* (Oxford, New York, and Toronto, 1979)

Jack Flam, *Matisse: The Man and His Art, 1869-1918* (Ithaca and London, 1986; a second volume, covering 1919-54, is in preparation)

MILLET

Jean-François Millet, exh. cat., ed. Alexandra R. Murphy et al.; Museum of Fine Arts, Boston; 1984 (Boston, 1984)

Jean François Millet, exh. cat., ed. Robert L. Herbert; Grand Palais, Paris; Hayward Gallery, London; 1975-76 (Paris, 1975; London, 1976)

MONET

Daniel Wildenstein, *Claude Monet: Biographie et catalogue raisonné*, 5 vols. (Lausanne and Paris, 1974-91)

Hommage à Claude Monet (1840-1926), exh. cat., ed. Hélène Adhémar, Anne Distel, and Sylvie Gache; Grand Palais, Paris; 1980 (Paris, 1980)

Monet's Years at Giverny: Beyond Im- *pressionism*, exh. cat., ed. Charles S. Moffett et al.; The Metropolitan Museum of Art, New York; St. Louis Art Museum, St. Louis; 1978 (New York, 1978)

Grace Seiberling, *Monet's Series* (New York and London, 1981)

John House, *Monet: Nature into Art* (New Haven, Mass., and London, 1986)

Monet in the '90s: The Series Paintings, exh. cat., ed. Paul Hayes Tucker; Museum of Fine Arts, Boston; Royal Academy of Arts, London; Art Institute of Chicago; 1989-90 (New Haven, Mass., and London, 1989)

Virginia Spate, *The Colour of Time: Claude Monet* (London, 1992)

PISSARRO

Ludovic Rodo Pissarro and Lionello Venturi, *Camille Pissarro: Son art, son œuvre*, 2 vols. (Paris, 1939)

Camille Pissarro 1830-1903, exh. cat., ed. Christopher Lloyd, Anne Distel, et al.; Hayward Gallery, London; Grand Palais, Paris; Museum of Fine Arts, Boston; 1980-81 (London, 1980; Paris, 1981)

Christopher Lloyd, *Pissarro* (London 1990)

Richard Brettell, *Pissarro and Pontoise: The Painter in a Landscape* (New Haven, Mass., and London, 1990)

The Impressionist and the City: Pissarro's Series Paintings, exh. cat., ed. Richard Brettell and Joachim Pissarro; Dallas Museum of Art; Philadelphia Museum of Art; Royal Academy of Arts, London; 1992-93 (New Haven, Mass., and London, 1992)

RENOIR

François Daulte, *Auguste Renoir: Catalogue raisonné de l'œuvre peint*, vol. 1 [of continuing series] (Lausanne, 1971)

Renoir, exh. cat., ed. John House, Anne Distel, and Lawrence Gowing; Hayward Gallery, London; Grand Palais, Paris; Museum of Fine Arts, Boston; 1985-86 (London, 1985; Paris, 1985)

Anthea Callen, *Renoir* (London, 1978)

Barbara Ehrlich White, *Renoir: His Life, Art, and Letters* (New York, 1984)

SEURAT

César Mange de Hauke, *Seurat et son œuvre*, 2 vols. (Paris, 1961)

Seurat, exh. cat., ed. Robert L. Herbert et al.; Grand Palais, Paris; The Metropolitan Museum of Art, New York; 1991-92 (Paris and New York, 1991)

John Rewald, *Seurat: A Biography* (London, 1990)

Richard Thomson, *Seurat* (Oxford and New York, 1985; 2nd ed. Oxford and New York, 1990)

SIGNAC

Signac, exh. cat., ed. Marie Thérèse Lemoyne de Forges; Musée du Louvre, Paris; 1963-64 (Paris, 1964)

Françoise Cachin, *Paul Signac* (Paris, 1971; English edition Greenwich, Conn., 1971)

Floyd Ratliff, *Paul Signac and Color in Neo-Impressionism* (New York, 1992; contains first English translation of Signac's essay "D'Eugène Delacroix au néo-impressionnisme")

SISLEY

François Daulte, *Alfred Sisley: Catalogue raisonné de l'œuvre peint* (Lausanne, 1959)

Alfred Sisley, exh. cat., ed. MaryAnne Stevens, Christopher Lloyd, Sylvie Patin, et al.; Royal Academy of Arts, London; Musée d'Orsay, Paris; Walters Art Gallery, Baltimore; 1992-93 (New Haven and London, 1992)

Richard Shone, *Sisley* (London, 1992)

TOULOUSE-LAUTREC

M.-Geneviève Dortu, *Toulouse-Lautrec et son œuvre*, 6 vols. (New York, 1971)

Toulouse-Lautrec, exh. cat., ed. Claire Frèches-Thory, Anne Roquebert, and Richard Thomson; Hayward Gallery, London; Grand Palais; Paris; 1991-92 (London, 1991; Paris, 1992)

Richard Thomson, *Toulouse-Lautrec: Paintings* (Chicago, 1979)

Notes

1 Letter of 3 September 1872, from Pissarro to Antoine Guillemet; quoted in John Rewald, *Cézanne: Sa vie, son œuvre, son amité pour Zola* (Paris, 1939), p. 196.

2 Quoted in John Rewald, *The History of Impressionism,* 4th rev. ed. (New York and London, 1973; repr. 1980), p. 476.

3 Quoted in Monique Angoulvent, *Berthe Morisot* (Paris, 1933), p. 76. See Rewald (note 2), p. 198.

4 See *Manet 1832-1883*, exh. cat., ed. Charles S. Moffet, Françoise Cachin, and Juliet Wilson Bareau; Grand Palais, Paris, and The Metropolitan Museum of Art, New York (Paris and New York, 1983), cat. no. 179, p. 432ff. and *Degas*, exh. cat., ed. Jean Sutherland Boggs *et al.*; Grand Palais, Paris, and National Gallery of Canada, Ottawa (Paris, 1988), p. 367.

5 Georges Clemenceau, *Claude Monet: Les Nymphéas* (Paris, 1928), pp. 19-20.

6 Harald Keller, *Französische Impressionisten*, ed. E. Herget and W. Schlink (Frankfurt and Leipzig, 1993), pp. 20-37.

7 Emil Zola, "*Le Naturalisme au Salon*," *Le Voltaire*, 18-22 June 1880; reprinted in *Emile Zola: Ecrits sur l'art*, ed. Jean-Pierre Leduc-Adine (Paris, 1991), pp. 409-38, passage quoted on pp. 422-23. See Rewald (note 2) and Rewald (note 1), pp. 251-58 and Rewald (note 2), pp. 444-47

8 Maurice Denis, *Théories, 1890-1910: Du Symbolisme et de Gauguin vers un nouvel ordre classique* (Paris, 1912), p. 242.

9 See the chapter "Spätrömische Porträts," in Guido Kaschnitz von Weinberg, *Römische Bildnisse* (Berlin, 1965), p. 62.

10 See the chapter "Die Reaktion gegen den Impressionismus in den achtziger Jahren, vom Künstlerischen her betrachtet," in Fritz Novotny, *Über das "Elementare" in der Kunstgeschichte und andere Aufsätze* (Vienna, 1968), pp. 26-32, passage quoted on p. 31. This text was first puplished as "The Reaction against Impressionism from the Artistic Point of View" in *Problems with the 19th and 20th Centuries: Studies in Western Art* (Princetown, N. J., 1963; Acts of the Twentieth International Congress of the History of Art).

11 Werner Hofmann, *Die Grundlagen der modernen Kunst* 3rd ed., (Stuttgart, 1987), pp. 179-90.

Photograph Credits

The artist biographies were compiled by Bettina Vaupel. The plate commentaries bearing the initials E. D. were written by Eva Dorrmann.